An

Art Collection of

Carl Cum'arah K. Bronner

Five thousand years of

African Kings & Queens
and Other VIPS
A Reference Guide

C. C. K. Bronner Coordinator/Editor

2018

COPYRIGHT NO. 1-3AY3Y7F

Covers: Mentuhotep II – Son of God – 22nd Century B.C.E.

Copyright © 2018 Carl Cum'arah K. Bronner
Copyright Registration Number: 1-3AY3Y7F

All rights reserved. No part of this publication may be reproduced, distributed or transmitted in any form or by any means, or stored in a database or retrieval system, without the prior written permission of the author.

Images used are Public Domain or used by permission and are properly attributed to the best of the author's ability.

Coordinator/Editor: C. C. K. Bronner

Published by G Publishing, LLC

ISBN: 978-0-5784913-2-5

Printed in the United States of America

PREFACE

Going beyond the studies of other great observationist, European archaeologists, anthropologists and historians, Dr. Cheikh Anta Diop greatly advanced the study of the ancient Egyptian's ancestors with Twentieth Century scientific experiments. Since the Senegalese was a physicist, anthropologist, historian and politician very, very few were able to approach the subject of the ancient Egyptian race than Diop. Garnering information from a number of European and African researchers, he perfected Melanin Dosage and Osteological Tests. Not since Imhotep –27th Century B.C.E. – has there appeared to be such a true, all-around universal 20th Cent. who Was scientist, Egyptologist, historian, philosopher and politician. Hundreds of contemporary Egyptologists (archaeologists, anthropologists, psychologists and other researchers), have assured that Dr. Cheikh Anta Diop will be our icon forever.

<u>FROM THE TYPEWRITERS AND COMPUTERS OF CHEIKH ANTA DIOP</u>

"The typically Negroid features of the Pharaohs (Narmer, First Dynasty, the actual founder of the pharaonic line; Zoser, Thirdy Dynasty,; Cheops, the builder of the Great Pyramid, a Cameroon type; Mentuhotep, founder of the Eleventh Dynasty, very black; Sesostris I, Queen Ahmosis Nefertari; and Amenhophis I) show that all classes of Egyptian society belong to the same Black Race."

"Melanin (eumelanin), the chemical substance responsible for skin pigmentation…is insoluble and is preserved for millions of years in the skins of fossil animals and it is readily recoverable in the skins of the Egyptian mummies. The samples I myself analysed were taken in the physical anthropology laboratory of the Musee de L'Homme in Paris off mummies from the Marietta excavations in Egypt. The same method is perfectly suitable for use on the royal mummies of Thutmoses III, Seti I and Ramses II in the Cairo Museum."

His Melanin Dosage Test needed "no more than a few square millimetres of skin as specimen just a few 'um' in thickness and lightened with the chemical

ethyl benzoate. It can be studied with ultraviolet or natural lighting which makes the melanin grains (glow) fluorescent." (I, C. Cum'arah K. found no definition for an',**um'** measurement.)

"In a major study made by Karl Richard Lepsius, Diop found that osteological measurements are... best...for distinguishing a Black man from a White Man. The 'Lepsius Canon' is the criterion which states that the Egyptians belong among the Black races. Twelfth and 13th Centuries dynasties (Before the Common Era = B.C.E.) found that all were long head skulls, broad faces, low orbit and broad nasal apertures which are the same characteristic features of the Negroid type. As for blood groups, the ancient Egyptians and their descendants have Type B."

This is what many, many Egyptologists, especially Dr. Asa G. Hilliard III, called setting the records straight by once again making Egyptian, Ethiopian and Nubian histories stand upright, instead of the upside-down effect created by European and American Egyptologists, anthropologists and archaeologists have done over the past 220 years. (See Martin Bernal, *Black Athena*... and others)

After the defeat of Egypt's last great army under Pharaoh Taharqa by Assyrian King Ashurbanipal in 667 C.E. (Common Era, a.k.a "A.D"). the evolution of skin color in Lower Egypt saw people of lighter tans emerging as true blooded Egyptians (Negroes) emigrated back to Upper Egypt and their southern ancestral lands. Through miscegenation and immigrants from Libya and people of the eastern shores of the Mediterranean Sea (so-called Middle East) skin colors in Lower Egypt Evolved into a greater mixture of black, brown and tan folks. The impetus for such changes came as the result of Macedonian General, Alexander invaded Egypt around the year 332 B.C.E., followed by the Roman invasions beginning in 31 B.C.E. by Emperor Ceasar Gaius Octavianus Augustus. However, the onslaught of people of lighter tans flooded Lower Egypt following the war between King Kalydosos of Makuria, Ethiopia and Muslim invader King Abdullarh in the year 643 C.E.. From that time forward, most of

Egypt's rulers were not full-blooded Egyptians. The leaders we see today are the descendants of the 7th Century C.E. conquerors.

The scholars and geniuses most responsible for my insight into the peoples of northeast African nations extending as far back as 10000 B.C.E. are as follows:

Na'im Akbar
Yosef A. A. ben-Jochannan Theophile Obenga
Martin Bernal Runoko Rashidi
Anthony A. Browder George Rawlinson
James Brunson Joel Augustus Rogers
Wayne Chandler Ivan Van Sertima
John Henrik Clarke Chancellor Williams
Legrand Clegg II U. N. Gen. History of Africa, Vol. II Basil Davidson
Charles S. Finch III Abdelgadir M. Abdalla
Kersey Graves E. A. Wallis Budge
Herodotus Donald Johanson
Godfrey Higgins Louis Seymour Leakey
Asa G. Hilliard III Mary Douglas Leakey
Drusilla Dunjee Houston Richard Erskine Leakey
John G. Jackson Karl Richard Lepsius
George G. M. James G. K. Osei
Gerald Massey S. Sauneron
Ali A. Mazrui Henry Morgan Stanley
Theophile Obenga Constantin Francois comte de Volney (I apologize for overlooked

authors and mentors)

Carl Cum'arah Khem Bronner, M.Ed, Historian, Lecturer and Retired Educator

This reference guide is dedicated to the
Life and Memory of
Professor Asa G. Hilliard III
"Free Your Mind In Preparation For A New Start"

Dr. Hilliard as a frequent guest of Listervelt Middleton on "For the People..." inspired the production of this publication by saying, "Someone should produce a magazine showing the features of African Kings, Queens and other dignitaries" from the 3100 B.C.E. to the opening of the 20th Century C.E. Only then can a whole lot of people begin to see and understand the true African features of those leaders as first described by their recordkeepers, and monument and temple builders. After that, came the descriptions of the Greek "Father of History," Herodotus in the Fifth Century B.C.E. and many other historians.

In reference to SCTV-PBS "For the People"

C. C. K. Bronner, M. Ed, Historian & Lecturer

C. C. K. BRONNER's Artifacts and Art Collection

Whatever net proceeds that will be generated by the sale of this publication will be distributed in the following manner:

C. C. K. Bronner & Designated Heirs	18% of Dollars Earned
Publisher	20% of Dollars Earned
The Photographers & Artists	62% of Dollars Earned

<u>Level One Artistic Painters Renditions</u> Page No.

Affonso I	Carl Owens
Akenaten & Nefertiti	? ah/budw
Amina	? ah/budw
Askia Muhammed Toure	Dillon
Behanzin Hossu Bowelle	Thomas Blackshear Ilen
Cleopatra VII	? ah/budw
Hannibal	? ah/budw
Hatshepsut	? ah/budw
Idris Alooma	Charles Lilly
Imhotep	?
Khama	Carl Owens
Makeda	?
Mansa Kankan Musa	Higgins Bond
Menelek II	Don Miller
Moshoeshoe	Jerry Pinkney
Nandi	? ah/budw
Nefertari-Rameses II	Jay Bakari
Nzingha	Dorothy Carter
Osei Tutu	Alfred J. Smith
Osiris & Isis (fill-in)	Braldt Bralds Newsweek 01/11/1988
Piankhi	?
Rameses II	Jay Ba.
Rameses II & Nefertari	? ah/budw

Level One Painters' Renditions (continued) Page No.

Samory Toure	Ezra ? ah/budw
Seti I with Biblical Moses	John L. Johnson
Shaka	Paul Collins
Shamba Bolongongo	Roy E. LaGrone
"Sistership"	Metu-Degg-Khet
	Khamatic Arts
Sunni Ali Ber	L + D Dillon
Taharqa	? ah/budw
Tenkamenin	? ah/budw
Thutmosis	? ah/budw

Anthrophotographer, Wayne Chandler
1. Mentuhotep II
2. Osiris (Asar, Ausar) - auth
3. Isis (Ausette) - auth
4. Narmer - auth
5. Pharaoh – Isis & Nepthys - auth
6. Imhotep – auth
7. Sphinx & Khufu's Pyramid – auth
8. Khafre – auth
9. Sen Wosret – auth
10. Akhenaten (Amenhotep IV)
11. Akhenaten's Daughters
12. Tutankhamen – auth
13. Tutankhamen's gold mask – auth
14. Rameses III's Tomb Depiction

Researcher & Ancient African Artifact Collector, Daud M. Watts
 Hatshepsut's Temple

Level Two Artists, Sketchers and Researchers

Horus (fill-in)	Joan Bacchus
Luqmaan	Yvonne Lawson
Luqmaan	Yvonne Lawson
Narmer's War Boat	George Perkins
Necho II	George Perkins
Piankhi	E. Harper Johnson
Rameses II & Nefertari	Mary E. Greer
Terence	Daud M. Watts

Unknown artists to be included as soon as identities are confirmed

"The Egyptian Race According to the Classical Authors of Antiquity"
Accompanied by Osteological Measurements and Melanin

"The mural in tomb SD 63 (Sequence Date 63) of Hierakonpolis shows the native-born blacks subjugating the foreign intruders into the valley if we accept Petrie's interpretations: 'Below is the black ship at Hierakonpolis belonging to the black men who are shown as conquering the red men'."

Aristotle, Greek Teacher & Scientist – 389-332, wrote
"Those who are too black are cowards, like for instance, the Egyptians and Ethiopians. But those who are excessively white are also cowards...

Lucian, Greek writer's – circa. 125 – 190 C.E.
Dialogue between Lycinus and Timolaus
"Lycinus: This Egyptian boy is not merely black, he has thick lips and his legs are too thin... his hair worn in a plait behind shows that he is not a freeman.
Timolaus: (responding to Lyncinus) But that is a sign of really distinguished birth in Egypt, Lycinus."

Apollodorus, Greek Philosopher – circa. 1st Cen.B.C.E.: "Aegyptos conquered the country of the black-footed ones and called it Egypt after himself."

Aeschylus – circa. 525-456 B.C.E. Greek writer of "The Suppliants"
"Danaos, fleeing with his daughters, the Danaids, and pursued by his brother Aegyptos with his sons, the Aegyptiads, who seek to wed their cousins by force, climbs a hillock, looks out to sea and desribes the Aegyptiads at the oars afar off in these terms: 'I can see the crew with their black limbs and white tunics'."

Diodorus of Sicily – circa: 63-14 B.C.E., "Ethiopia colonized Egypt... The Ethiopians say that the Egyptians are one of their colonies, which was led into Egypt by Osiris."

All from our multilingual, Master Teacher extraordinaire, Dr. Cheikh Anta Diop: Egyptologist, Chemist, Osteologist, Mathematician and prolific Author

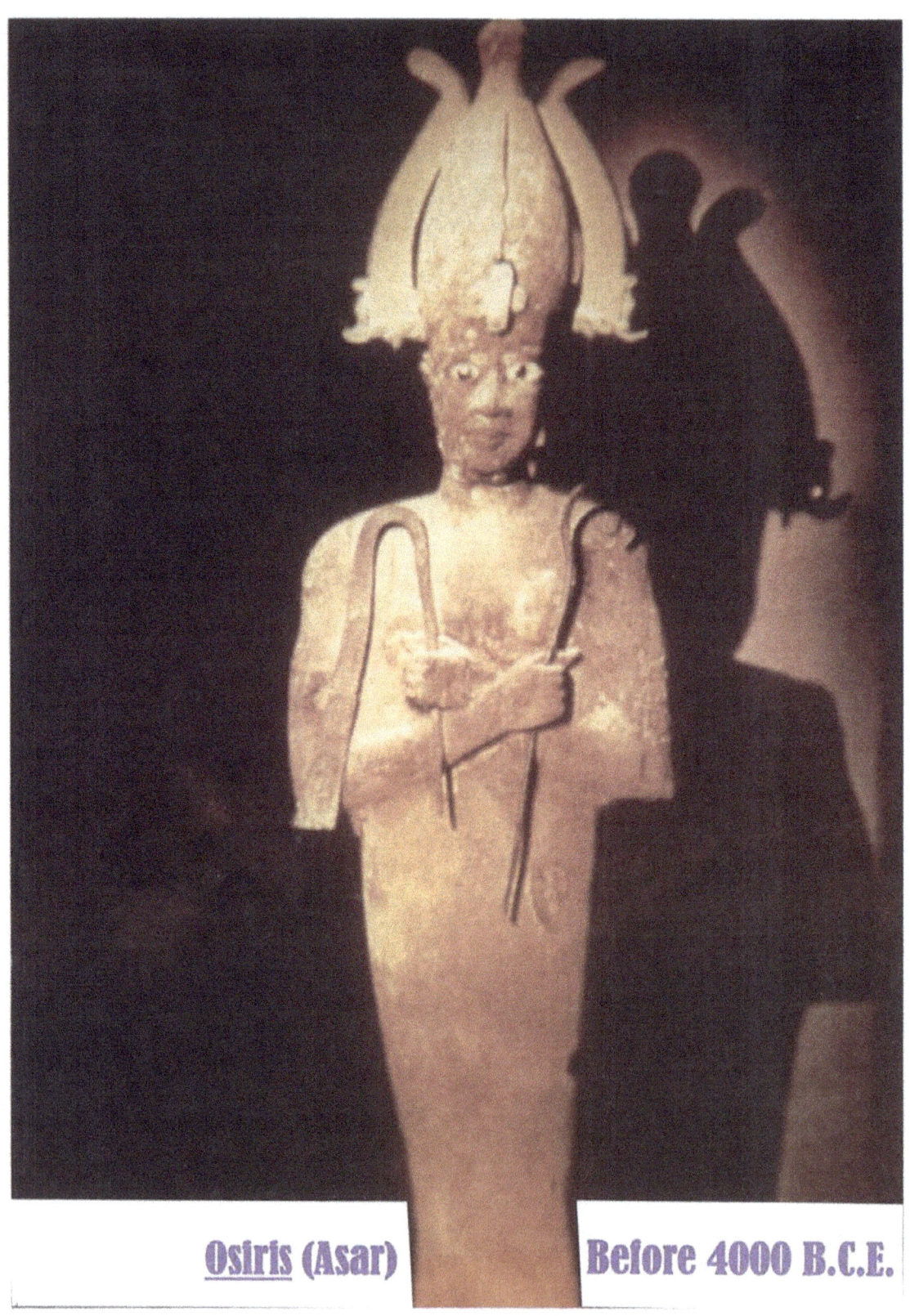

Popular Egyptian God, Asar, "The Black One." The ancient Greeks renamed this god, Osiris. (photograph – courtesy of Wayne Chandler)

E. A. Wallis Budge - **ibid**.

Yosef A. A. ben-Jochannan - No. 1: **ibid**.

From **The Egyptian Book of the Dead (The Book of Coming Forth, From Darkness Into Light)** and its "Papyrus of Ani", a document which pre-dates the Holy Bible's Old Testament by thousands of years, comes the ideas for the Adam and Eve story. The contents of this book, which is reported to be between 6,500 to 7,500 years old, describes the creation of the world as follows:

> "In the primeval matter, or water, lived the God Nu, and when he rose for the first time, in the form of the sun, he created the world."

Then Nu said,
> "I united myself to my shadow, and I sent forth Shu and Tefnut out of myself; thus from being one God I became three, and Shu and Tefnut gave birth to Nut and Seb, and Nut gave birth to Osiris, Horus-Khent-an-maa, Sut, Isis, and Nephthys, at one birth, one after the other, and their children multi-ply upon this earth."

All Egyptian Gods were portrayed in sculpture and paintings as black. The *earliest report in history which placed a God on a Throne dealt with the throne of Asar: The Black One.* He is the one the Greeks re-named Osiris. Among the world's first Goddesses, Hathor: the Black Woman, might rightfully be considered the oldest. The Pharaonic name for Isis is Auset which literally means "the Black Woman. The Greeks called the son of Asar and Auset, Horus. His Pharaonic name is Heru.

Carl Bronner

Isis (Ausette) Before 4000 B.C.E.

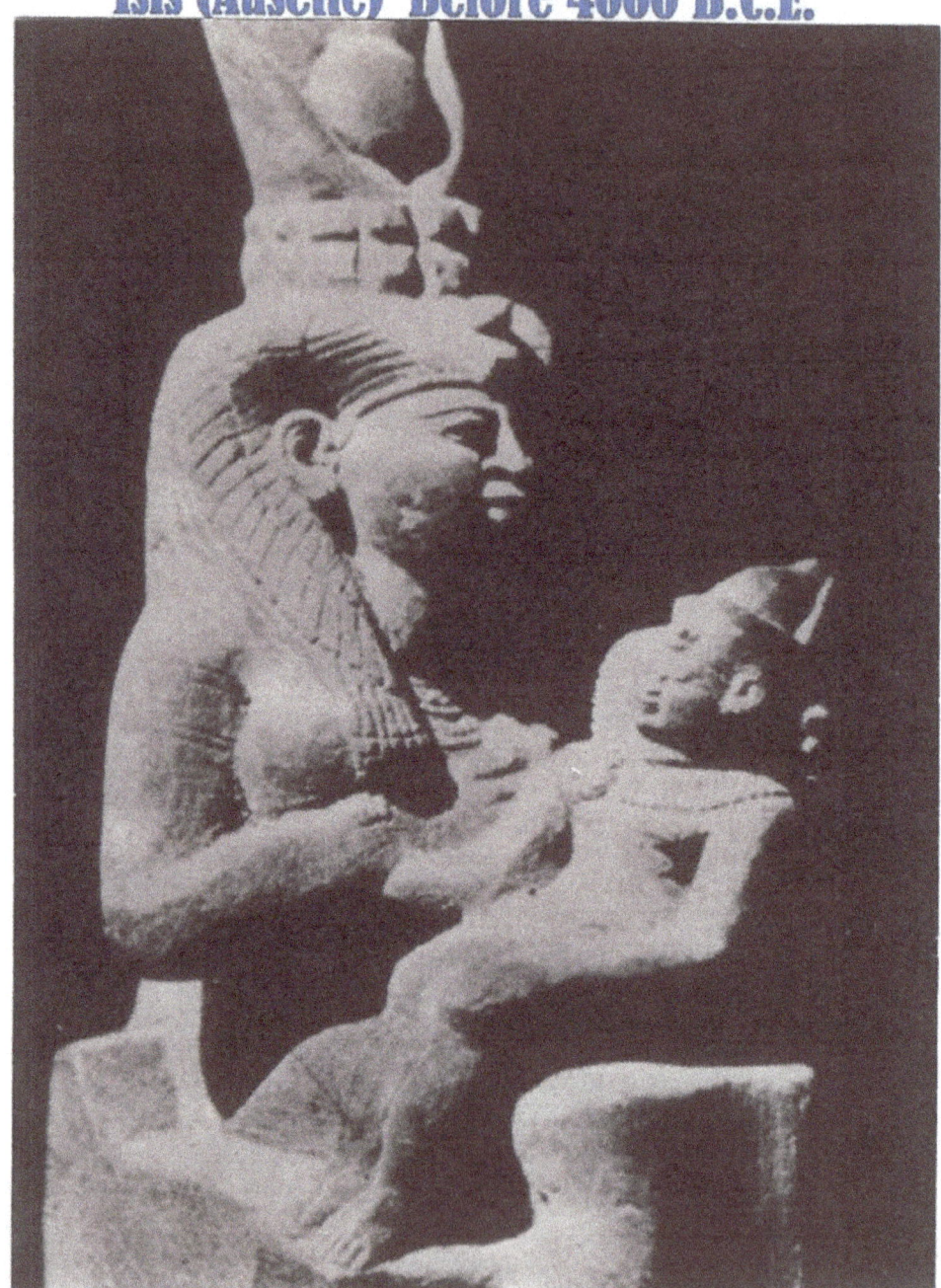

Isis's "…legends …suggest that she was originally an independent deity… In her aspects as the wife of Osiris she is the chief actor, but only after his death: she finds his corpse at Byblos, she finds the fragments of his dismembered body scattered throughout (pre-dynastic) Egypt, she is the chief mourner at the funeral, she unites the fragments of the body and, by her divine power, brings Osiris to life again." *Encyclopaedia Britannica*, Vol. 12, 1972

Isis and the divinity of Mary, Mother of Jesus

As a goddess, Isis's popularity ranged from northeast Africa and into eastern and western Europe. The Parisian Temple of Isis was razed for the purpose of erecting the great Cathedral of Notre Dame on that very same location. Consequently, Isis (Ausette) and Horus (Heru), the original "Madonna and Child" were replaced by the new "Madonna and Child: Mary and Child," (baby Jesus). Notre Dame translates into "Our (Divine) Lady."

By the year 381 C.E., the founding bishops of the Roman Catholic Church met again. One of the primary issues they needed to resolve was how to bring Jesus's mother to the forefront in order to reduce and eventUally force everyone within the realm to turn away from Isis and Horus.

For millennia Isis was a supernatural goddess so then they must imbue Mary with divine powers like Isis. You see, the first Council at Nicaea in Constantinople (Turkey) gave Emperor Flavius Valarius Constantius I a unified bible after much wranging between the 220 eastern bishops in attendance. One can only speculate why Constantine I did not extend his invitatiions to the bishops of the western Empire. The major players, all from Alexandria, Egypt, were followers of Bishop Alexander and Bishop Arian. To be resolved was the question: Was Jesus the "son of god," an extraordinary man or both? Then as now, the contest was settled by an elite group of males. By no more than twenty-four (24) votes Bishop Alexander's group prevailed as the minority was bound to accept the outcome: Jesus was both the "son of god" and an extraordinarily unique man; hence, a demigod who resided in heaven with his father. When the group adjourned in 325 C.E., there had been no discussion regarding the human or divine status of Mary. Nevertheless, confusion continued to reign; such as, since Jesus dwells within god and god dwells within Jesus, are they one and the same? In any case, the Alexandrian bishops, the primary redactor and supervisor of the scribes and righthand man of Constantine I, Greek Bishop Eusebius, and the non-Christian, Constantine I himself created the most overriding Christian law: Jesus is the "son of god"! Out of perhaps hundreds or even thousands of scrolls, letters and compositions, they whittled their Bible down to 39 non-descript scrolls into the Old Testament and as for their letters and compositions in the New Testament, they chose 27 more non-descript books.

It was not until the second Nicene Council in 381 C.E. that the bishops took up and deliberated the divine status of Mary. Debate raged for fifty years, when finally in 431 C.E., 150 bishops at the Council of Ephesus confirmed the divinity of Jesus's mother. At the time, both Jesus and Mary had been dead for nearly 400 years and the existing biblical, biographical information on both of them was not even sufficient enough for a researcher to write anything comparable to a paragraph of at least thirty-six lines on 8 ½ x 11" paper.

The evolution of Christianity had begun thousands of years before the terms: "Christians, Christianity and church" were ever uttered, and from some very ancient religions, the scribes and redactors used and adapted myths and tales to fit their own needs. No problem, because not for two millennia would the Word "plagiarism" be invented to scrutinize writers claiming false credits.

Carl Bronner

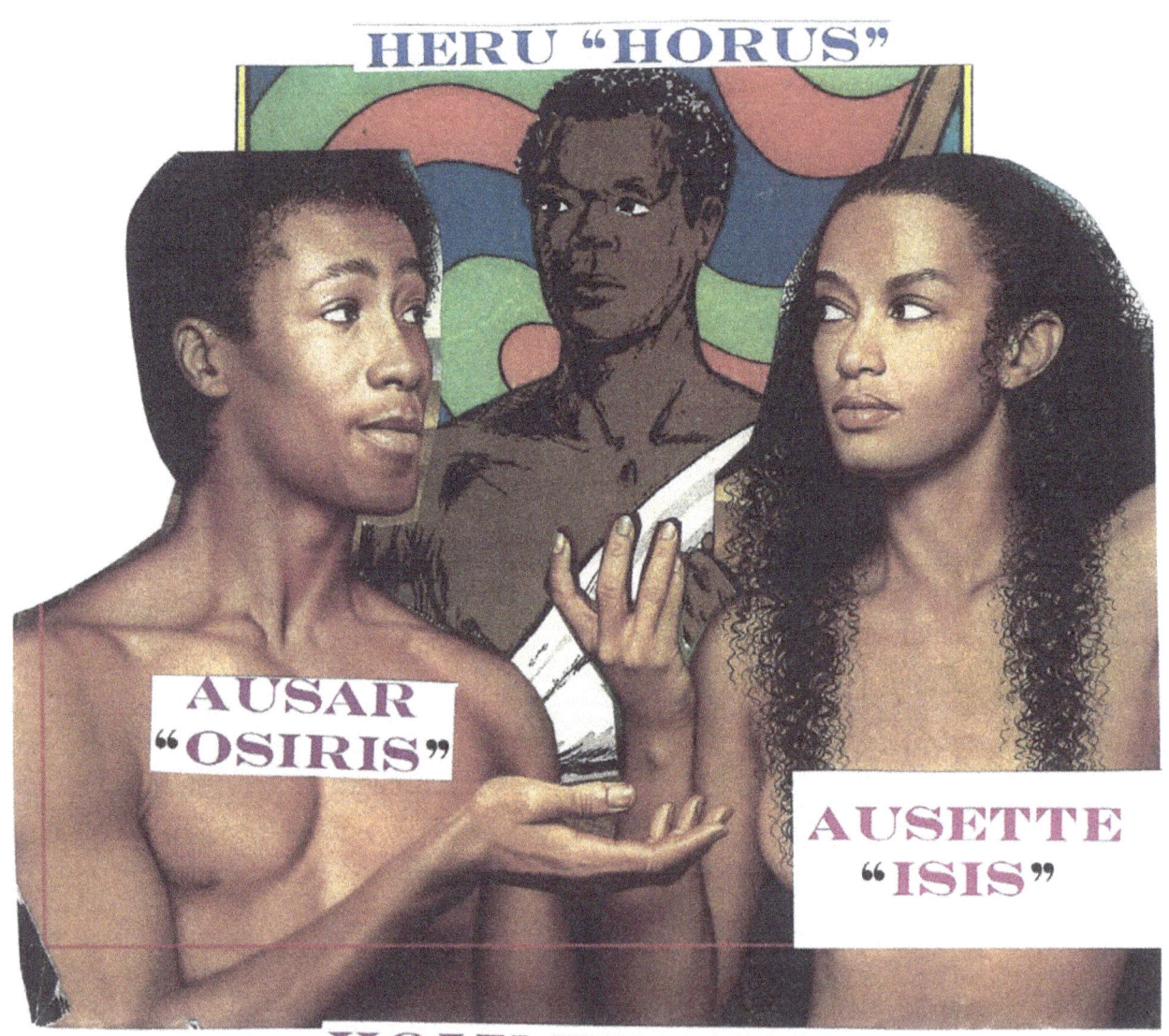

HOLY TRINITY
Bradlt Bralds's "Adam & Eve"; my Osiris & Isis
Joan Bacchus's "Cinquez of Amistad Mutiny"; my Horus

Wayne B. Chandler - **Egypt Revisited** - Ivan Van Sertima, Editor

You will also find that Wayne Chandler gives an interesting account of the Osirian legend:

> "In brief, the legend of Osiris states that he was the God of transformation and immortality, King of the other world (death). In life he was the lord of creation, became king of Egypt and taught the people science, husbandry (the cultivation and production of crops and animals), and established a code of laws...On the 28th year of his reign Set (also known as Typhon or Seth) plotted with Aso, the Queen of Ethiopia, to murder Osiris... When Isis learned of Osiris' death, her lamentations were so terrible that one of the royal children died of fright. Later Osiris was avenged by his son, Horus who fought Seth (Set) several times...
>
> ...Osiris, Isis, and Horus comprise the divine trinity of father, mother, and son... (and) together Isis and Horus form the first and original Black Madonna (and Child)..."
>
> (Parentheses mine)

Carl Bronner

Part One

Includes

"Great Kings of Africa" Series

by
The Budweiser Artists
(Anheuser-Busch, St. Louis, MO)

Carl Bronner

Pharaoh Narmer, Unifer of Upper & Lower Egypt – circa 3000 B.C.E.

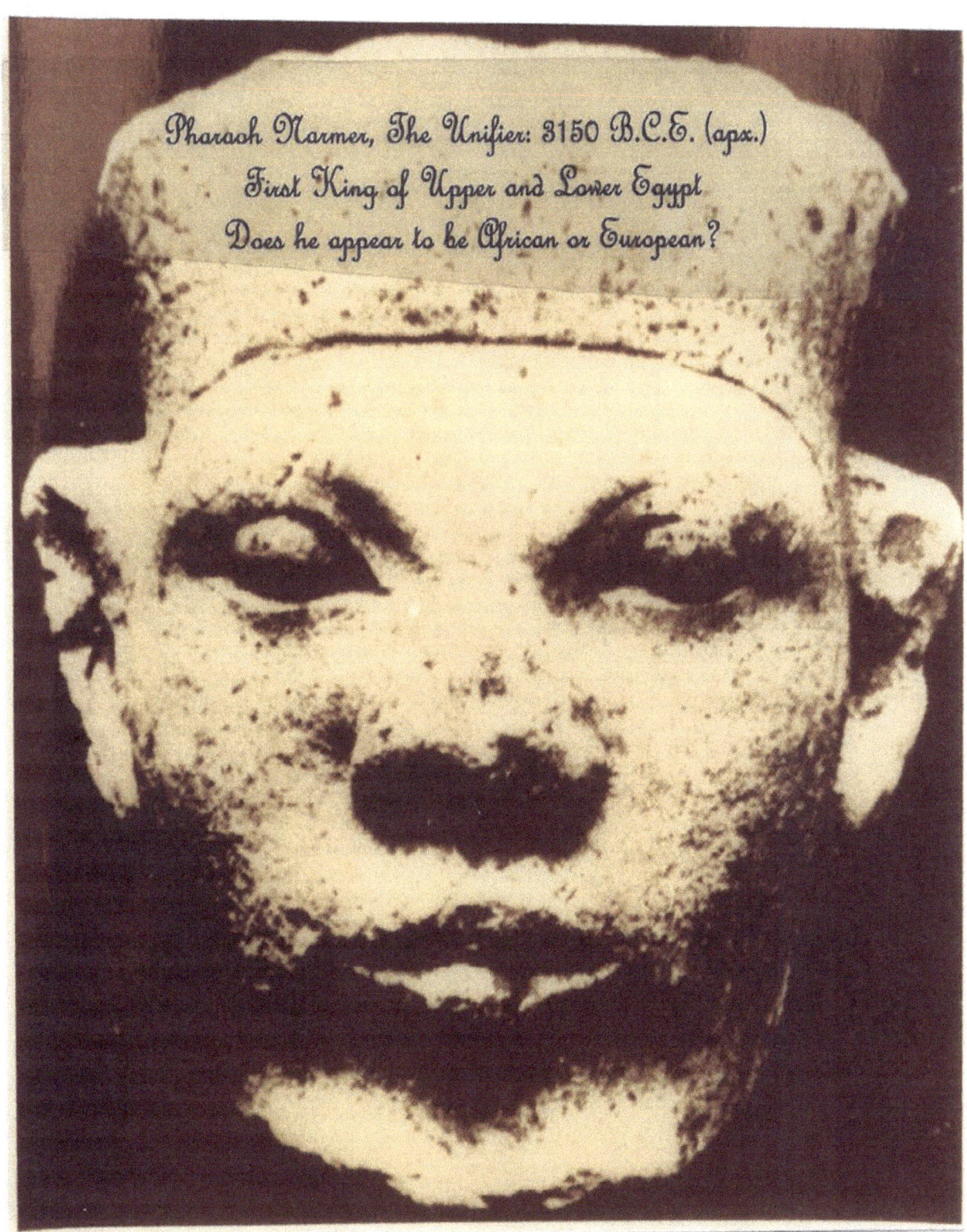

Pharaoh Narmer, The Unifier: 3150 B.C.E. (apx.)
First King of Upper and Lower Egypt
Does he appear to be African or European?

Yosef A. A. ben-Jochannan – No. 1: **ibid.**
No. 2: **ibid.**
Wayne B. Chandler – **ibid.**

Narmer-Menes: The first Pharaoh of Unified Kemet (Egypt)
c. 3100 B.C.E. (Approximately 5,100 to 5,500 years ago)

In the ancient kingdom of Upper Kemet there was a strong military king whose name was Narmer. As we pointed out earlier, the people described their homeland as "Kemet: the land of the blacks." (Also written as Kamit or Kimit). Before the Greek label of "Egypt" had been affixed to the country, Kemet had been identified in several other terms. To the natives it was also known as Ta-Merry and they were the Romiti (singular - Romitu). They were familiar with the Kimit Sea and the Kimit Desert, and not with the Mediterranean Sea and the Sahara Desert as these places are known today.

Narmer was determined to unite the upper kingdom of Kemet with the lower kingdom. As a point of clarification, the most important part of the Egyptian empire was located in the upper kingdom which was situated from central to southern Egypt, and the lower kingdom made up the northern region of the country. Although the people of the north presented no real threat to Egypt's military, Narmer nevertheless was confronted with the task of controlling and organizing the unruly Euro-Asian (Libyan) tribes there into cooperative communities. These "wild barbarians" as Chandler calls them were more like criminal elements that preyed on the wealthier, established communities of the south. Nevertheless, Narmer's crowning glory was to adorn himself with the double crown of both kingdoms. This colossal event created the world's first nation-state which grew into perhaps the world's longest surviving empire. If we include the originating city-state, Ta-Seti, we can say that this empire lasted for nearly three thousand years.

Under Narmer, Egypt prospered, and the steady educational, economic, political, and social growth of the new empire could only be attributed to his long sixty-two year reign. You will learn from Chandler that Narmer was no ordinary fellow. In the fields of hydrostatics and hydraulic engineering, his genius is easily recognizable. With talents such as these he was able to divert the course of the Nile River into a new channel. He was the first in an extremely long line of kings who came to be known as Pharaohs. Chandler says the title of Pharaoh derives from the Egyptian term "per-'o' which meant the king's palace (or Great House). The Bible's Old Testament gave rise to the term Pharaoh.

Carl Bronner

Artifact used for Scorpion King

R. R. Palmer and Joel Colton – *A History of the Modern World*, Sixth ed.

For additional evidence and support consider the words of Professor R. R. Palmer and Joel Colton which read as follows:

> "Europeans were by no means the pioneers of human civilization. Half of recorded history had passed before anyone in Europe could read or write. The priests of Egypt began to keep written records between 4000 and 3000 B.C., but two thousand years later the poems of Homer were still being circulated in the Greek city-states by word of mouth. Shortly after 3000 B.C., while the pharaohs were building the pyramids, Europeans were laboriously setting up the huge, unwrought stones called megaliths, of which Stonehenge is the best-known example. In a word, until after 2000 B.C., Europe was in the Neolithic or New Stone Age. ...But the Near East -- Egypt, the Euphrates and Tigris valley, the island of Crete, and the shores of the Aegean Sea (which belonged more to Asia than to Europe) -- had reached its Neolithic Age two thousand years before Europe. By about 4000 B.C. the Near East was already moving into the Bronze Age..."

Although they seem to overlook the fact that Egypt is in Africa and not Asia, this is still a most interesting article.

Carl Bronner

Narmer carrying out his mission

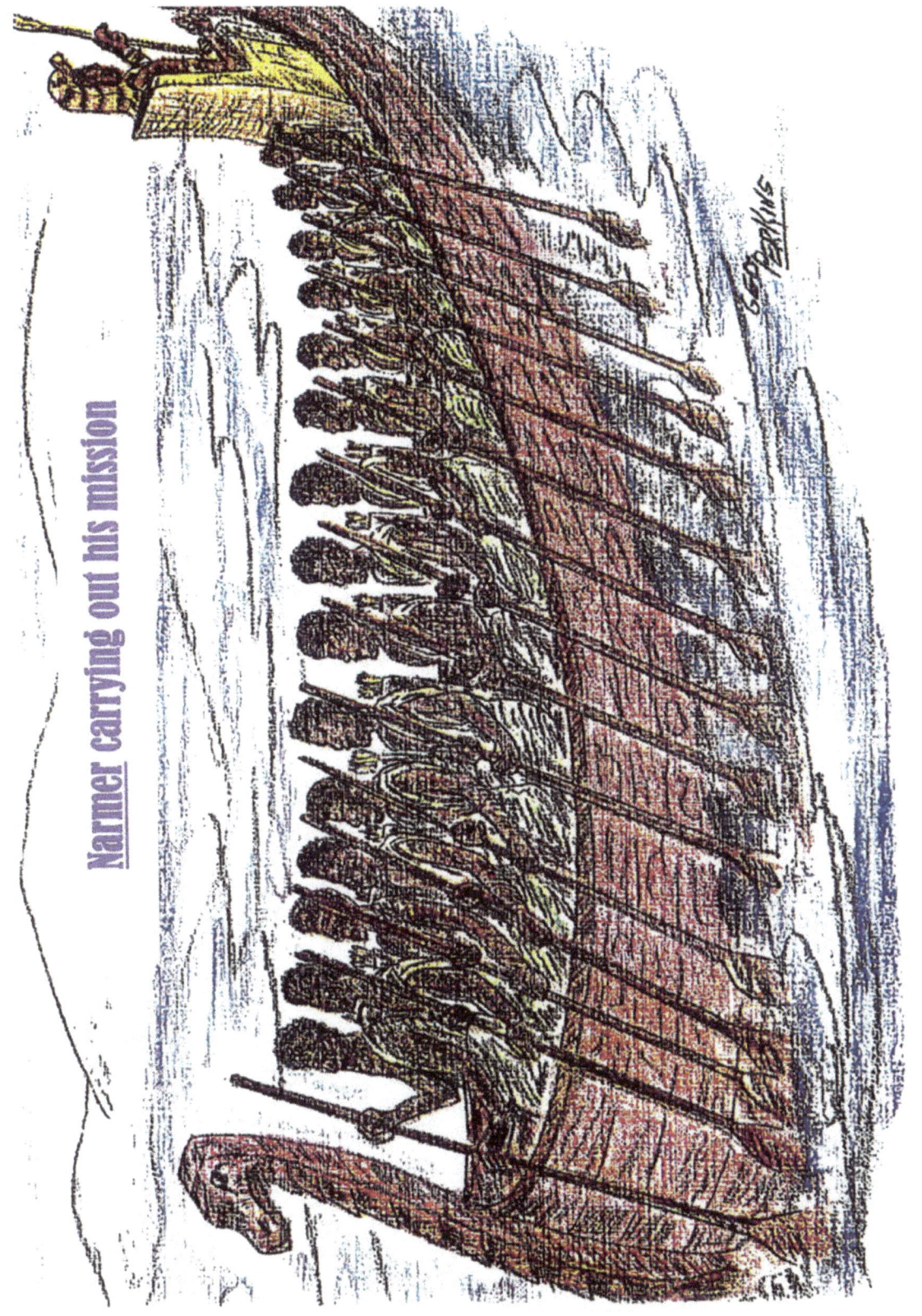

In his royal boat, Pharaoh Narmer traveled to different parts of his kingdom along the great Nile River. (Artist: George Perkins)

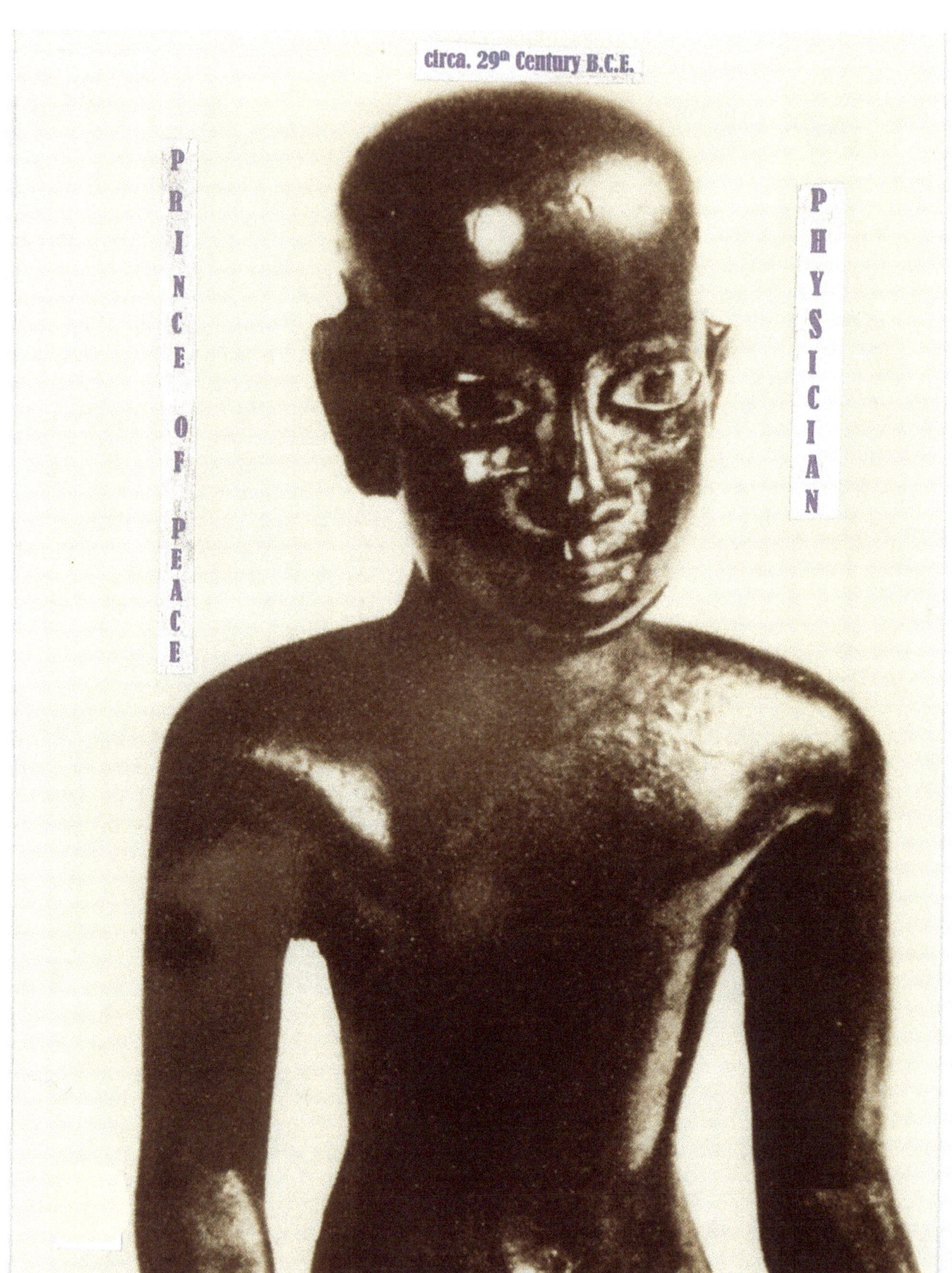

J. A. Rogers - **ibid.**

Sir William Osler, M. D. - **Evolution of Modern Medicine**

Yosef A. A. ben-Jochannan - No. 2: **ibid.**

Editors - "Sir William Osler," Encyclopaedia Britannica, Volume 16 (1972)

Imhotep: The Real Father of Medicine – c. 2980 B.C.E.
(approximately
 five thousand years ago)

 The first figure of a physician to stand out clearly from the mists of antiquity, was not the Greek Hippocrates as many westerners believe. In truth it was the black Egyptian high priest, Imhotep, said Sir William Osler. Dr. Osler was a British physician and professor of medicine at the universities of Mc Gill, Pennsylvania, and Johns Hopkins. His medical textbook, **The Principles and Practice of Medicine** dominated the field from its first edition until after his death. He died in 1919. Both Osler and J. A. Rogers describe Imhotep as the first known universal-man:

> "As a multi-genius, Imhotep was skilled as a scribe, sage, architect, astronomer, collector, priest and scientist. As a philosopher, he is famous for the adage:
> 'Eat, drink, and be merry for tomorrow we die.'
>
> Imhotep treated diseases of the bone, stomach, rectum, bladder, eyes, tuberculosis, gout, appendicitis, and rheumatoid arthritis."

 For three thousand years, the Egyptians, the Greeks, and others worshipped Imhotep as a God. The Greek physicians honored him as the God of Medicine, whom they called "Aesculapius." They, including Hippocrates, swore by the "Oath of Aesculapius" to faithfully treat the sick and injured. "Even early Christianity worshipped him as the Prince of Peace," says J. A. Rogers.

Carl Bronner

Yosef A. A. ben-Jochannan - No. 1: **ibid.**

J. A. Rogers - **ibid.**

Imhotep: He Who Comes in Peace

 J. H. Breasted said that Imhotep was the one remarkable figure of (Pharaoh) Zoser's reign whose reputation was so notable until it ensured that his name would live on forever. Ben-Jochannan informs us that "he was the foremost architect of the known world during his lifetime, and designed the first Step Pyramid and many other modern structures of his era ...He designed his Seven Steps Pyramid at Sakharah (Saqqara) during the year c. 3000 B.C.E. under the reign of Pharaoh Djoser (whom the Greeks renamed 'Zoser')."

> "The great temple of Amen (Karnak) contains two bas-reliefs of him. On the island of Philae there is a temple in his honor. The inscription to him there reads:
> > 'Chancellor of the King of Lower Egypt; Chief under the King of Upper Egypt; Administrator of the Great Mansion; Hereditary Noble, Heliopolitan High Priest, ...Imhotep.' " —J. A. Rogers

> "The stones used in the building of this structure (Imhotep's Seven Step Pyramid) were taken from Quaries which were opened-up earlier by indigenous Africans at the easternmost point of North Alkebu-lan (Africa), the Sinai Peninsula of Ta-Merry during the reign of Pharaoh Semerkhet, and kept in service by following pharaohs from c. 3200 to at least c. 2780 B.C.E." — ben-Jochannan

Carl Bronner

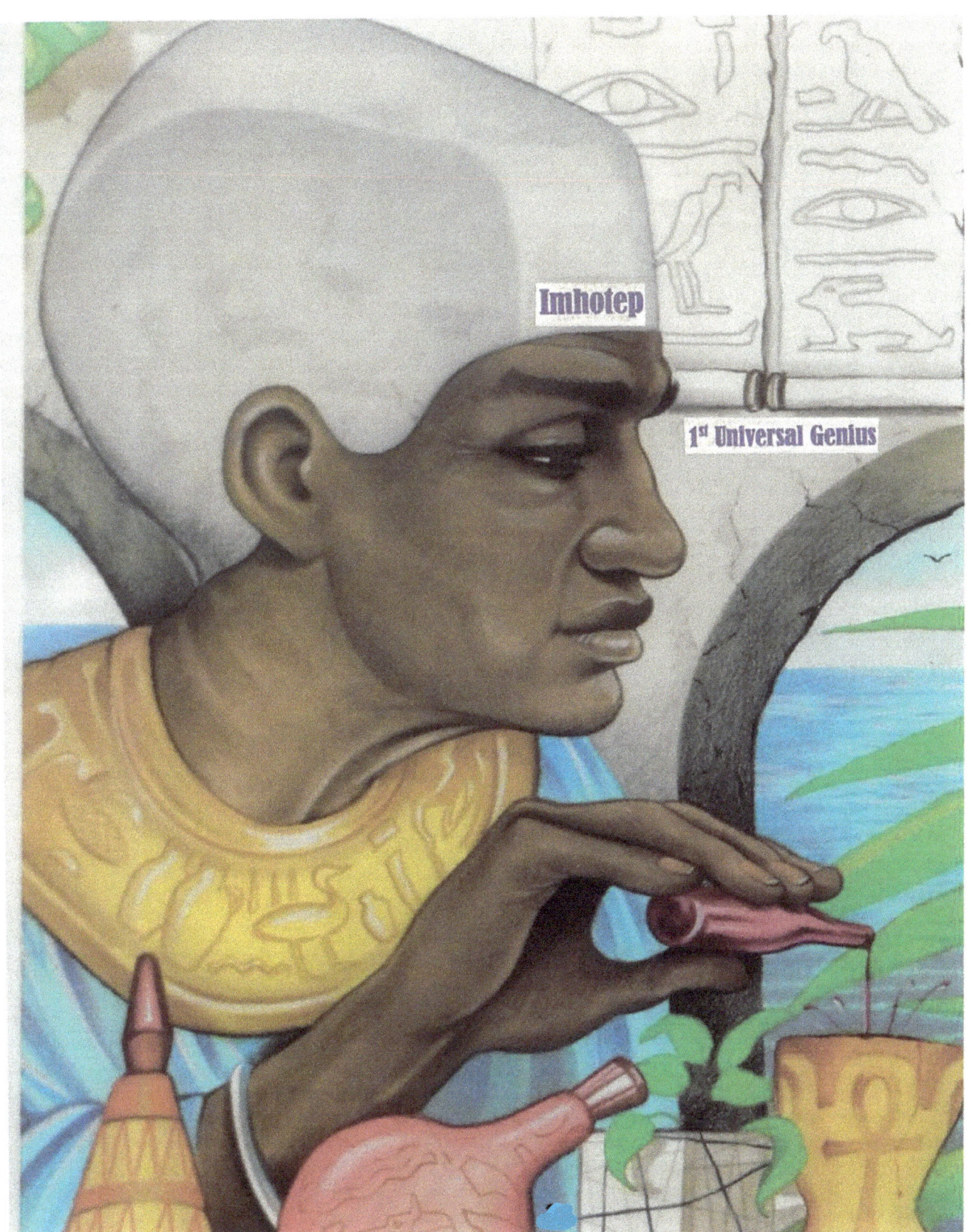

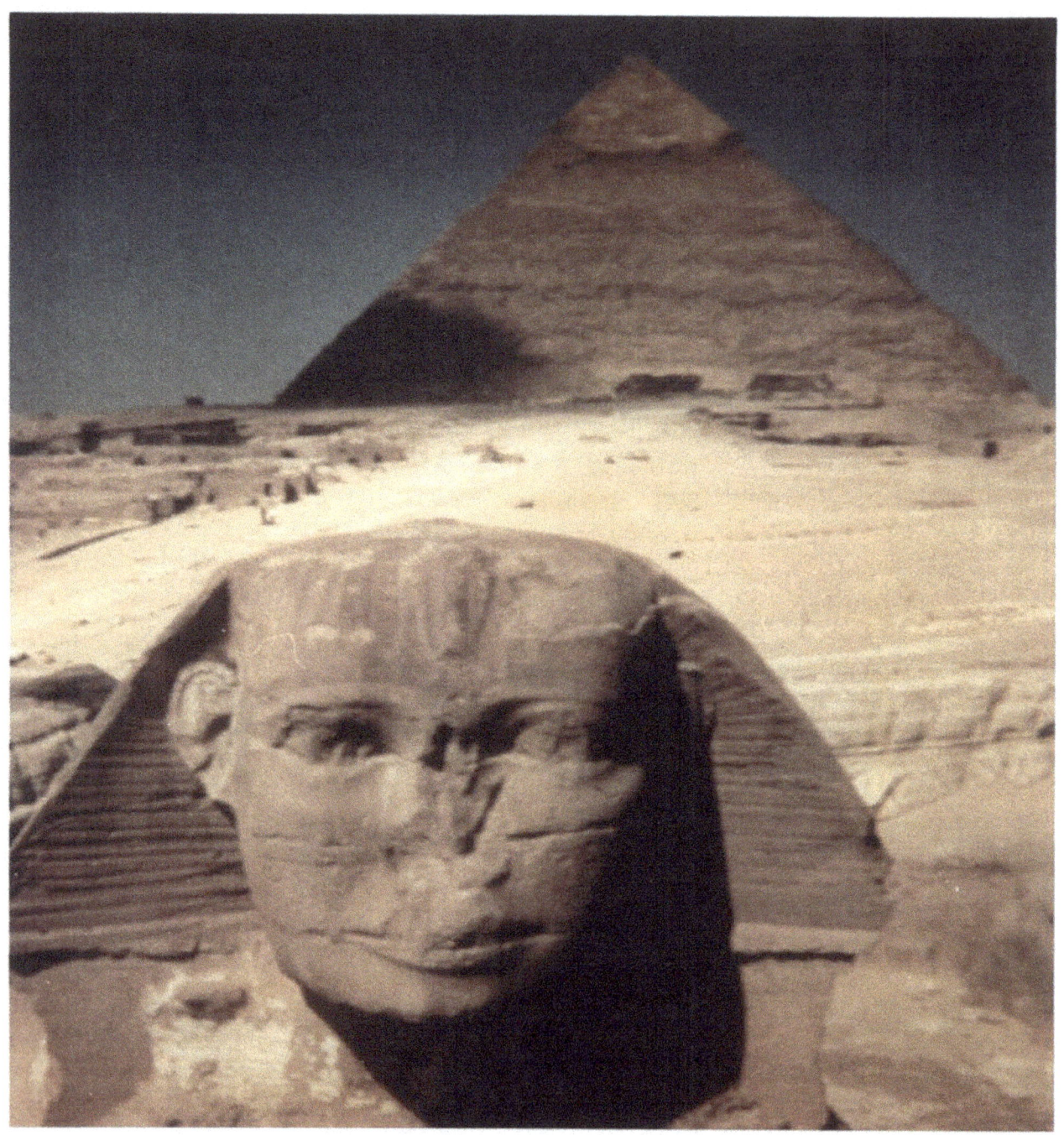

Pharaoh Khufu built the Grand Lodge of Wa-set at Danderah in Egypt around 2685 B.C.E. It is now called the Grand Lodge of Luxor. His pyramid ("a world wonder") stands approximately 482 feet (or 147 meters). The inscription engraved between the paw of the Great Sphinx of Ghizeh (Giza) implies that Pharaoh Khafra (Chephren) had something to do with its construction. (See Khafra, p. 48) (photograph by Wayne Chandler)

Drusilla D. Houston - **Wonderful Ethiopians of the Ancient Cushite Empire**
Yosef A. A. ben-Jochannan - No. 1: *ibid.*
Asa G. Hilliard III - No. 2: *ibid.*

The Great Pyramids – c. 2780 to 2565 B.C.E. (about 4,780 to 4,565 Years Ago)

The other great pyramids were built by three old kingdom Pharaohs who reigned in the Third and Fourth Dynasties. The construction plan for Khufu's ("Cheops") pyramid called for a height of 147 meters or approximately 482 feet. The height of Pharaoh Khafra's ("Chephren") pyramid is 143 meters or approximately 470 feet. Menku-ra-re ("Mycerinus") made his 66.40 meters high or approximately 218 feet.

Drusilla Dunjee Houston

Pharaoh Khufu built the Grand Lodge of Wa-set at Danderah in lower Egypt around 2685 B.C.E. It is now called the Grand Lodge of Luxor. It was also known as the temples of the ancient city of Thebes. This is where the history of Free Masonry began. The Egyptians made it a part of the Secret Societies of the Mystery System.

Only after I had learned just a little bit of what Asa Hilliard knows about the city of Thebes was I able to sort out its roots and location:

> "Wa-set was...referred to in ancient times as Niwt ('The City'). The Hebrews later called it No or No-Amon. Chancellor Williams (1974) called it Nowe or Wose. The Greeks who renamed everything in Kemet, giving them Greek names, including the kings and queens, renamed the city 'Thebai' ...from this we get 'Thebes.' The Arabs ... named it 'L'Ouqsor.' Today it is Europeanized into the name of 'Luxor.'"
> – Hilliard

Carl Bronner

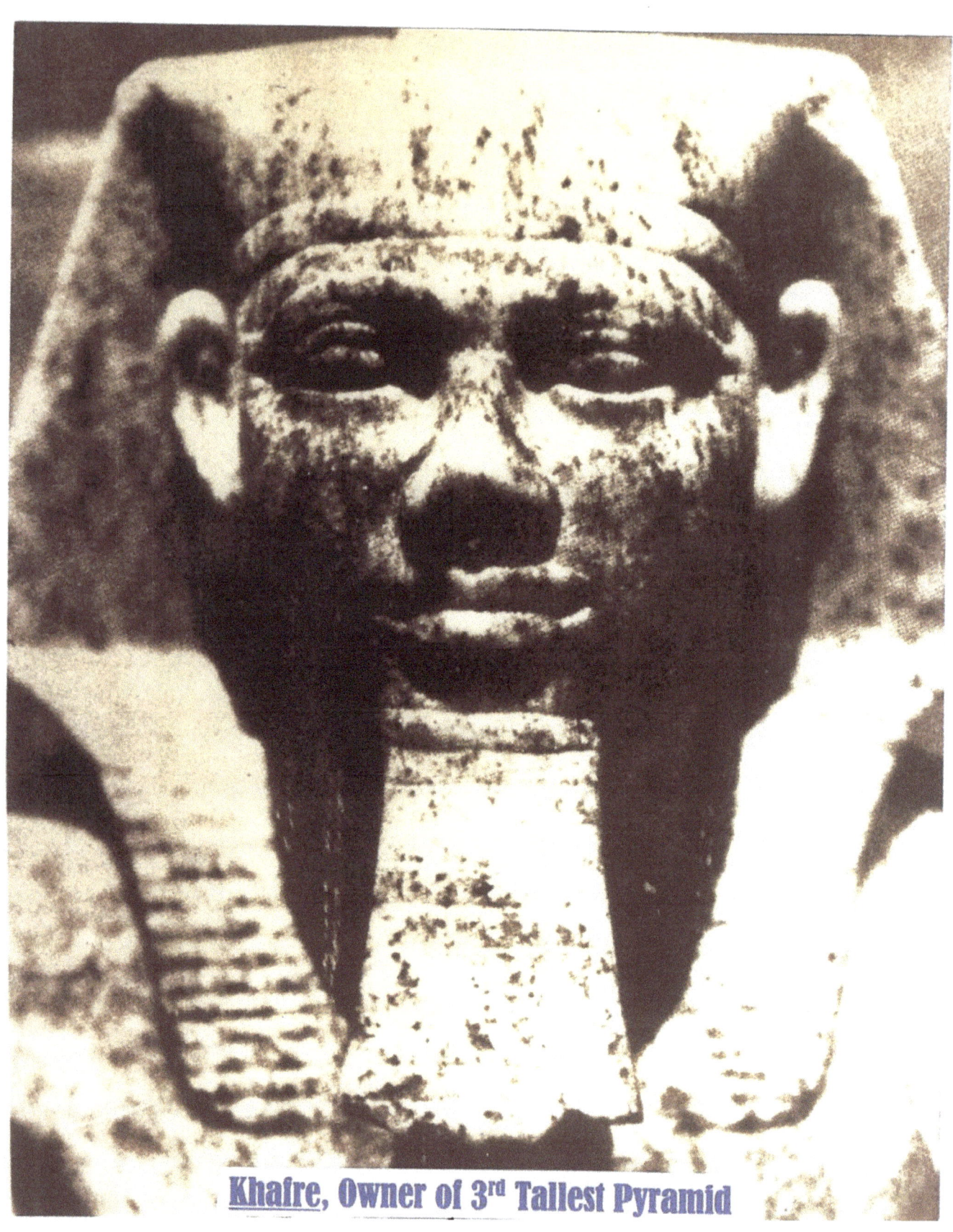
Khafre, Owner of 3rd Tallest Pyramid

Yosef A. A. ben-Jochannan - No. 1: **ibid.**

Asa G. Hilliard III - No. 1: **ibid.**

Wayne B. Chandler - **ibid.**

Russell L. Adams - **Great Negroes: Past and Present**

Pharaoh Khafra (Chephren) - c. 2300 B.C.E. (Approximately 4,300 Years Ago)

Historians cannot confirm which Pharaoh built the Great Sphinx of Ghizeh (Giza) or when it was built. Some say it is older than the pyramids and still others say it was built during Pharaoh's Khafra's reign. The latter drew this conclusion because they thought the Negro facial features of the Sphinx resembled Khafra. However, it appears that an inscription engraved between its paws during the reign of Thutmose IV of the Eighteenth Dynasty might prove to be our best and only clue. This inscription implies that Khafra had something to do with the constsruction of the Sphinx. Also, we may never know the purpose for which Khafra had it constructed. Was it to "protect the records of man's true beginnings and the origins of the earth" as some researchers believe? As "One of the Wonders of the World" it is the largest and oldest of "man and beast" statues.

In 1798, during a French expedition into Egypt, the frenchman, Baron Viviant Denon drew a picture of the Sphinx with all of its African features still intact. After Denon had completed his work, Napoleon Bonaparte's soldiers began blasting their canons at the Sphinx's face. To the bystander it appeared that the Frenchmen were not pleased to find that Negroes were the architects and genuises behind the greatest empire of antiquity. Some historians believe there existed a bitter French feeling for Negroes because of the troubles they were experiencing at the time in Haiti where the slave army of Toussaint L'Ouverture, Jacques Dessalines, and Henri Christophe defeated a well-trained French army to gain their freedom. Needless to say, this was most humiliating.

Carl Bronner

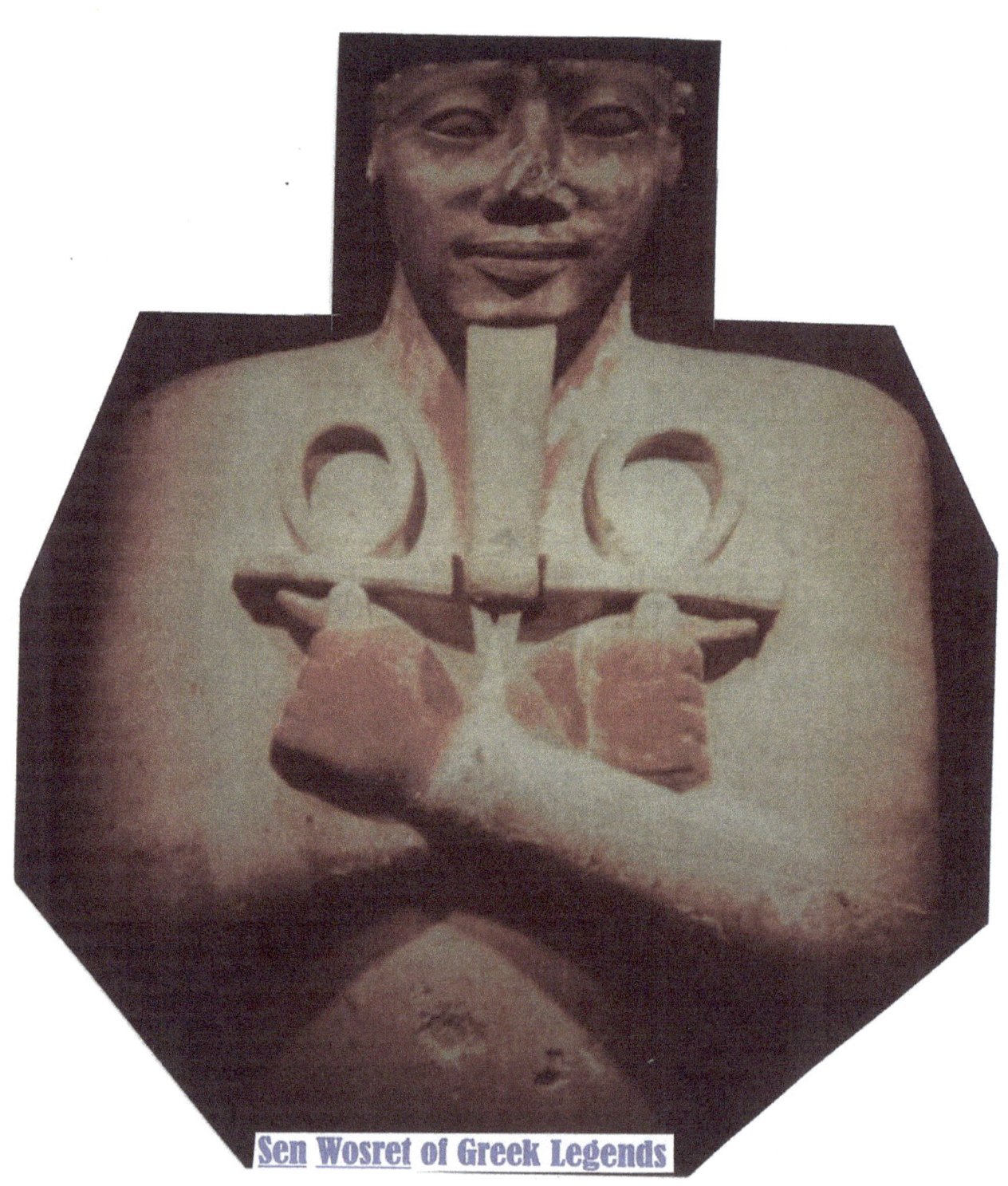
Sen Wosret of Greek Legends

Cheikh Anta Diop - No. 1: **ibid.**

Yosef A. A. ben-Jochannan - No. 2: **ibid.**

Asa G. Hilliard III - No. 2: **ibid.**

Martin Bernal - **ibid.**

Sen Wosret - 1971 to 1927 B.C.E., and **Amen-Em-Het III** - 1843 to 1797 B.C.E.

Sen Wosret I, Amen-Em-Het I, and Amen-Em-Het III can easily be identified as three of the greatest Pharaohs (kings) of the Twelfth Dynasty. According to Hilliard, Ka-Kepra-Re Sen-Wos-ret I "is identified by Bernal (1987) as the African king who is mentioned in the ancient Greek legends, 'King Kecrops.' Kecrops is important in that he was said by the Greeks to be the founder of the Greek city-state, Athens.

By reading ben-Jochannan you will learn that "The beginning of the Middle Kingdom Period was marked by a series of family wars between the minor kings (lords) of Ahnasis and those of Hermonthis (currently Armant). ...So the reunification of Egypt (Kemet, Ta-Merry, etc.) was left up to a "unique and most powerful monarch - 'The Most Glorious Son of the Sun, Pharaoh Amen-em-het I'." Amen-em-het I established the worship of Amen, built many temples in the main region of the Delta, Memphis, Fayum, and in Ta-Hehisi (Nubia or Zeti).

The line of the Grand Pharaohs of the Twelfth Dynasty ended with Amen-em-het III, says ben-Jochannan. This is the same Amen-em-het that "Bernal identifies ... with the legendary Memnon from the Greek Heroic Age."

> "Greeks who came to visit Kemet apparently expected to find evidence of their 'Memnon.' ...they could not find the real **Imnmht** (Memnon) or Amen-em-het III. As a result, they made a mistake and identified as 'Memnon' the two 18th Dynasty colossal statues of Amenhotep III on the bank of the Hapi (Nile) opposite Waset. Amen-em-hat was also the king who built the famous Labyrinth." — Hilliard

Carl Bronnu

The Hyksos pharaoh who reigned over Egypt during the days of the biblical Abraham is depicted as a black in the first portion of a scene reproduced from a priceless, Eleventh Century (A. D.) Byzantine icon. (photograph from Afro-Vision Collection of Daud M. Watts)

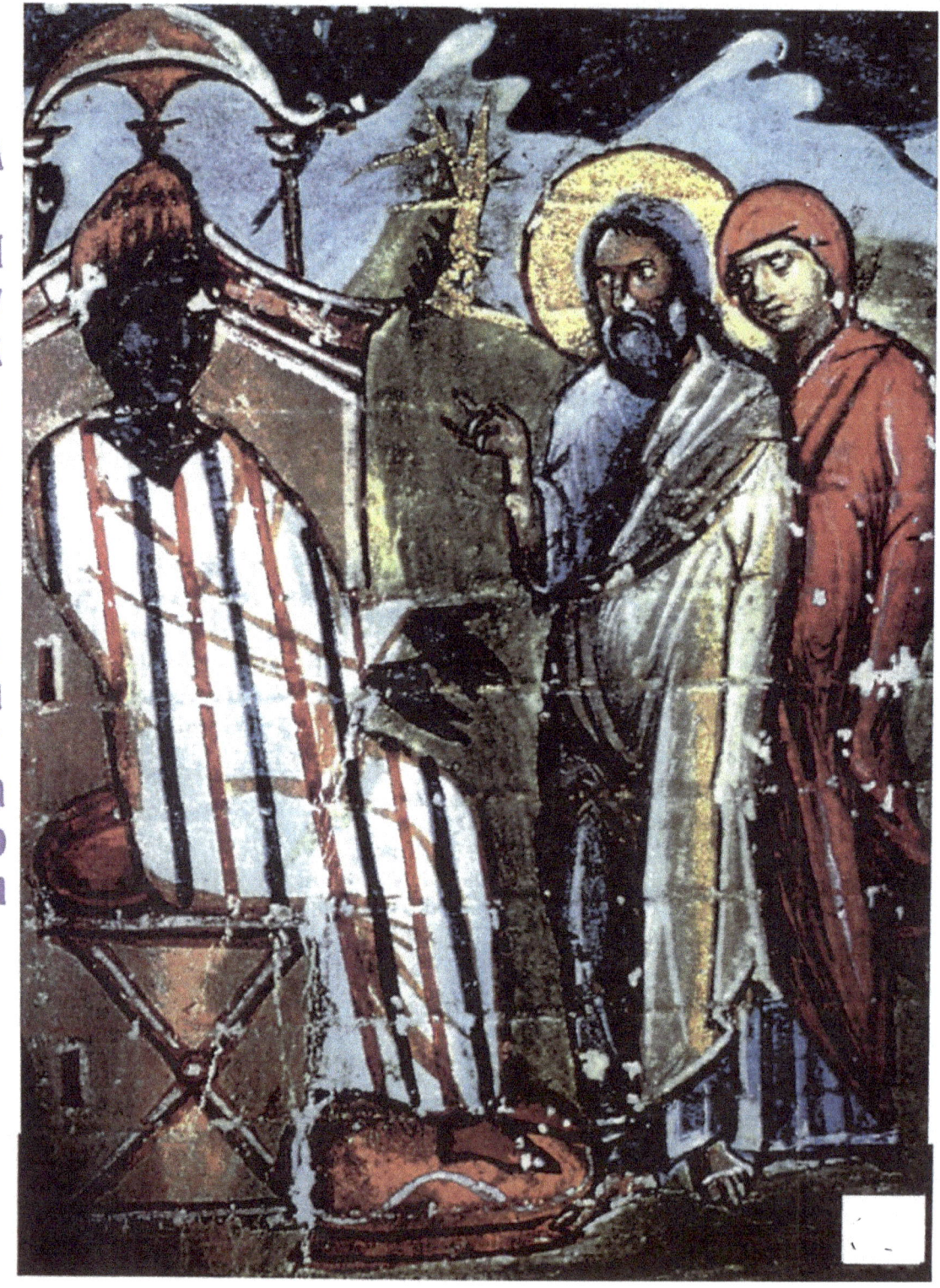

A Hyksos Pharaoh

Abraham & Sarah

Yosef A. A. ben-Jochannan - No. 1: **ibid.**

John L. Johnson - **ibid.**

Cheikh Anta Diop - No. 1: **ibid.**

The Hyksos Period of Non-African Pharaohs – c. 1675 to 1558 B.C.E.

> "Saltis (Salitis) was the first of the Hyksos monarchs to rule over Lower Egypt. He led the first invasion of the first foreigners on African soil – in Kimit (Egypt). ...The (Asian) Hyksos people were ... former captives of an Egyptian army that extended itself to the banks of the Indus River – today's Ganges River (named in honour of the African general of the army of Kush-Ethiopia who invaded and captured much of India.)... – ben-Jochannan

The Hyksos had no impact whatsoever on the culture or infrastructure of Egypt. Not even "the fortifications at Tell el-Yahudiah and Heliopolis" was of their construction as some Europeans claim. It is basically the same kind of African structure that the Hyksos came upon throughout Egypt. So they added nothing new in the way of buildings or systems for doing things. Though they have tried, Euro-centric researchers have been unable to:

> "...cite one aspect of change the Hyksos made to the African's (Egyptian's) religion, burial rites, method of constsruction of their temples and other buildings, agriculture, medical science, astronomy, mathematics, philosophy, or any other discipline in which the indigenous people of Kimit were engaged in..."
> – ben-Jochannan

Carl Bronne

John L. Johnson - **ibid.**

Walter Arthur McCray - **ibid.**

The Biblical Abraham's (c. 1675 B.C.E - approximately 3,675 Years Ago) journey into Egypt occurred during the reign of the Hyksos Pharaohs according to a number of historians. This Abraham (whose name is translated from Avram and Abram) was a Hebrew (or "Haribu") from the city of Ur in the Egyptian colony of Chaldea.

"Abraham was a descendant of the Chaldeans... The earliest settlers of Chaldea were Hamitic (European term for black) in race, language, and *civilization*," says John L. Johnson. Johnson further reports that these people later became a mixed race of Hamites and Semites who possessed such strong African features as deep black skins and woolly hair.

As you study the Eleventh Century Byzantine Icon on the next page, you will notice that these Europeans only portrayed the Egyptian Pharaoh and his assistants as black while Abraham and his wife, Sarah are portrayed as white. This is contrary to the findings of many experienced researchers.

McCray provides another account of Abraham's place of origin.

> "Chaldea was 'a land occupied by Cushites.' And it must be noted that the culture and civilization of this area are traceable back to Nimrod the son of Cush, according to Genesis 10:8-10. Sumer was the home of an indigenous people who called themselves 'the Blackheads.' It has been demonstrated that this indigenous Black people migrated into Sumer from the Nile Valley. Their Blackness and Africanness is attested in archaeological evidence, whose skulls contained the same variations of Ethiopic or Africoid skulls found in Africa's interior and in Egypt."

Carl Bronner

Ahmose-Nefertari

"Ancestress to a prestigious line of Black Theban royalty and nobility"
J. Brunson - (photo. by A. G. Hilliard III)

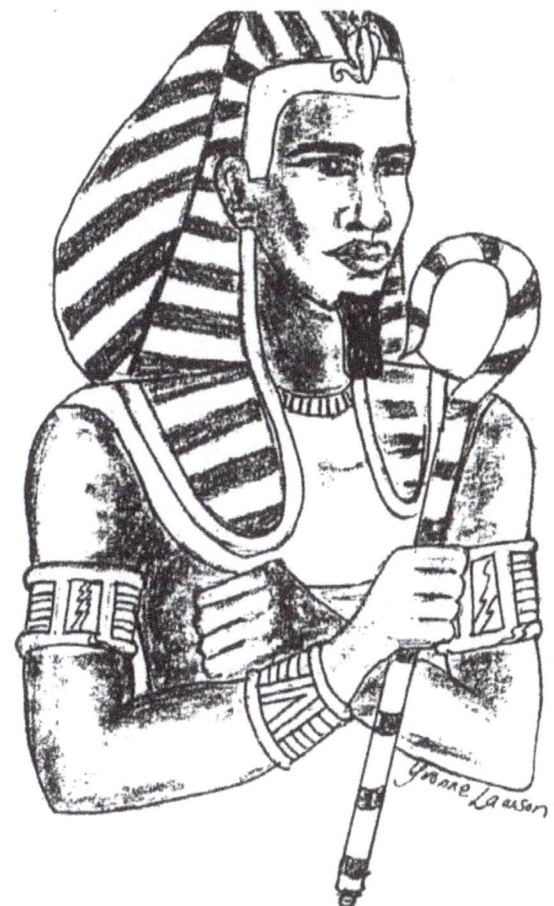

"King
Nebpehtyre Ahmose I
The Liberator"

Runuko Rashidi

(Artist: Yvonne Lawson)

Ahmose I (Amasis I)

Asa G. Hilliard III - No. 2: **ibid.**

John L. Johnson - **ibid.**

Yosef A. A. ben-Jochannan - No. 1: **ibid.**

Ahmose I (Amasis) - c. 1580 to 1558 B.C.E. (Approximately 3,375 Years Ago)

The indigenous Egyptians hated the Hyksos invaders, and became even more resentful toward the immigrant Hebrews because the Hyksos kings granted them more wealth and freedom than they offered the home folk.

These denials and mistreatments of the indigenous population led to the expulsion of the Hyksos Pharaohs by Pharaoh Seqen-En-Re Ta'O and his successor, Ahmose I. The "Wars of Liberation" were started by Seqenenre and completed by Ahmose I. Hence, with the crowning of the Eighteenth Dynasty, African rule was re-established in Egypt. In view of the growing dislike for the Hebrew friends of the Hyksos it can almost be said without fear of reprisal that this very well could have been the beginning of the period of difficult times and slavery for the Semites in Egypt. According to Johnson, "Ahmose I made the lives of the Israelites unpleasant with harsh affliction, in all affairs."

Nevertheless, for twenty-two years, Ahmose I and his beautiful black, Ethiopian Queen, Nefertari, "ruled Egypt (wisely) and stringently." About Nefertari, Hilliard has this to say:

> "The great Queen Nefertari (Nefer-ta-Re) was the sister of King Ah-mes (Ahmose I) and his Great Royal Wife. She also served as co-regent with her son Amen-hotep I, second king of the 18th Dynasty. Both she and her son were later worshipped as God and Goddess. Queen Nefertari, Queen Hat-shep-sut and Queen Tiy were the three most powerful queens of the great 18th Dynasty.

With the rise and crowning of Ahmose I, African rule was re-established in Egypt around 1580 B.C.E. Co-founder of the Eighteenth Dynasty was the Queen-Mother, Ahmose Nefertari. "William Osburn (1854) described her as a queen 'Ethiop (Kush) in complexion and descent. Karl Lepsius (1810-1884) called her the 'Black Queen'..." James Brunson - "Ethnic or Symbolic: Blackness and Human Images in Ancient Egyptian Art"

Carl Bronner

Nefertari-Ahmosis (Ahmose)

For 22 years, Ahmose I and his beautiful Ethiopian Queen, Nefertari ruled Egypt. The records reveal that they ruled Egypt wisely and with a firm-hand. Black like this painting are all of the biographies and images of Nefertari-Ahmose.

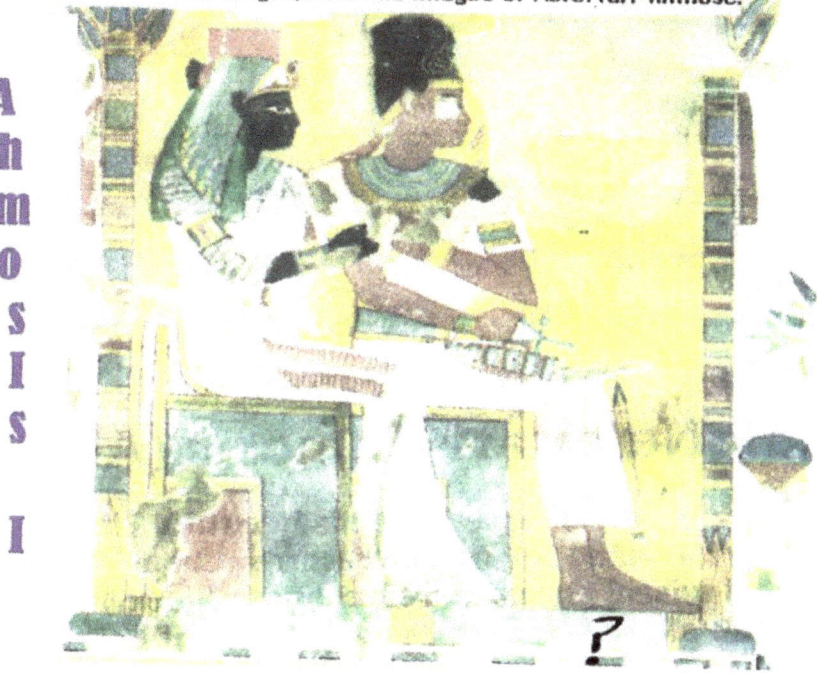

Ahmosis I

Ahmose I – AHMOSE – End of Hyksos: 1567 b.c.e.

About 150 years after Abraham's time, two powerful African kings warred to rid Egypt of the Pharaohs that had come from Black Asia. Sequenenre Tao started the wars against the Hyksos and Ahmose I victoriously ended them. Ahmose I became the first Pharaoh of the glorious 18th Dynasty. The indigenous or native Egyptians had come to hate both Hyksos people and their allies, the Hebrews. For they both were seen as invaders who had claimed the wealth and glory of Egypt. After vanquishing the dreaded Hyksos, Ahmose decided to strip the Hebrews of their wealth and proceeded to enslave them. This enslavement would last down to the days of Moses.

Carl Bromner

Queen (Pharaoh) Hatshepsut

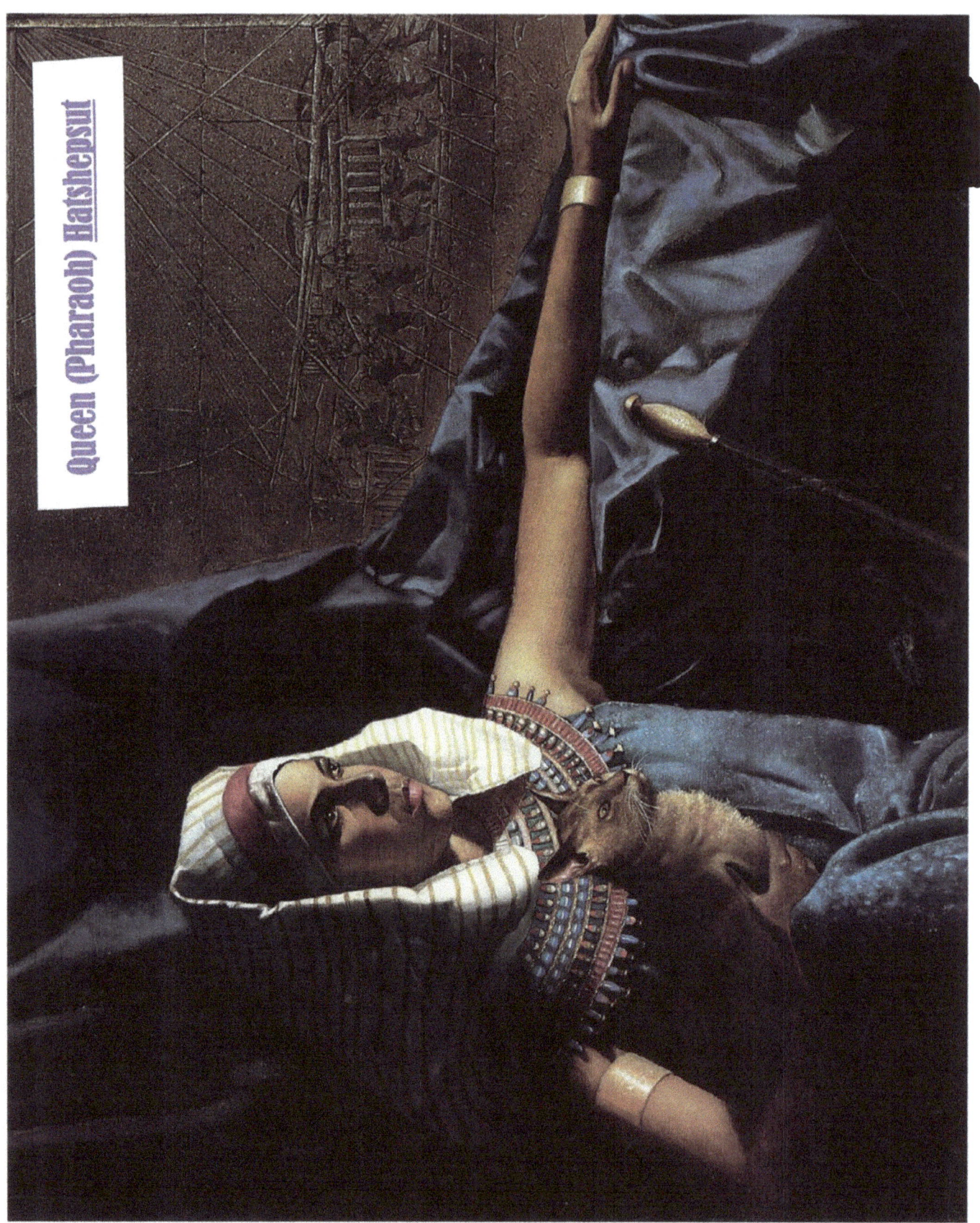

J. A. Rogers - **ibid.**

Asa G. Hilliard III - No 1: **ibid.**
 No. 2: **ibid.**

Maat-Ka-Re Hat-Shep-Sut – c. 1515 to 1484 B.C.E. (Approximately 3,500 Years Ago)

For many researchers, Queen Hatshepsut stands out from history as the ablest and the greatest of the female rulers in ancient times. This does not mean to say that she was less capable than her male counterparts. For she was as equal to the task of ruling an empire as they, and even surpassed many of them in both deeds and endurance. She was the Queen who ruled as a Pharaoh (king) for thirty-one years.

There were at least ten powerful queens in ancient Egypt (Kemet). They included Neith-hotep and Mer-Neith of the First Dynasty, Anchnesmerit and Nitocris of the Sixth Dynasty, Sobeknofru (Skemiophris) of the Twelfth Dynasty, Ahotep of the Seventeenth Dynasty, Ahmose-Nefertari, Tiye, Hatshepsut, and Mutemivia all of the Eighteenth Dynasty, and Ta-wsret of the Nineteenth Dynasty. However, only Mer-Neith, Nitocris, Sobeknofru, and Hatshepsut ruled as Queen-Pharaoh; that is, they had no male equal and each was a supreme monarch.

> "She (Hatshepsut) had the most magnificent funerary in the Valley of the Kings. A record of the expedition that she sent to Punt (Somaliland) is preserved in her temple... To Hat-shep-sut, the south was the Holy Land, Punt in particular..." – Hilliard

Carl Bronner

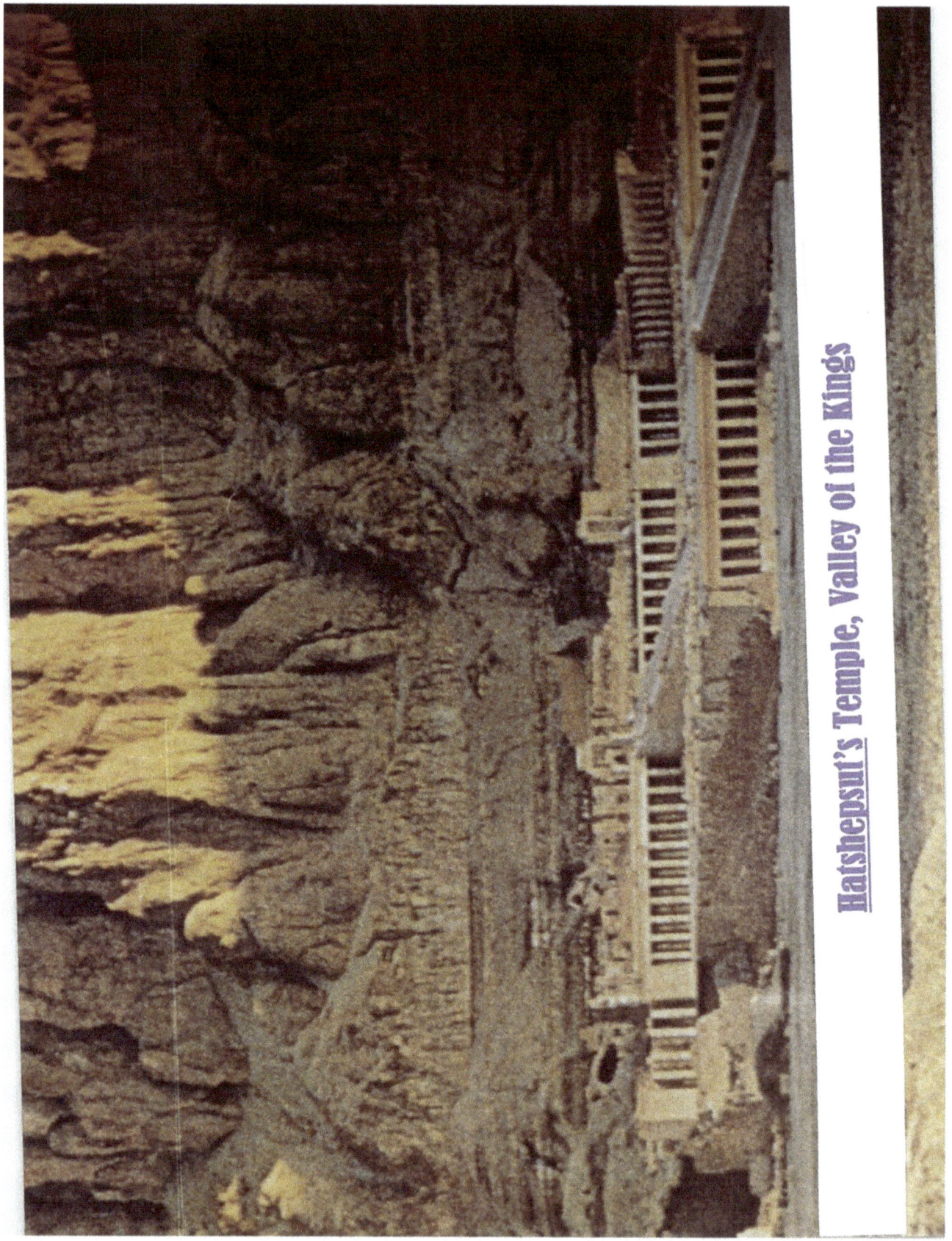
Hatshepsut's Temple, Valley of the Kings

J. A. Rogers - **ibid.**

Asa G. Hilliard III - No. 2; **ibid.**

Hat-Shep-Sut ("Chief Spouse of Amen")

Hatshepsut was the granddaughter of Nefertari-Ahmose (Aahmes) "The Beautiful," and the daughter of Thutmose I and Queen Ah-mes. However, to convince her challengers of her "divine right" to the throne of Upper and Lower Egypt, she proclaimed herself to be the daughter of "...the great God Amen himself. And as if this was not enough, she adopted the male equivalent of her previous name, "Hatshepsitu," and began to dress herself in the royal garments of a king. Says Rogers, "...her sculptured portraits showed her with a man's chest and beard. This, she must have thought would ensure her of gaining the worship, devotion, and respect enjoyed by her male predecessors. Finally, she issued this proclamation:

> "I, Queen Hatshepsut, rule over this land
> like the Son of Isis (Isis' son: Horus = Heru)
> I am mighty like the Son of Nu (Amen?)
> I shall be forever like the stars which
> changeth not..."

To ensure her place in the annals of history, Hatshepsut commanded her Ethiopian architect, Senmut, to build for her "a temple in the Valley of the Kings, the likes of which the world had never seen." She crowned this grand undertaking by ordering two obelisks (tenkenus) taller and more brilliantly decorated than any of those existing at that time. Accordingly, Senmut complied by having the tops of the obelisks encased in electrum, a metal more costly and luminous than gold. These obelisks were Hatshepsut's gifts to the Temple of Amen-Ra, but their glittering peaks and brilliancy made the temple less noticeable. She had them engraved with the following words:

> "O ye people, who shall see my monument in the ages
> to come, beware of saying, 'I know not, I know not why
> this was made and a mountain fashioned entirely from
> gold.' These two obelisks, My Majesty hath wrought
> that MY name may abide, enduring in this temple for
> ever and ever."
> - Rogers

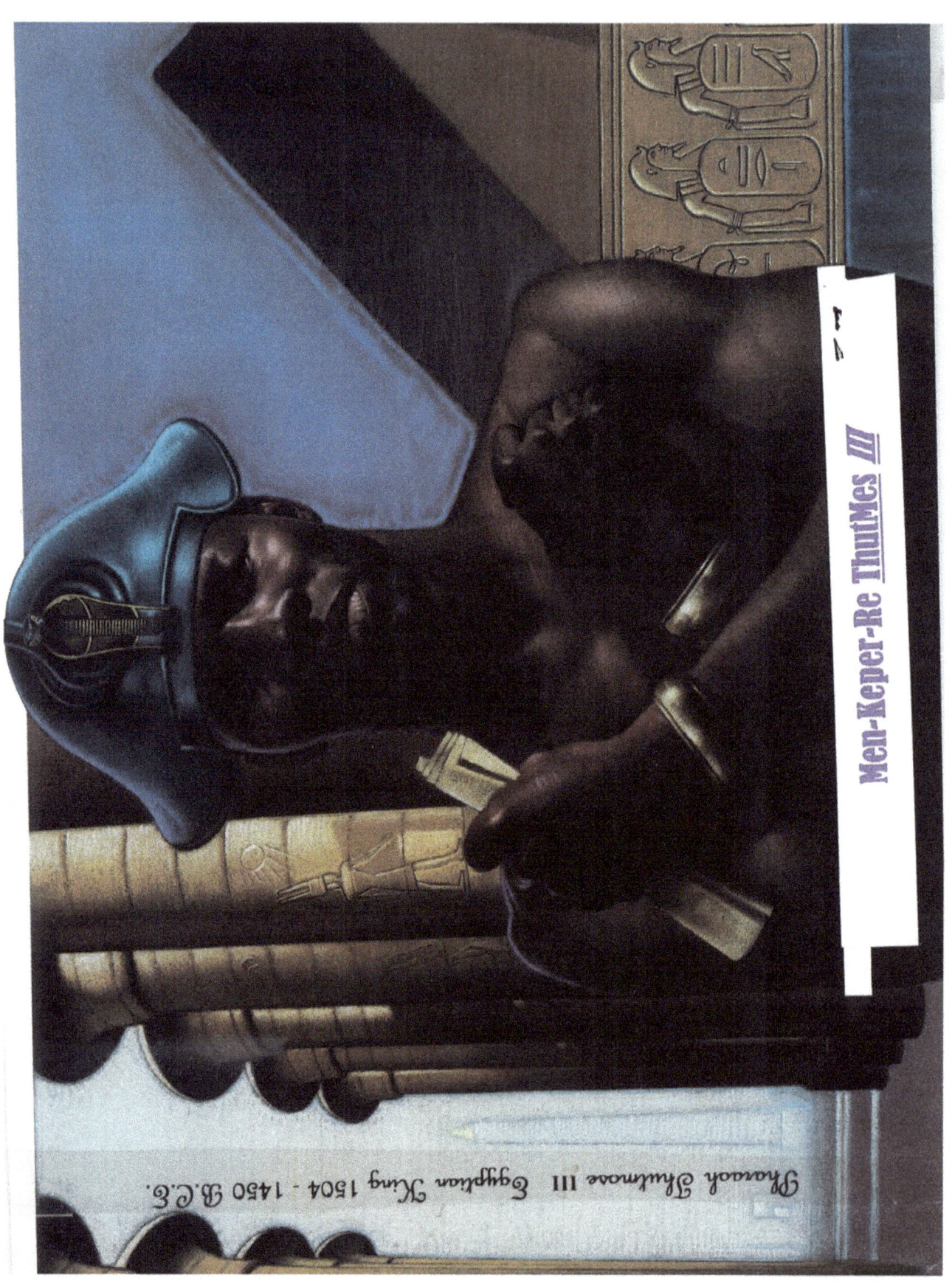

Pharaoh Thutmose III Egyptian King 1504 - 1450 B.C.E.

Men-Keper-Re ThutMes III

J. A. Rogers - **ibid.**

Asa G. Hilliard III - No. 2: **ibid.**

Yosef A. A. ben-Jochannan - No. 2: **ibid.**

Men-Keper-Re Thut-Mes III - c. 1504 tyo 1450 B.C.E. (Approximately 3,500 Years Ago) (Thutmose; Thutmosis)

Upon the death of Hatshepsut, Thutmose III, her half-brother or her nephew (as determined by different historians), ascended the throne of Kemet (Egypt). Rogers, for one, concluded that he was fathered by the same Pharaoh who fathered, Hatshepsut, Thutmose I. However, as Hatshepsut's mother was Queen Ah-mes, the Royal Wife, Thutmose III's mother was a woman named Isis (or Asnut) who could have been either a lesser wife of Thutmose III or a slave. Hilliard, on the other hand, concludes that he was Hatshepsut's nephew.

Nevertheless, Thutmose III's potential was apparently unrecognized until he began to make his reign more dazzling than Hatshepsut's. Without a doubt he became "...the mightiest conqueror and administrator of far antiquity." (-Rogers) He "...controlled the known world, at a time when Asia had yet to develop its great civilizations." (-Hilliard) Thutmose III continued the conquests begun by his mighty ancestor, Ahmose I (Aahmes I) who had ousted the Hyksos (or shepherd kings). Leading the way at the head of his army, he was "...mighty like a flame of fire." It was he who built the world's first, real empire. In light of this, he must be viewed as the world's first real hero and the first character possessed of universal greatness.

J. A. Rogers - *ibid.*

Asa G. Hilliard III - No. 1: *ibid.*

Yosef A. A. ben-Jochannan - No. 2: *ibid.*

Walter Arthur McCray - *ibid.*

John L. Johnson - *ibid.*

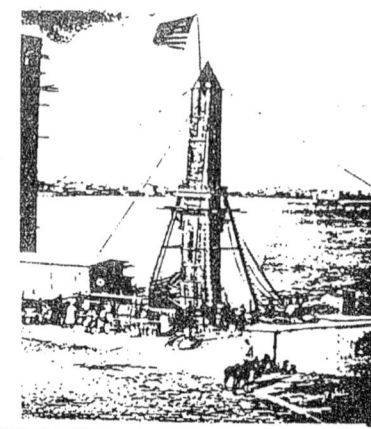

Raising one of Thutmes III's Tenkenus in New York.

ben-Jochannan No. 2: *ibid.*

OBELISK OF PHARAOH THUTMOSE III, SUCCESSOR OF QUEEN HAT-SHEP-SUT
(The so-called "Cleopatra's Needle" in Central Park, New York City, N.Y.)

Thutmose III ("The Mightiest Conqueror... of Far Antiquity")

Thutmose III's character stands forth from history with more color and individuality than that of any other Pharaoh of early Egypt with the exception perhaps of Akhenaton (Ikhnaton). (-Rogers) He is remembered as much for his monuments and administrative accomplishments as he is for his conquests. So it is very racist of western society, and "...ironic," says Hilliard "that two of the principal ones, his giant tenkenu (obelisks) today are called by names that ignore him ... King Thut-mes III, The Great, rules in spirit in four major cities of the world, Constantinople, Rome, London and New York," because these are the four modern cities where his obelisks still stand.

More than 3,000 years after the passing of the Golden Eighteenth Pharaonic Dynasty, many cities (worldwide) continue to adorn their landscapes with replicas of tenkenu (obelisk) monuments. This basic architectural design is perhaps one of the world's most recognized pinnacles of honor.

"The rule of Thut-mes III reached all the way to the Aegean, to mainland Greece, and to the Euphrates River." (-Hilliard) The map on the next page should give you a good idea of how extensive this empire was. It stretched from ancient Nubia (Ethiopia) in the south to the Kemet Sea (Ethiopian Sea or Mediterranean Sea) in the north and then throughout southwest Asia (including a part of Arabia--known in those days as Kush-- Palestine, Phoenicia, Syria, Asia Minor--Turkey--, and Greece). From east to west on the African continent it stretched from the Red Sea and the Sinai Peninsula to Numidia (Libya) and the Kemet Desert (Sahara Desert).

Carl Bronner

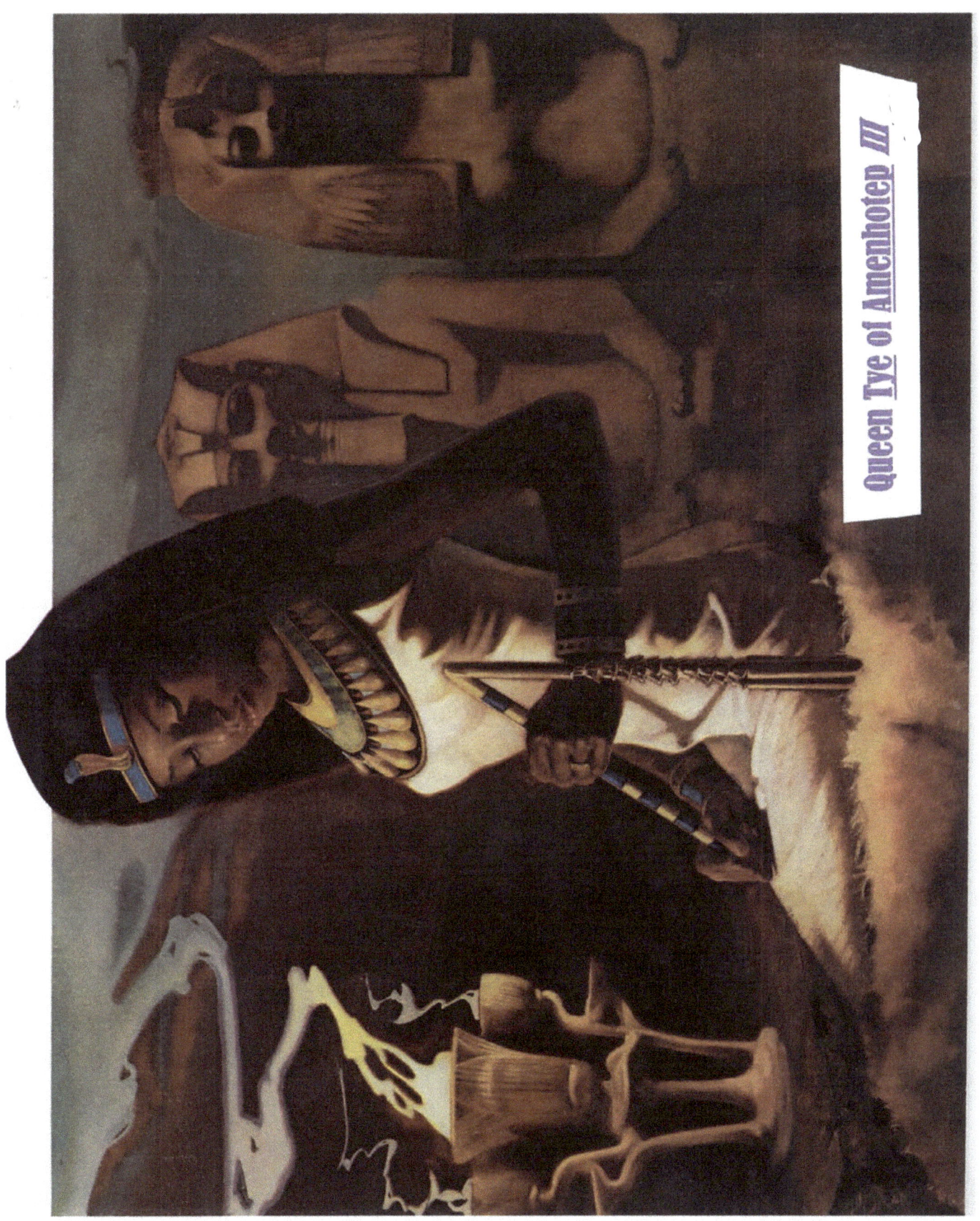

Queen Tye of Amenhotep III

Virginia Spottswood Simon – **Black Women in Antiquity** – Editor: Ivan Van Sertima

Asa G. Hilliard III – No. 2: **ibid**

Legrand H. Clegg II – **Egypt Revisited** – Editor: Ivan Van Sertima

Queen Tiy ("The Great Royal Wife") – c. 1415 to 1340 B.C.E.

Queen Tiye (Tiy) was the mother of one of the most remarkable Pharaohs, Aknenaton (Akh-En-Aten; Ikhnaton). Her two other sons, Tutankhamen (King Tut) and King Smenkhare, whom she conceived during middle-age, were much younger than Aknenaton. Her husband, Pharaoh Amenhotep III (c.1417 to 1379 B.C.E.) was called "...the magnificent."

From Legrand H. Clegg II, we learn:

> "A number of scholars have described Amenhotep III as black. 'The features' of this monarch, writes British Egyptologist John Wilkinson, 'cannot fail to strike everyone who examines the portraits of the Egyptian kings (as) having more in common with the Negro than those of any other pharaoh.' (Gerald) Massey notes that the sculptures of Amenhotep III 'show Aethopic (Ethiopian or Nubian) type.' (W. E. B.) DuBois adds that the king 'inherited his mother's Negroid features.' And Rogers concluded that 'the Eighteenth Dynasty was of almost unmixed Negro strain...'"

As "The Great Royal Wife" and co-regent, Tiye could be rated as a queen of unequal ability and power. For during the reigns of both her husband and her sons "...the kings of foreign lands wrote to (her) when they were desperate." And during critical times, says Simon, "...she was the stablizing force in the nation." She demonstrated her power and wisdom when her husband's, Amenhotep III's, health began to decline, she tended to royal matters when her son's, Akhenaten's, religious devotions and practices caused him to neglect Egypt's defenses and foreign affairs, and finally, she guided the reigns of her two immature sons, Smenkhare and Tutankhamen. (-Simon)

Carl Bronner

At least three centuries before the biblical, King David, Akhenaten wrote psalms as beautiful as those of the Judean monarch, and thirteen hundred years before Jesus, he uttered the words, "the Kingdom of God is within you." J. A. Rogers

Inset: Daughters of Akhenaten and Nefertiti.
(photographs – Courtesy of Wayne Chandler)

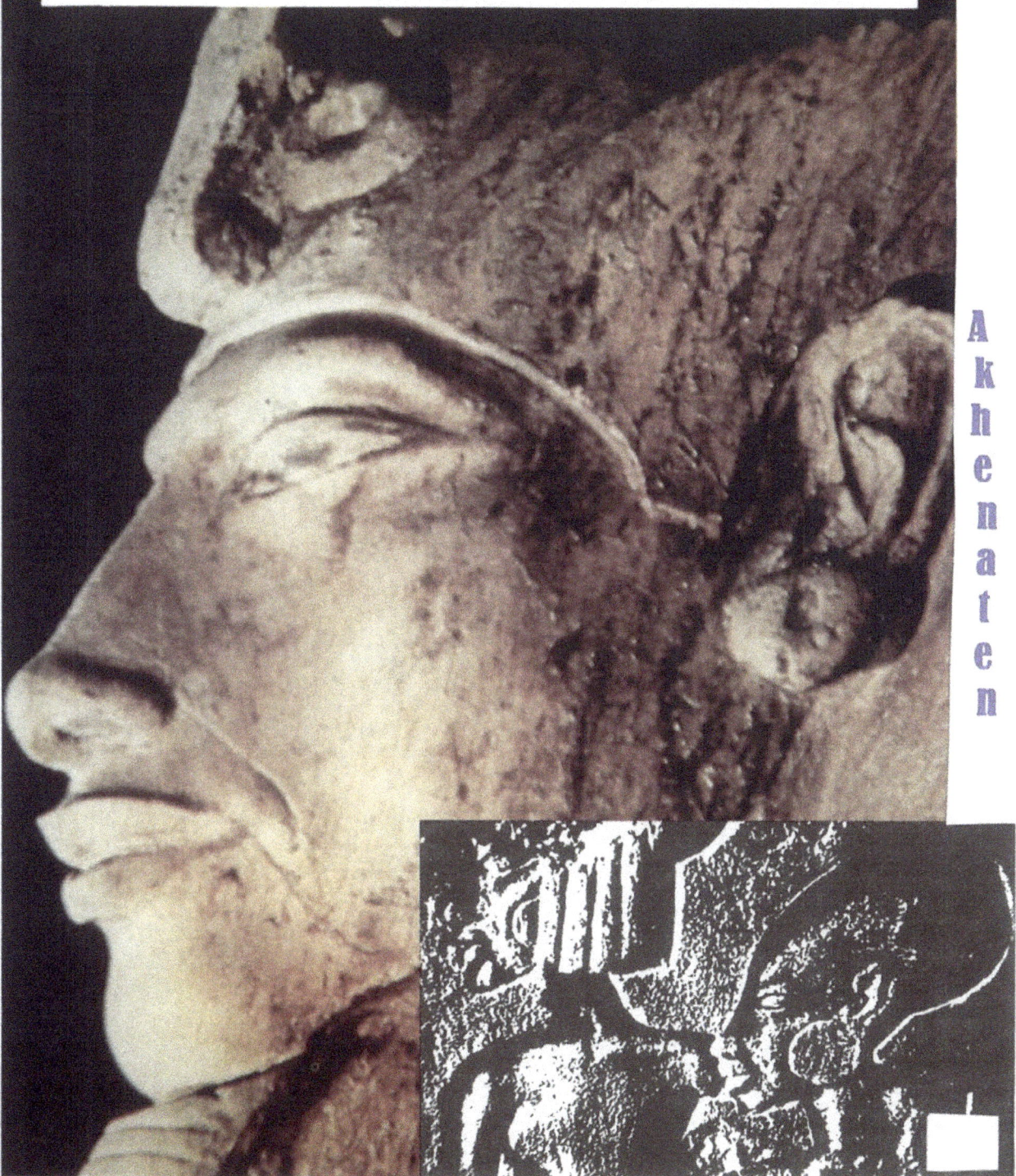

Akhenaten

J. A. Rogers - *ibid.*

Asa G. Hilliard III - No. 2: *ibid.*

Nefer-Kheperu-Re-Wah Akh-En-Aten – c. 1379 to 1362 B.C.E. (Approximately 3,360 Years Ago)

> "Living centuries before King David, he wrote psalms as beautiful as those of the Judean monarch. Thirteen hundred years before Christ he preached and lived a gospel of perfect love, brotherhood, and truth. Two thousand years before Mohammed he taught the doctrine of One God. Three thousand years before Darwin, he sensed the unity that runs through all living things."
> – J. A. Rogers

This enlightened Pharaoh was Amenhotep IV who changed his name to Akhenaten in order to fulfill his mission. This son of Amenhotep III and Queen Tiye was a remarkable Pharaoh and is best known "...for changing the national religion of Kemet (Egypt)." Although the Egyptians were a monotheistic people "...at least 1500 years before Ankh-en-Aten, ...he did lead a religious revolution toward a new form of monotheism. The religion of Aten, using the sun as the symbol of the one God, did not survive him as the national religion. Some believe that the Prophet Moses was a student of this religion, if not a student of Ankh-en-Aten." (-Hilliard). Other researchers believe that although he may have been a student of Akhenaten's teachings, Moses lived in Egypt during the days of Seti I and Rameses II.

Besides making some radical changes in religious worship, other cultural changes have been attributed to Akhenaten and Queen Nefertiti. He moved away from Thebes, 'the home of his ancestors, and...built the beautiful city of Akhenaton (now Tell el'Amarna)--a city 'great in loveliness...' Here he erected beautiful temples dedicated to religion, art, and music. This first Messiah... who uttered the words"The Kingdom of God is within you, taught his poets to write what they felt, and his artists to paint what they saw'." (-J. A. Rogers)

Carl Bronner

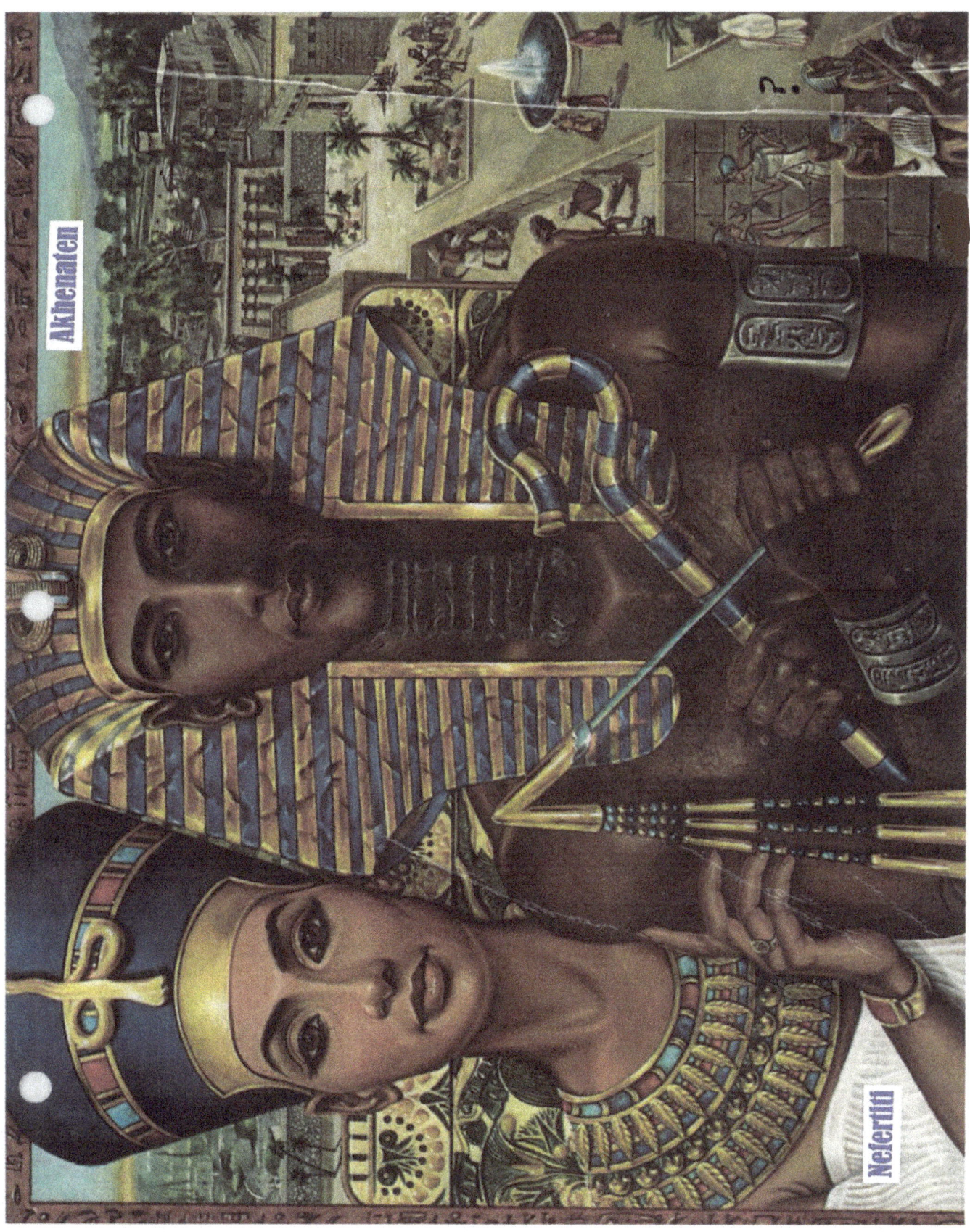

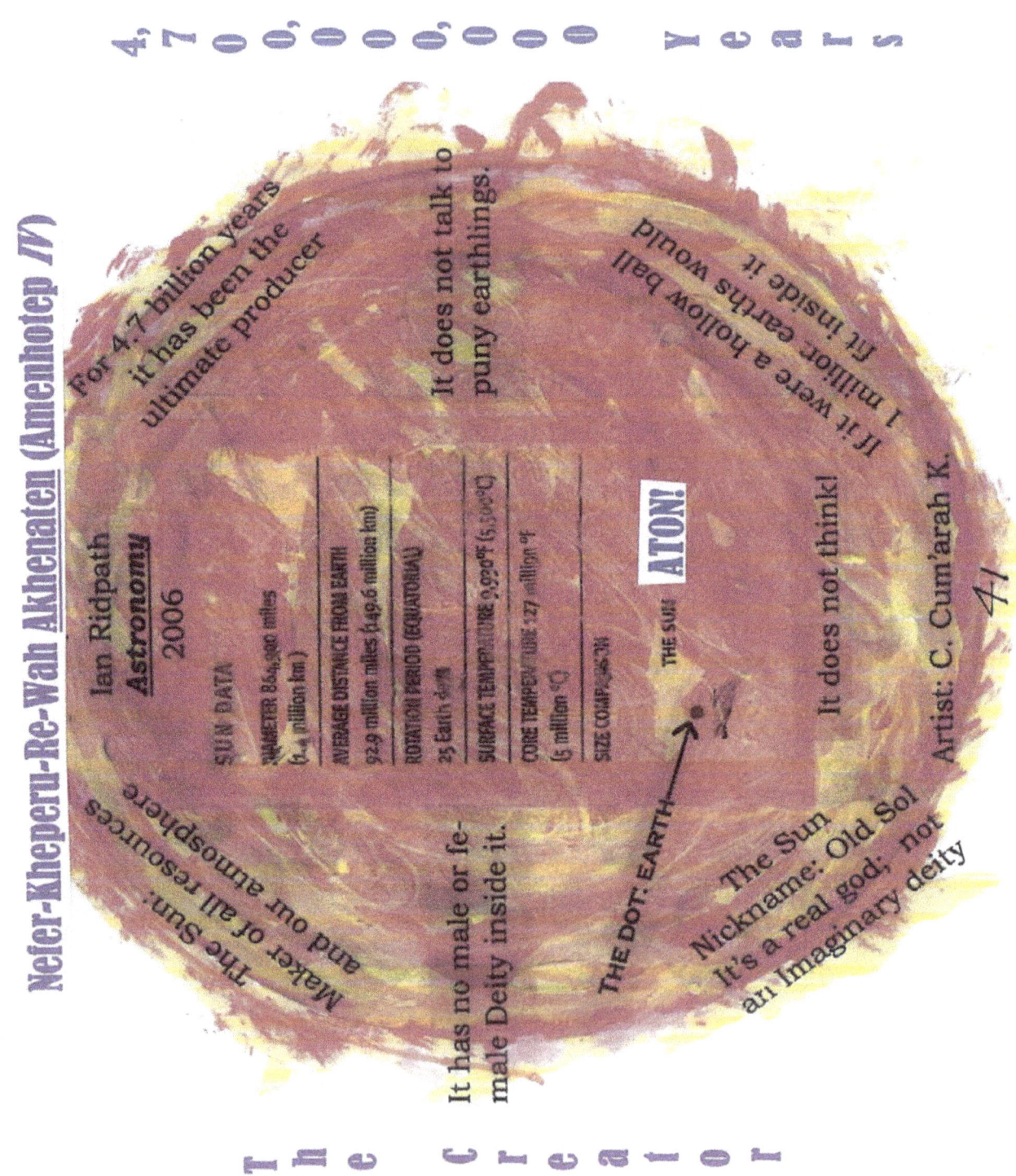

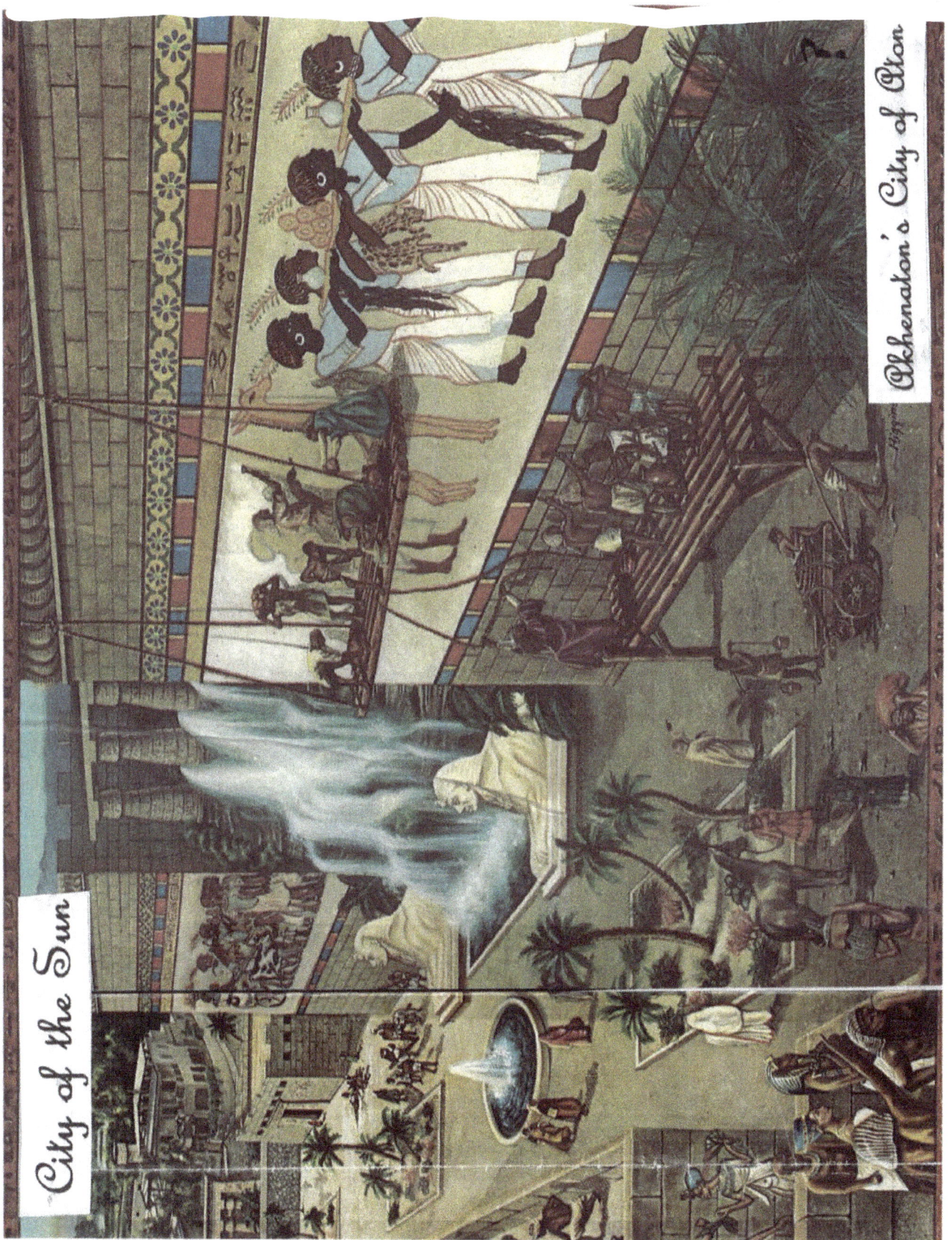

City of the Sun

Akhenaton's City of Aton

Legrand H. Clegg II - **ibid.**

Asa G. Hilliard III - No. 2: **ibid.**

Akhenaten ("The Dreamer King) and Nefertiti

This great reformer of Egyptain art, literature and religion inherited his parents' African racial features, says Clegg.

> "Egyptologists Cyril Aldred and A.T. Sandison note that Akhenaton's 'face is shown to be elongated with a prominent prognathous or progeniac jaw, large full lips, a coarse nose, large ears, and oblique eyes.' Another Egyptologist, Edward Wente, speaks of Akhenaten's 'elongated skull, protruding jaw (and) thick lips,' while Osburn observes that the pharaoh's 'dusky complexion, high cheekbones, projecting jaws and thick lips, call forcibly to mind the features of the true Negro,' and J. A. Rogers adds that Akhenaton's 'skull... is what some scientists call that of a typical Negro'."
> - Clegg

As for the portrait of Nefertiti found on the wall of her temple, she too is shown as having definite African features that are similar to those of her husband, Akhenaton. She too has the elongated skull, protruding jaw and thick lips. The bust (statue) that all the world recognizes as Nefertiti does not resemble her temple wall image in any way. Because, says John Anthony West, it "...is almost certainly not Nefertiti, but perhaps one of her daughters." Did German professors Herman Ranke and Ludwig Borchardt really believe that they had discovered the true bust of Nefertiti in their archaeological dig at Armana, or were they looking for objects that would support some Aryan or white roots in Egypt? Remember, many of the European historians and anthropologists began building an "Aryan Model of History" at the expense of the more accurate "Ancient Model of History" in the late Eighteenth Century. They directed more attention toward this woman who was quite possibly an Afro-Asian, than they did on all of the fantastic, history making events of the Golden Eighteenth Dynasty itself.

Carl Bronner

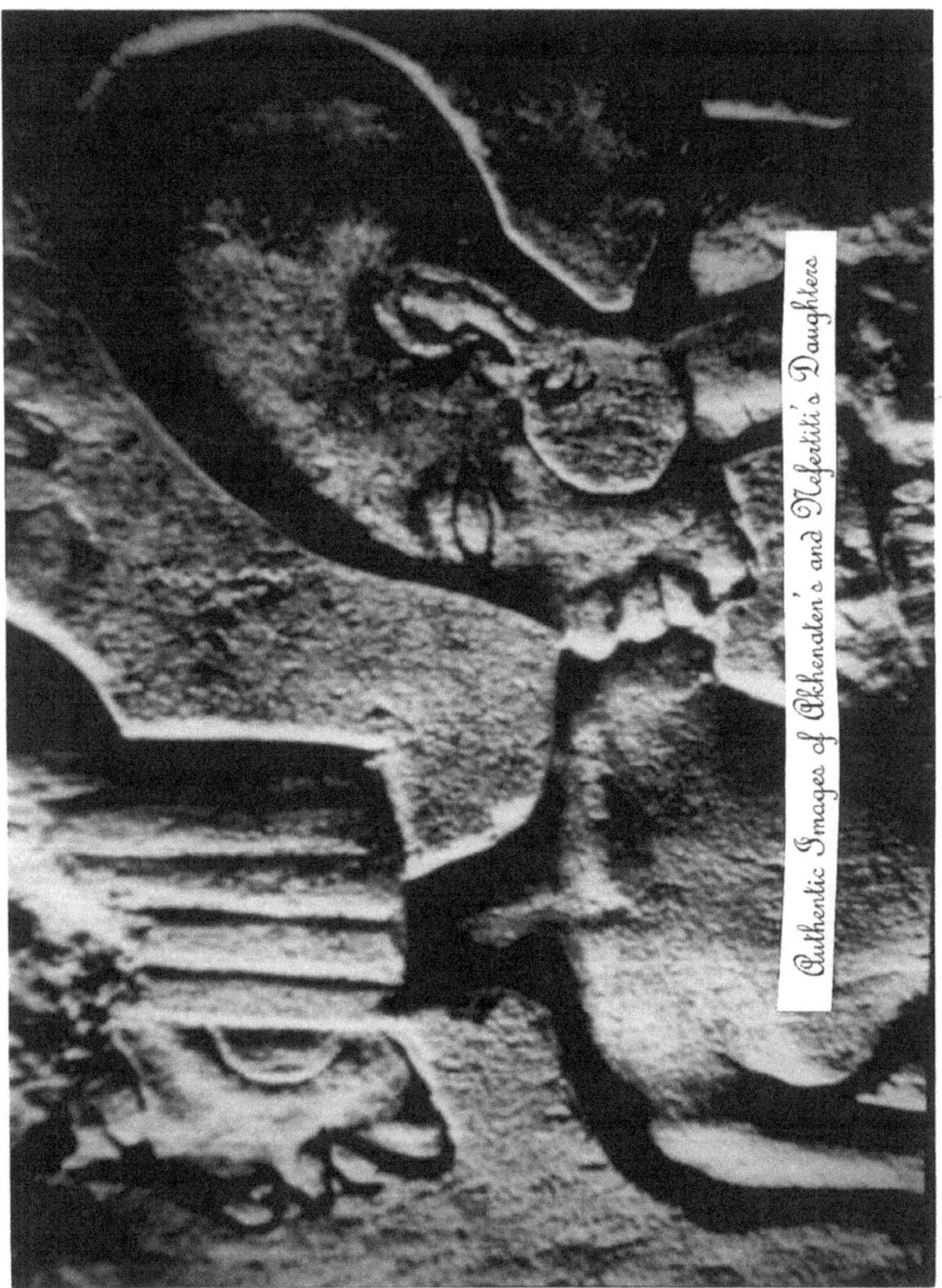

Authentic Images of Akhenaten's and Nefertiti's Daughters

(photograph – Courtesy of Wayne Chandler)

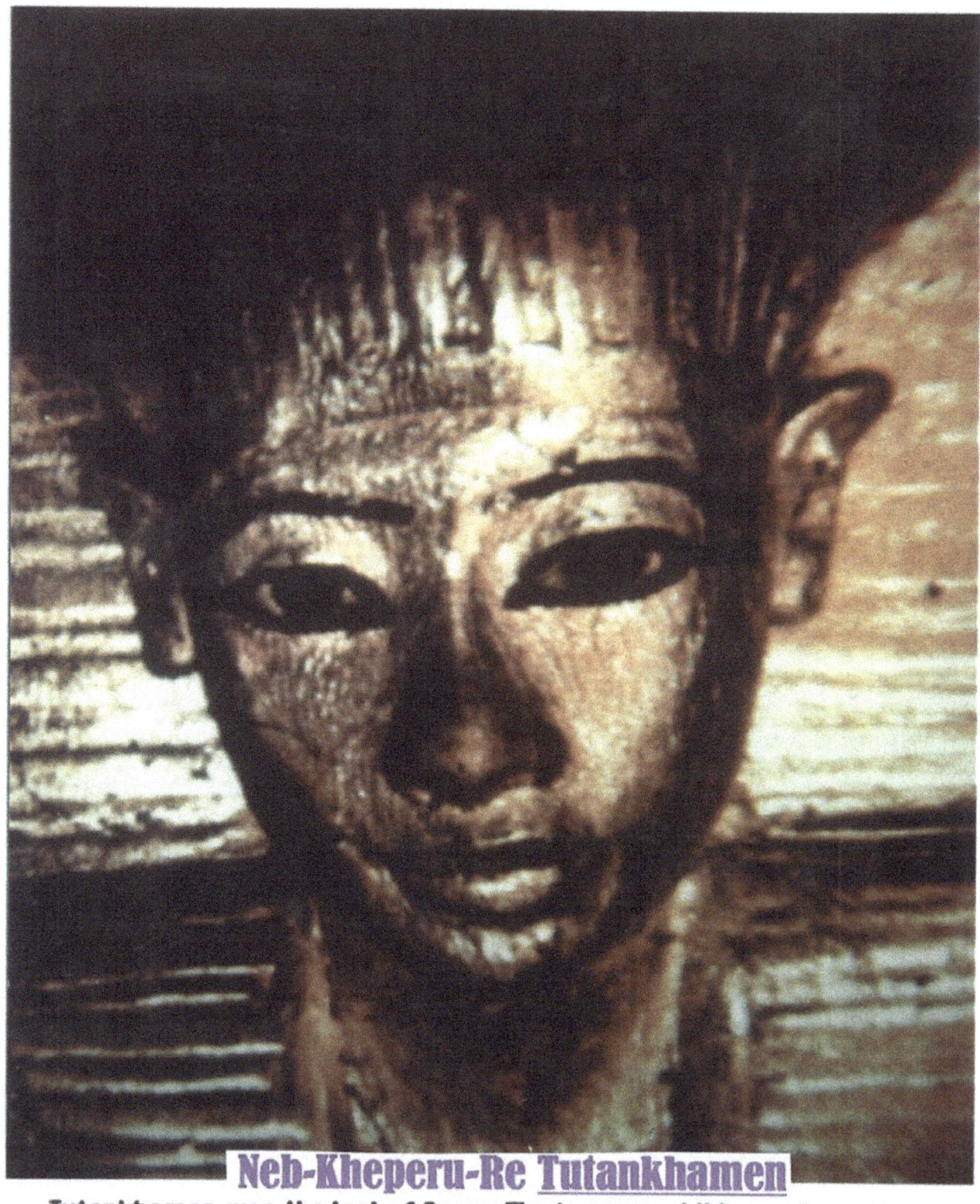

Neb-Kheperu-Re Tutankhamen

Tutankhamen was the last of Queen Tiye's seven children. Two of his brothers, Akhenaten and Smenkhare, had preceded him on the throne. Although the discovery of King Tut's tomb has given him worldwide recognition, his short life reveals no significant accomplishments.: V. S. Simon

Asa G. Hilliard III - No. 2: **ibid.**

Legrand H. Clegg II - **ibid.**

Editors - "Egypt," Encyclopaedia Britannica, Volume 8 (1972)

Neb-Kheperu-Re Tut-Ankh-Amen - c. 1361 to 1352 B.C.E.

After the death of Akhenaten, the second successor to the throne of Kemet was Tutankhamen, also known as the "boy king," because he became Pharaoh at the age of nine and died at about the age of eighteen. Probably due to the counseling of his co-regent mother, Queen Tiye (or perhaps another person of high rank), "King Tut" (his Twentieth Century nickname), changed his name from "Tutankhaton" to "Tutankhamen." This name change signified that he had abandoned the religious worship of the God Aton in favor of the God Amen. Still following the advice and counseling of his elders, his next historical move was to restore the powers of religious leadership to the high priests at Karnak.

Because of the discovery of his tomb, loaded as it was with highly valuable furniture, ornaments, precious items, and other relics, Tutankhamen is probably the one Pharaoh that the whole world is most familiar with. People have found all kinds of uses and misuses for the Golden Mask that was found on his mummy. Yet when both his mummy and his mask clearly show that he was a Negro boy, why do white artists insist on making him white? Not to belabour it here, but one merely has to consider his parents, siblings, grandparents, and other distant relatives who were all black. Recall how we stated in the preceding pages that his mother, Queen Tiye has been described by a number of very reputable Egyptologists, anthropologists, and historians as a beautiful, jet-black woman:

> J. A. Rogers has described Tiye as a "full-blooded African,' ...Ivan Van Sertima calls her 'the Negroid mother of Tutankhamen,' and Alexander Von Wuthenau states that Tiye was of "pure black stock."
> - Clegg

Recall also that scientists, John Wilkinson, Gerald Massey, W. E. B. DuBois, and J. A. Rogers talked about the Negro or Nubian features of his grandfather, Amenhotep III. And finally, reconsider the historians' description of his elder brother, Akhenaten.

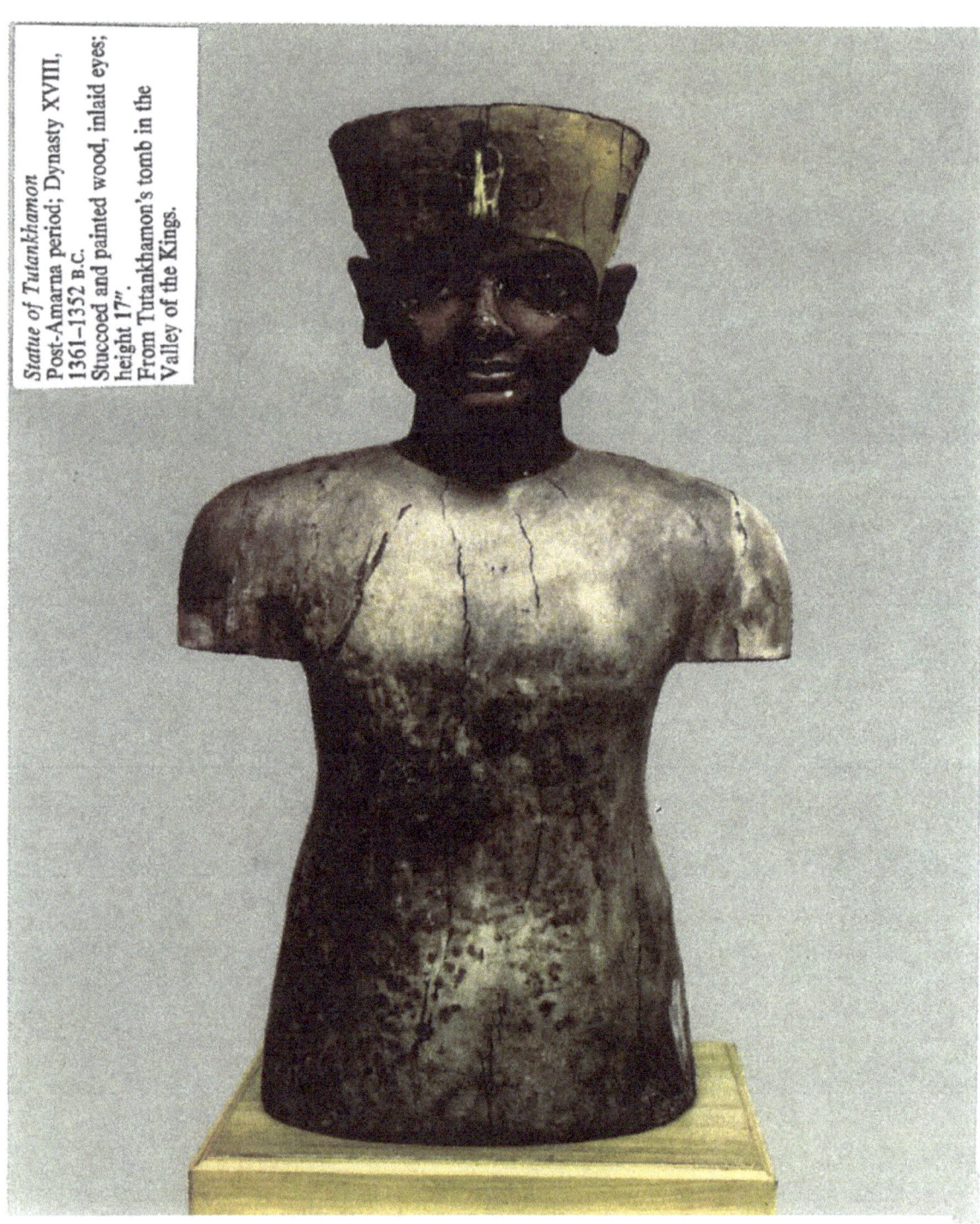

Statue of Tutankhamon
Post-Amarna period; Dynasty XVIII, 1361–1352 B.C.
Stuccoed and painted wood, inlaid eyes; height 17".
From Tutankhamon's tomb in the Valley of the Kings.

STATUE OF TUTANKHAMON. *Dynasty XVIII.*
A curious piece, this statue has no legs and the arms are cut off at the armpits. There are no details of musculature or dress. It has been suggested that this is an example of the private statuary that was made to serve as cult images of the dead, which had only a head and trunk without any details. The face is of a type known at Tell el Amarna, with a swelling mouth and a sinuous development of the features. There is also a generalized and pleasing rotundity that reflects tradition as well as current practice.

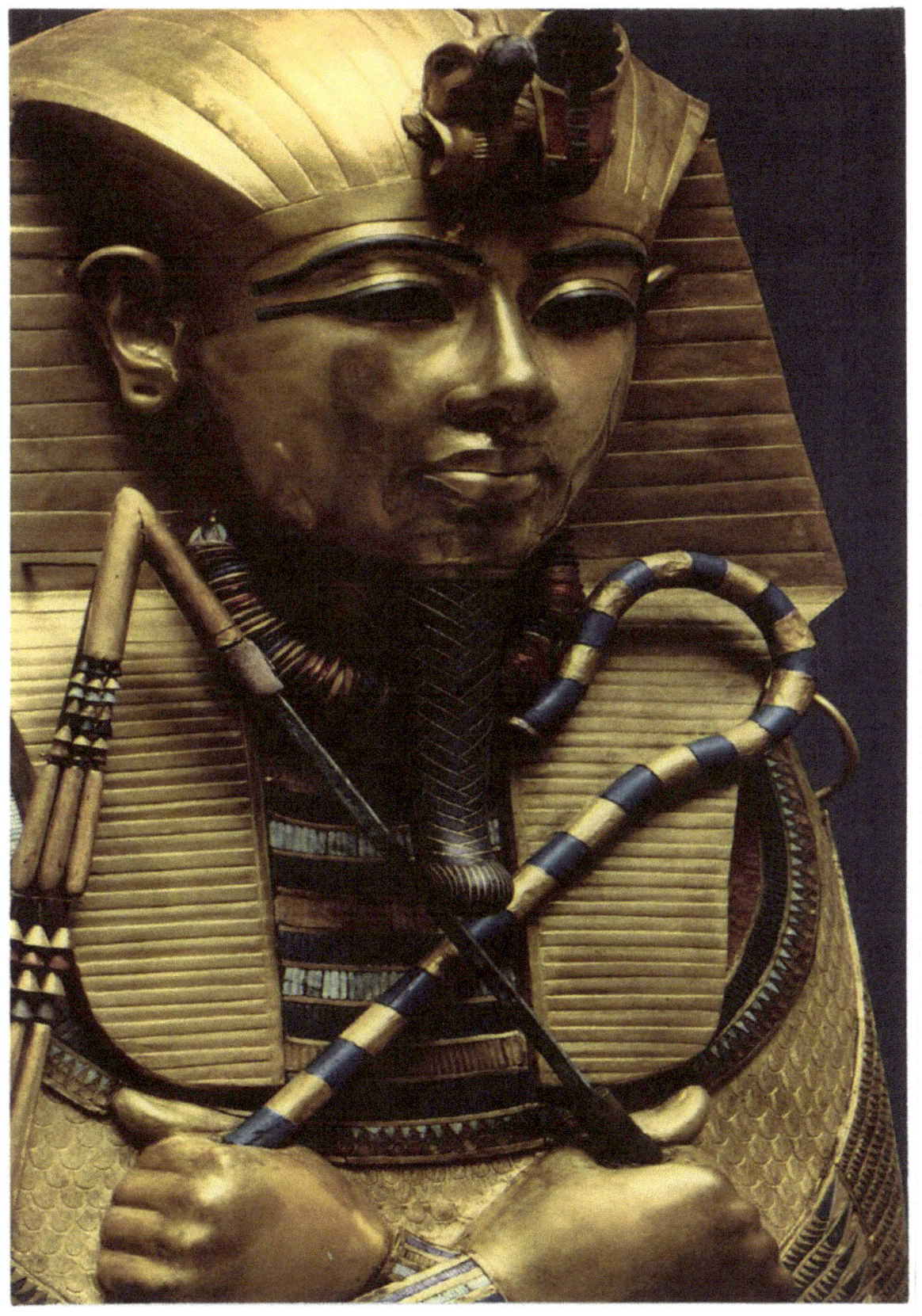

Tutankhamen

John L. Johnson - **ibid.**

Sigmund Freud - **ibid.**

Yosef A. A. ben-Jochannan - No. 2: **ibid.**

Seti I - c. 1318 - 1298 B.C.E. (Approximately 3,300 Years Ago)

The legend of the Biblical Moses places him in Egypt during the reigns of Pharaohs Seti I and Rameses II of the Nineteenth Dynasty. According to the Egyptian historian, Manetho, Rameses I was a black king and the father of Seti I, and Seti I was the father of Rameses II. Historian, G. Rawlinson said that Pharaoh Seti I had "...a strong, complete African face with thick lips and a depressed nose."

Although Moses is said to be mostly a Jewish forklore figure, it seems appropriate to say that his adoption of commandments which appear to be extracted from the very ancient Admonitions of Maat (or "The Forty-Two Negative Confessions") and his adoption of the one God concept, offers some support for the Hebrew convert's connection with the Egyptian ruling class. For even the Holy Bible's New Testament states in the Book of "The Acts," Chapter Seven, Verse Twenty-Two:

> "And Moses was learned in all the wisdom of the
> Egyptians and was mighty in words and in deeds."

Now if this legendary figure was actually taken into the royal household of Seti I, he most certainly would have been well-educated, particularly in the ways of the priests as Sigmund Freud concluded from his research. If this is true, then Moses must have taught his people in both the old and new ways of the Egyptian religion. By teaching "The Ten Commandments," he held onto old religious ideas that existed at least fifteen hundred years before his time, and by adopting the one God concept of Akhenaten, he embraced the new.

Sigmund Freud - **ibid.**

"The Admonitions of Maat" and Moses

After approximately twenty years of research, the great, Jewish founder of psychoanalysis, Sigmund Freud, wrote that Moses must have been an Egyptian priest and this would explain his acquaintance with the very antiquated laws known as "The Admonitions of Maat." These were Egyptian laws which contained the much heralded "Forty-Two Negative Confessions." Hence, the ten laws Moses passed on to the "Children of Israel" were laws extracted from the "The Admonitions of Maat."

Freud further writes that "if Moses gave the Jews not only a new religion, but also the law of circumcision, he was not a Jew, but an Egyptian." Therefore, his mosaic religion was most likely an Egyptian religion because the religion of Aton and the religion of the Jews "...show agreement in some remarkable points."

> "The Jewish creed, as is well known says:
> 'Schema Jisroel Adonai Elohenu
> Adonai Echod.'
> If the similarity of the name of the Egyptian Aton (or Atum) to the Hebrew word Adonai and the Syrian divine name Adonis is not a mere accident, but is the result of a primeval unity in language and meaning, then one could translate the Jewish formula:
> 'Hear, O Israel, our God Aton (Adonai) is the only God'." - Sigmund Freud

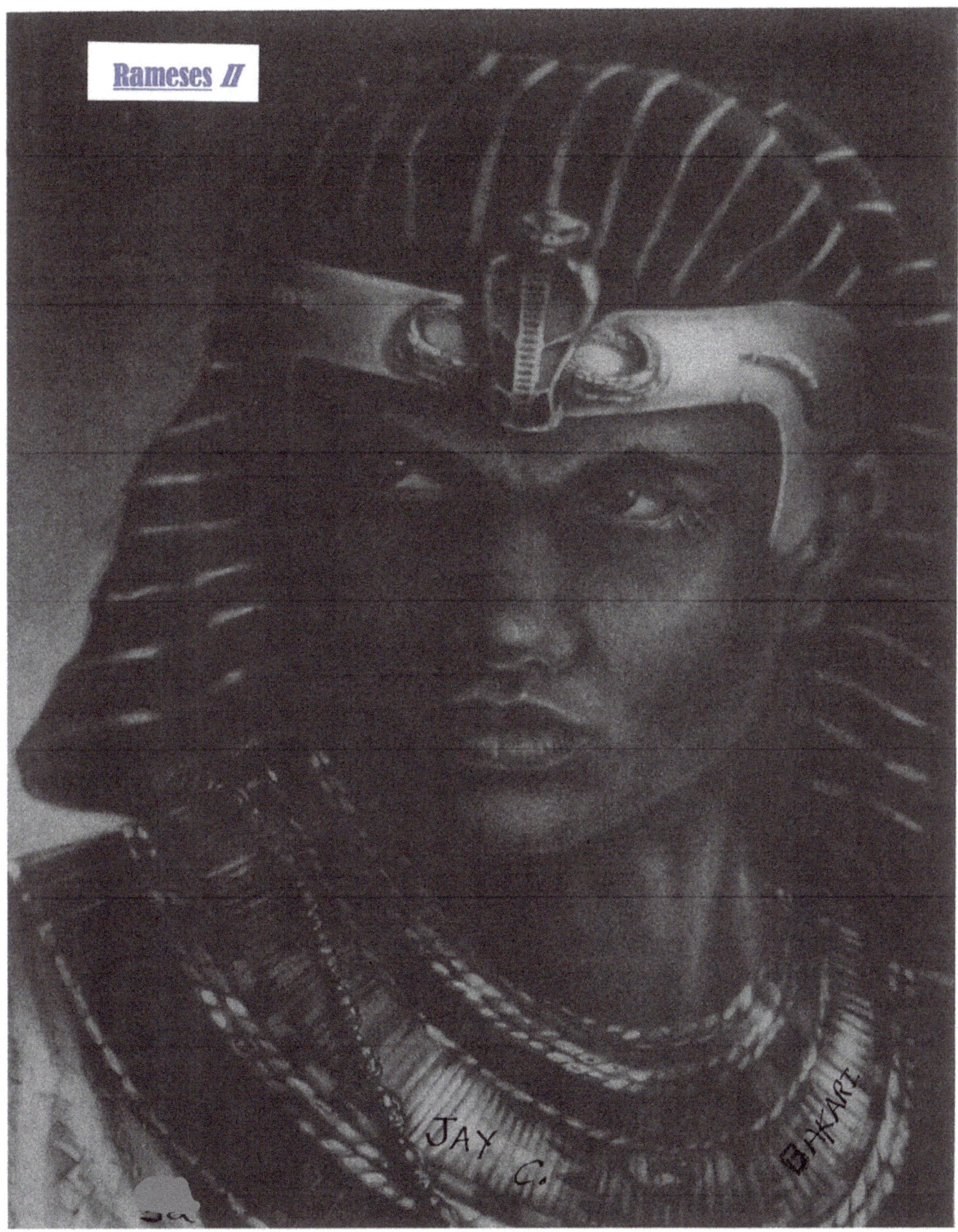

Yosef A. A. ben-Jochannan - No. 1: **ibid.**

John L. Johnson - **ibid.**

Asa G. Hilliard III - No. 2: **ibid.**

Editors - "Egypt," **Encyclopaedia Britannica,** Volume 8 (1972)

User-Maat-Re-Setep-En-Re Ra-Mes-es II- c. 1298 to 1232 B.C.E.
 (Approximately 3,250 Years Ago)

So the story goes that Moses fled from Egypt during the time of Seti I as a fugitive from the lawful authorities. Seti I seems to have been very upset with him for murdering a popular Egyptian. Many years would pass before Moses was to show himself again in Egypt. This time the legend has him on a holy mission to free the Haribus (Israelites--Hebrews--Jews) from bondage (slavery). He so antagonized Pharaoh Rameses II until the king drove Moses and his followers out of Egypt into Palestine.

Rameses II reigned for 67 years and fancied himself a great builder. He completed the work on his father's building program, and then seemed to have filled Egypt and Nubia with his own monuments. But some historical investigators say that Rameses II inscribed his name on temples and monuments that were built by his predecessors. Nevertheless, Hilliard says that he was well known for his military exploits and because of his Power and vast building schemes, he should be viewed as one of the "great Waset Kings."

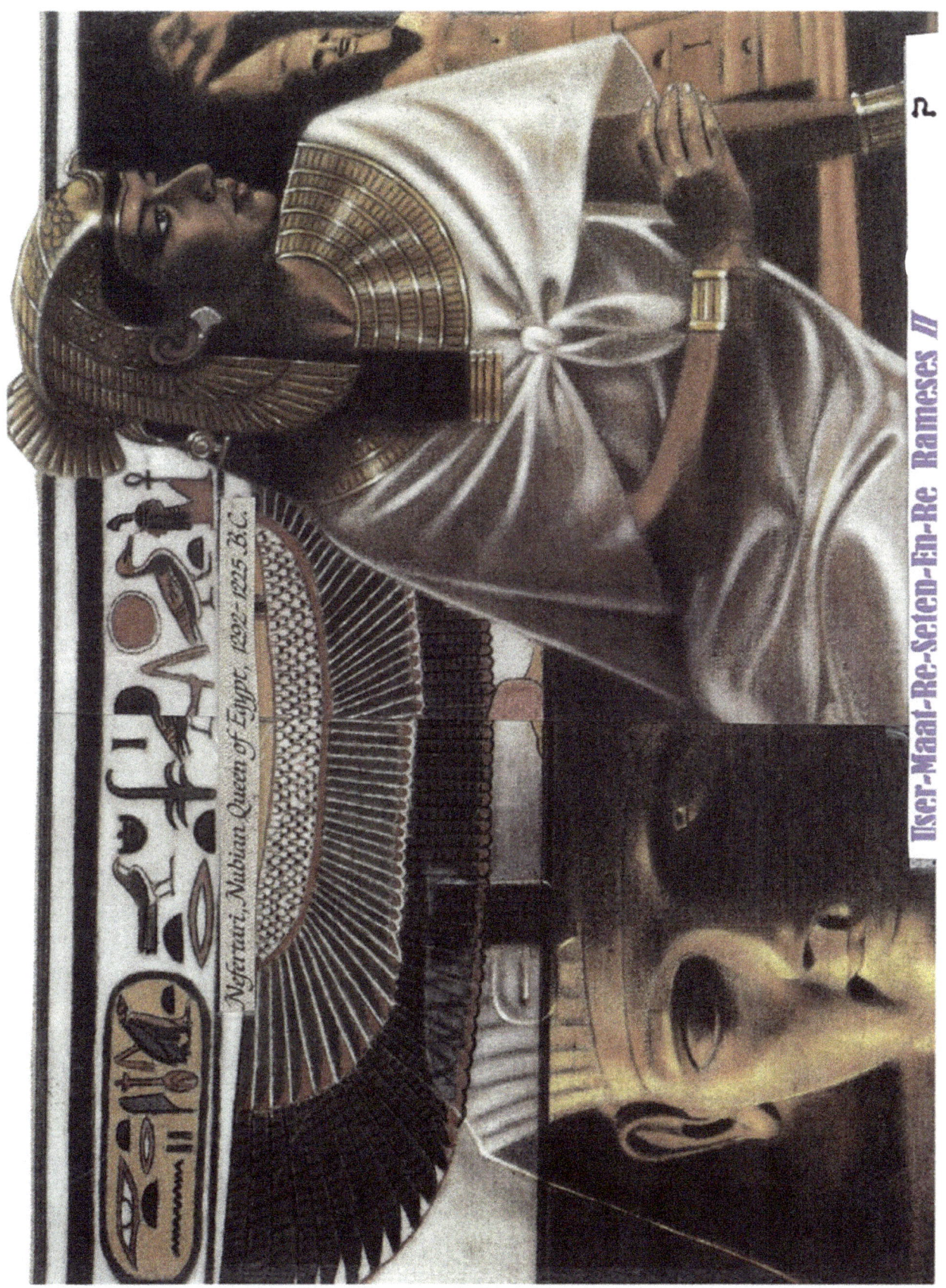

User-Maat-Re-Setep-En-Re Rameses II
Nefertari, Nubian Queen of Egypt, 1292–1225 B.C.

Yosef A. A. ben-Jochannan - No. 2: **ibid.**

Rameses II –

The two black Pharaohs most maligned by European writers are Akhenaten (Amenhotep IV) and Rameses II: Akhenaten because he redefined and embraced the one God concept before Moses, and because he was the forerunner in psalm and proverb writings before the Biblical David and Solomon. Akhenaten also taught the doctrines of love, brotherhood and truth more than one thousand, three hundred and fifty years before the birth of Jesus. Similarly, these writers' grounds for assassinating the character of Rameses II also appear to be for racial and religious reasons. They have billed him as the "tyrant" Pharaoh who drove the Haribu (Jews) out of Egypt and Nubia.

> "...Moses, like Rameses II, was an African," says Dr. ben-Jochannan. "...the Book of Exodus drama dealing with the 'Jewish Passover' is an African story of people who had been in Africa (Alkebu-lan) for at least 400 years as 'Slaves'..."

To establish a mutual military alliance against the Asyrians, and build a political, economic, and social relationship between Egypt and the Hittite Kingdom, Rameses II married a black Hittite princess, Nefertari. His extraordinary long reign of sixty-four to sixty-seven years is ample testimony to the fact that the doings of a legendary Moses must have had no effect whatsoever on his administration as he engaged himself in the construction "...of new metropolitan centers, towns, and cities--all over the Delta. Two of his most prominent achievements were the construction of the rock Temple of Abu Simbel in Nubia, and a number of buildings and monuments at Luxor. He expressed his devotion and admiration for Nefertari by dedicating some of the largest and most beautiful monuments at Abu Simbel to her.

Carl Bronner

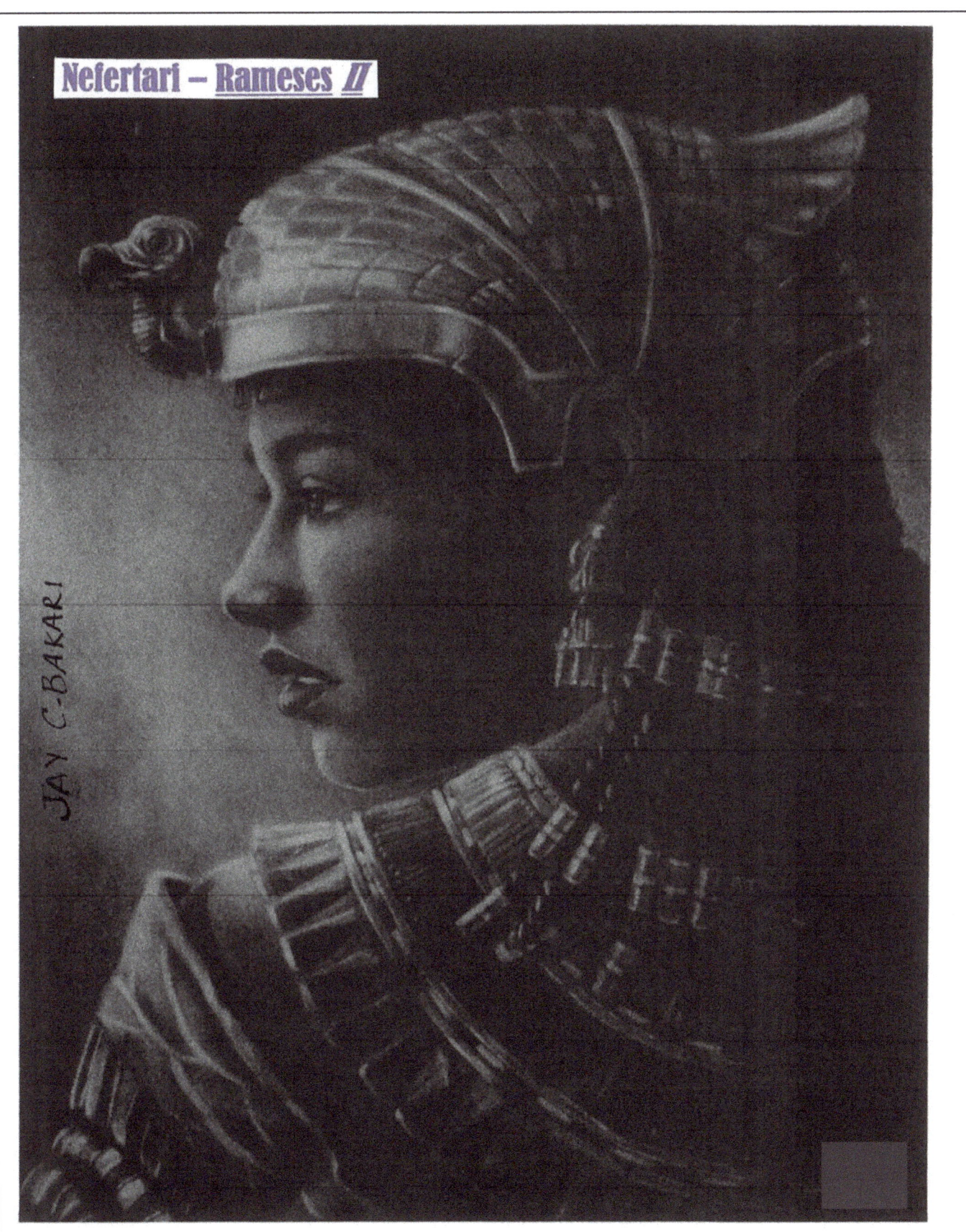

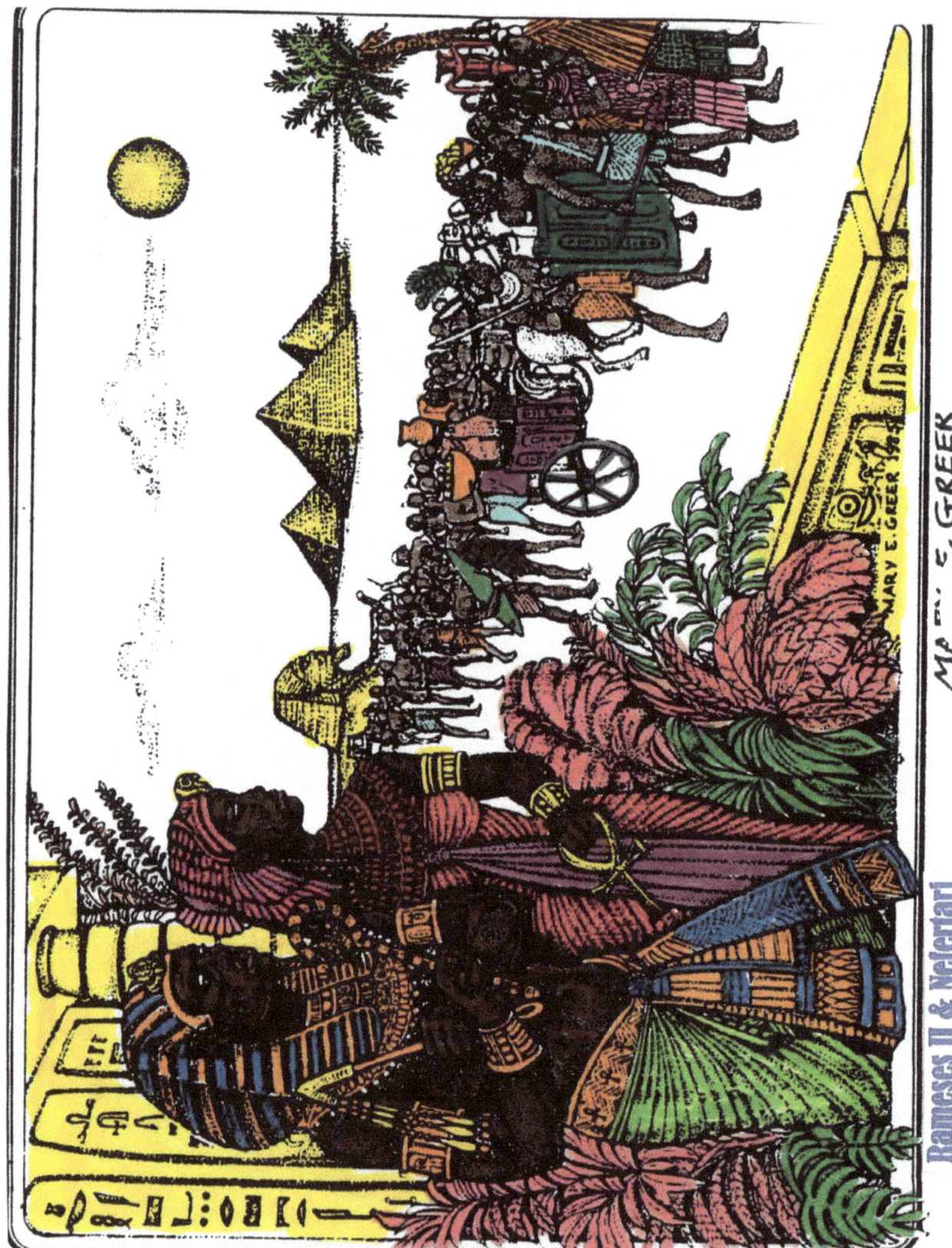

Rameses II & Nefertari

Art in Rameses III's Tomb

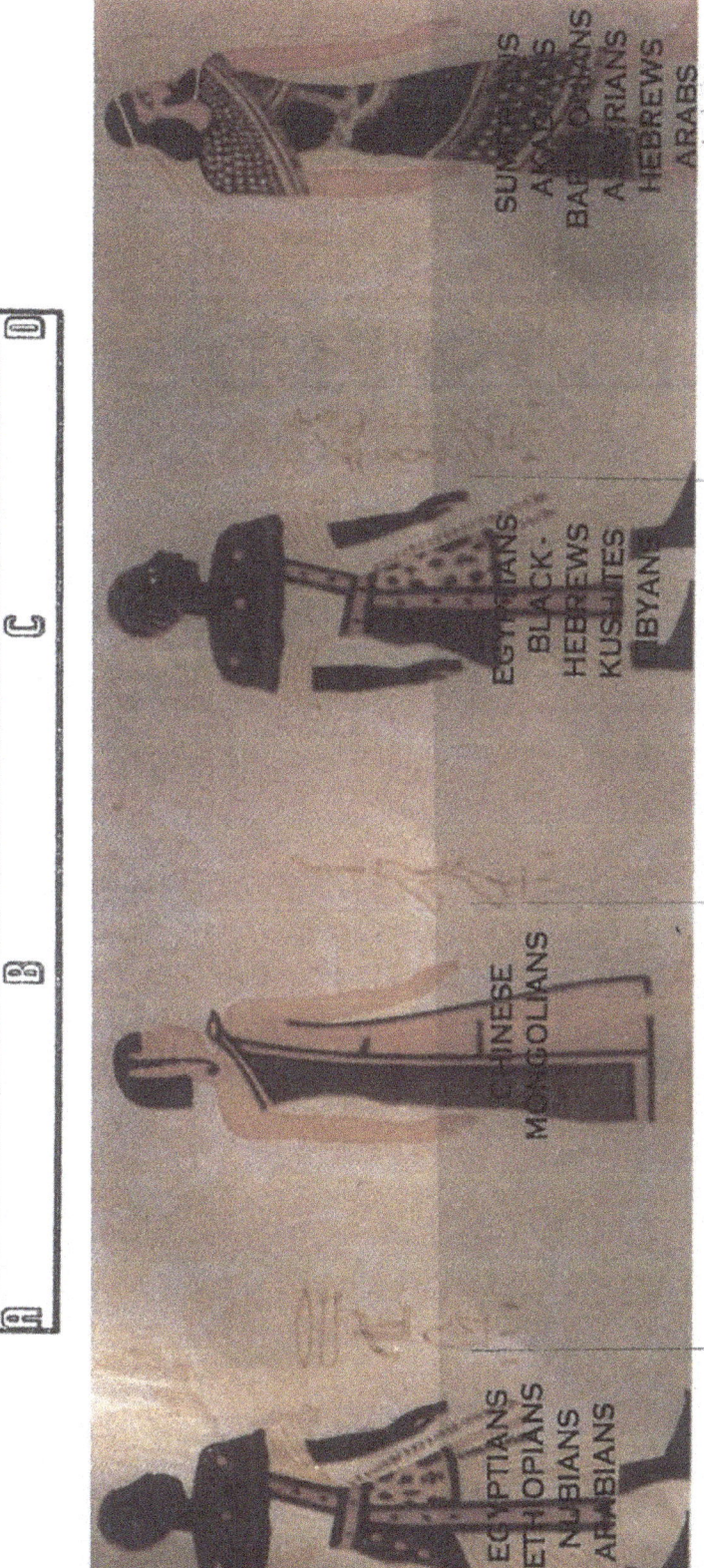

"This painting from the tomb of Ramses III (1200 B.C.) shows that the Egyptians saw themselves as Blacks, and painted themselves as such without possible confusion with the Indo-Europeans (Caucasoids) or the Semites. It is a representation of the races in their most minute differences, which insures the accuracy of the colors. Throughout their entire history, the Egyptians never entertained the fantasy of portraying themselves by types B or D.

A) The Egyptian seen by himself, black type C) The other Blacks in Africa
B) The "Indo-European" D) The "Semite" : Ivan Van Sertima
(From K. R. Lepsius: Denkmaler aus Aegypten und Aethiopien, Erganzungsband, plate 48)

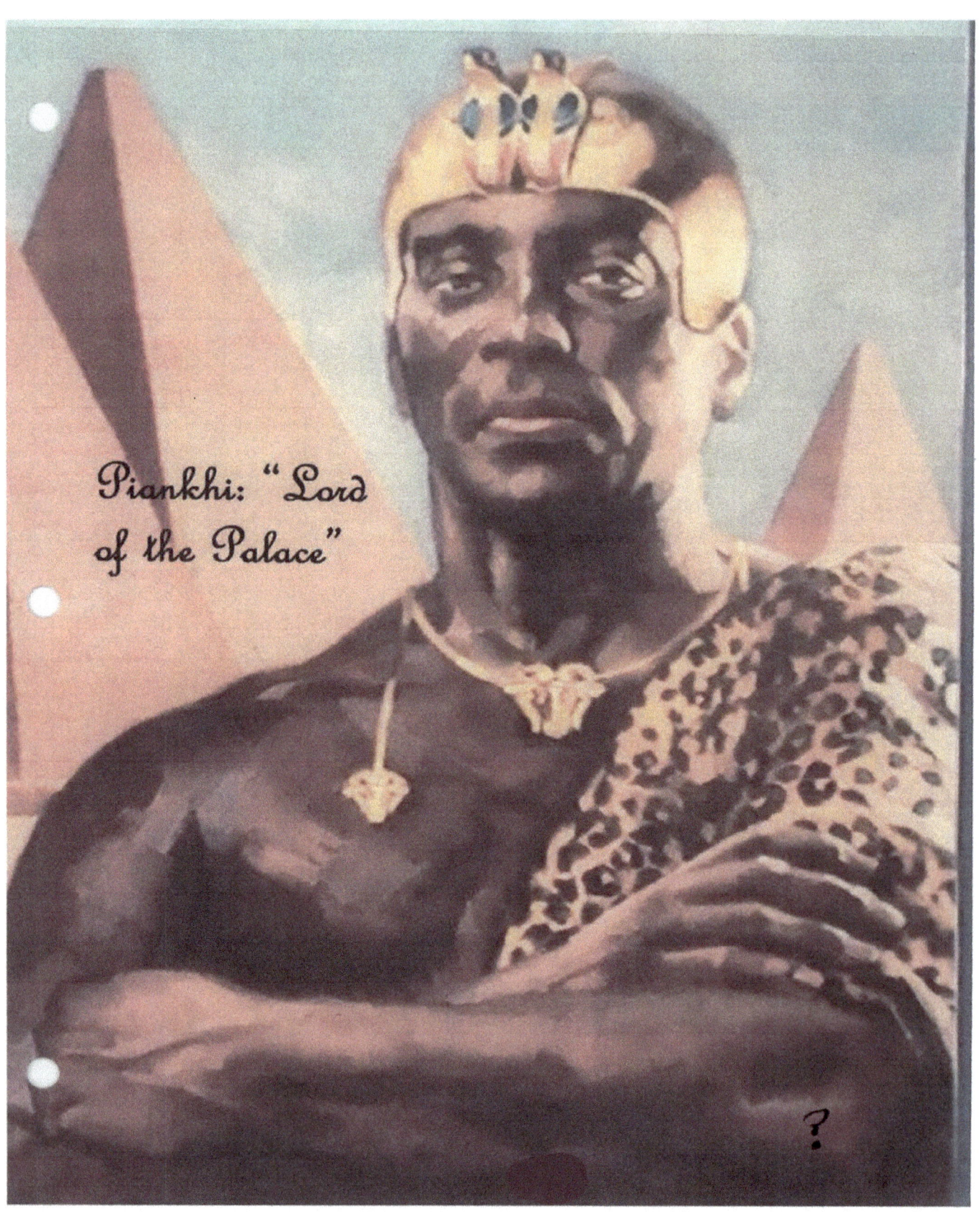

Piankhi: "Lord of the Palace"

Yosef A. A. ben-Jochannan - No. 1: **ibid.**
Phaon Goldman (Tarharka) - **Egypt Revisited** - Editor: Ivan Van Sertima
J. A. Rogers - **ibid.**

Piankhi (Piankhy)- "Lord of The Palace" - c- 751 to 718 B.C.E.
(Approximately 2,750 Years Ago)

As this volume of **BLACK AFRICANS** is prepared for the singular purpose of being a reference guide, we make no attempts or claims to be all inclusive when it comes to the black Pharaohs of ancient Egypt. In the preceding pages there are giant leaps from the Dynasties of the Old Kingdom to the Dynasties of the Middle Kingdom to the Dynasties of the New Kingdom where we ended with Rameses II at c. 1232 B.C.E. Here we shall again leap far ahead, five hundred years plus, to the Twenty-Fifth Dynasty when Piankhi, a Cushite (Ethiopian or Kushite) succeeded in re-unifying Egypt (Kemet), Kush (Ethiopia), Ta-Nehisi (Nubia) and Meroe. Once again the empire was placed under the control of a powerful, indigenous African ("Negro").

Around 751 B.C.E., the royal palace of King Piankhi was located in Napata, the Cushite capital city.

> "Ethiopia (Cush) was in a flourishing state, and the
> Ethiopian kings had a certain claim to the throne
> of Egypt. Piankhy of Napata, therefore, set out
> to enforce the claim, and he left a detailed ac-
> count of his invasion..." - Dr. Margaret A. Murray, Egyptologist

Piankhi's army captured Memphis and drove Pharaoh Tefnakhte's army out of middle Egypt. Soon afterwards, a number of Egyptian princes and chiefs crowned him as the new ruler of Egypt. They threw themselves upon their bellies at his feet saying:

> "Be appeased, Horus, Lord of the Palace;
> It is thy might which has done it.
> We are your slaves, paying impost
> into the treasury."

And the people chanted in song:

> "Oh, mighty ruler, Piankhy,
> Thou comest having gained the dominion of the north...
> Thou art unto eternity, thy might endureth,
> Oh Ruler, beloved of Egypt." - Rogers

Carl Bronner

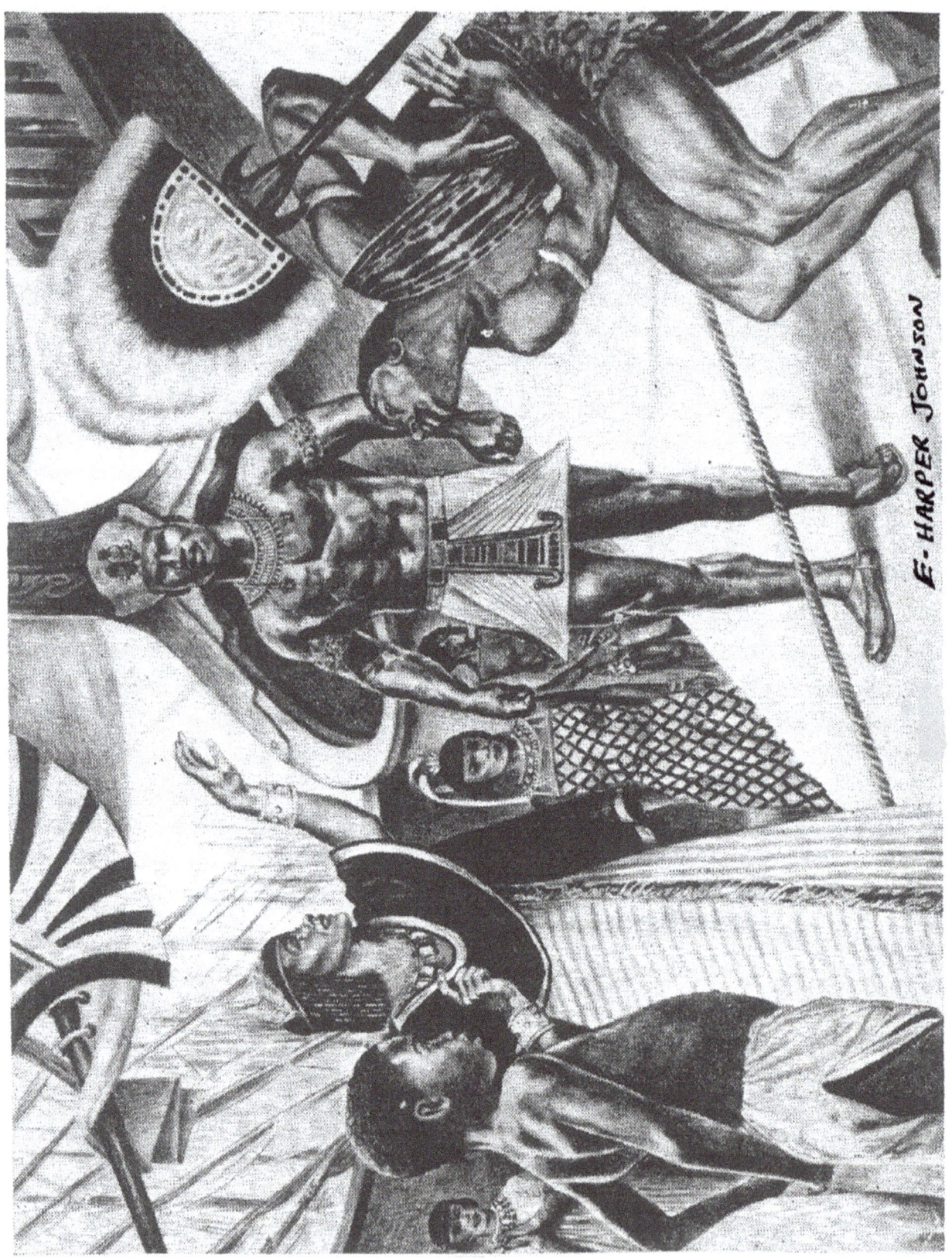

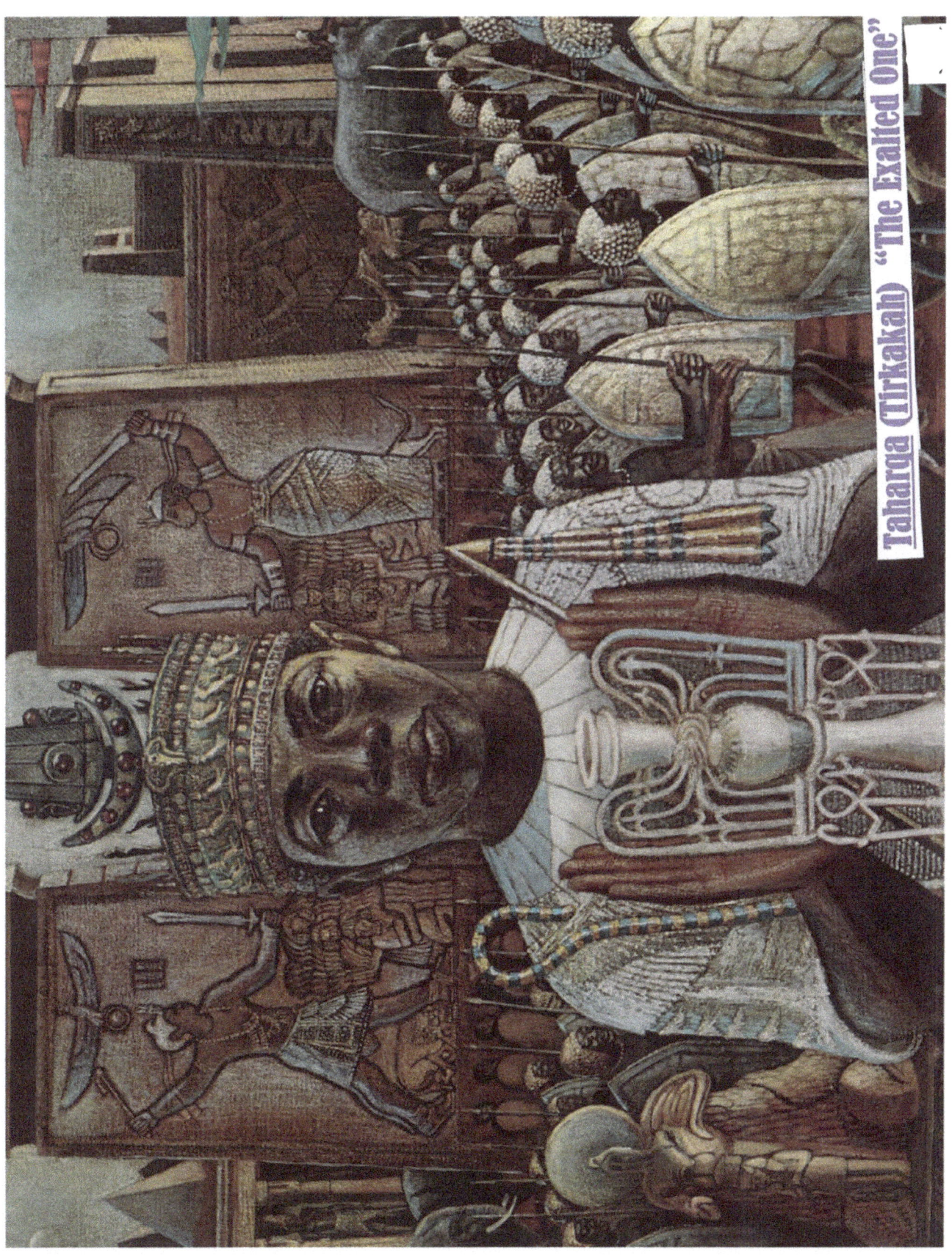

Taharqa (Tirkakah) "The Exalted One"

Yosef A. A. ben-Jochannan - No. 1: **ibid.**
No. 2: **ibid.**

Phaon Goldman - **ibid.**

John L. Johnson - **ibid.**

Taharqa (Tarkarka; Biblical: "Tirkakah") - c. 690 to 664 B.C.E.
(Approximately 2,675 Years Ago)

 After Pharaoh Piankhy, Pharaoh Shabaka continued the Cushitic rule over the three kingdoms. The Ethiopian kings maintained this rule for another fifty years. Shabaka was succeeded by his nephew, Shabataka, and Taharqa, the son of Piankhy, followed Shabataka. Taharqa's nephew, Tanutemun was the last of the Twenty-Fifth Dynasty's Ethiopian kings.

 Pharaoh Taharqa is easily recognized as the second most powerful king of the Twenty-Fifth Dynasty. He is the same "Tirkakah" which the Holy Bible speaks of as the defender of Judah against the Assyrians. During Shabaka's and Taharqa's reigns the empire was re-established from Syria and Palestine in the North to Kush in the south.

 Taharqa, "The Exalted One" wore the triple crown of Kush, Upper Egypt and Lower Egypt, and held three coronations in all three localities (in the cities of Thebes, Tanis, and Napata) to assert his power and absolute rule. Nations near and far, feared and respected his Egyptian army which was largely manned by a division of fierce Ethiopian soldiers. According to Phaon Goldman, the Third Century, Greek geographer and librarian, Strabo at Alexandria said:

> "Tarkarka...was...as warrior who...penetrated into
> Europe as far as the "Pillars of Hercules' (Gibraltar)
> --that is as a great conqueror." - Goldman

 Taharqa's construction programs included the enlargement and beautification of his capital city, Napata, and he did a magnificent job of remodeling and expanding the monumental Temple of Amon at Jebel Barkal that had been raised by his father, Piankhy. Here in this temple that was carved out of natural rock, Taharqa built images of himself which stood over one hundred feet high. Knowing of no equals, he saw himself as "Emperor of the World."

Carl Bronner

Taharqa "Defender of Israel"

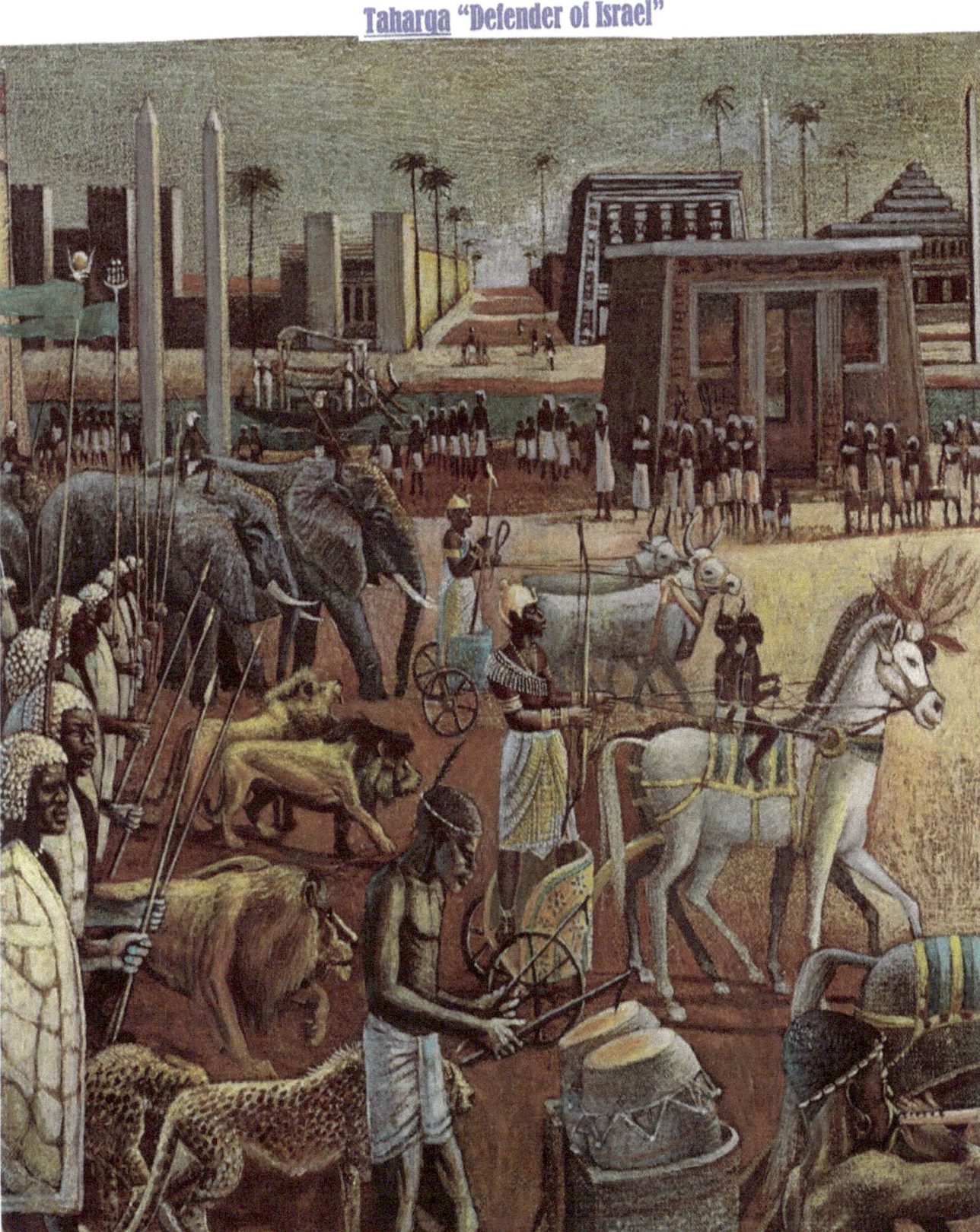

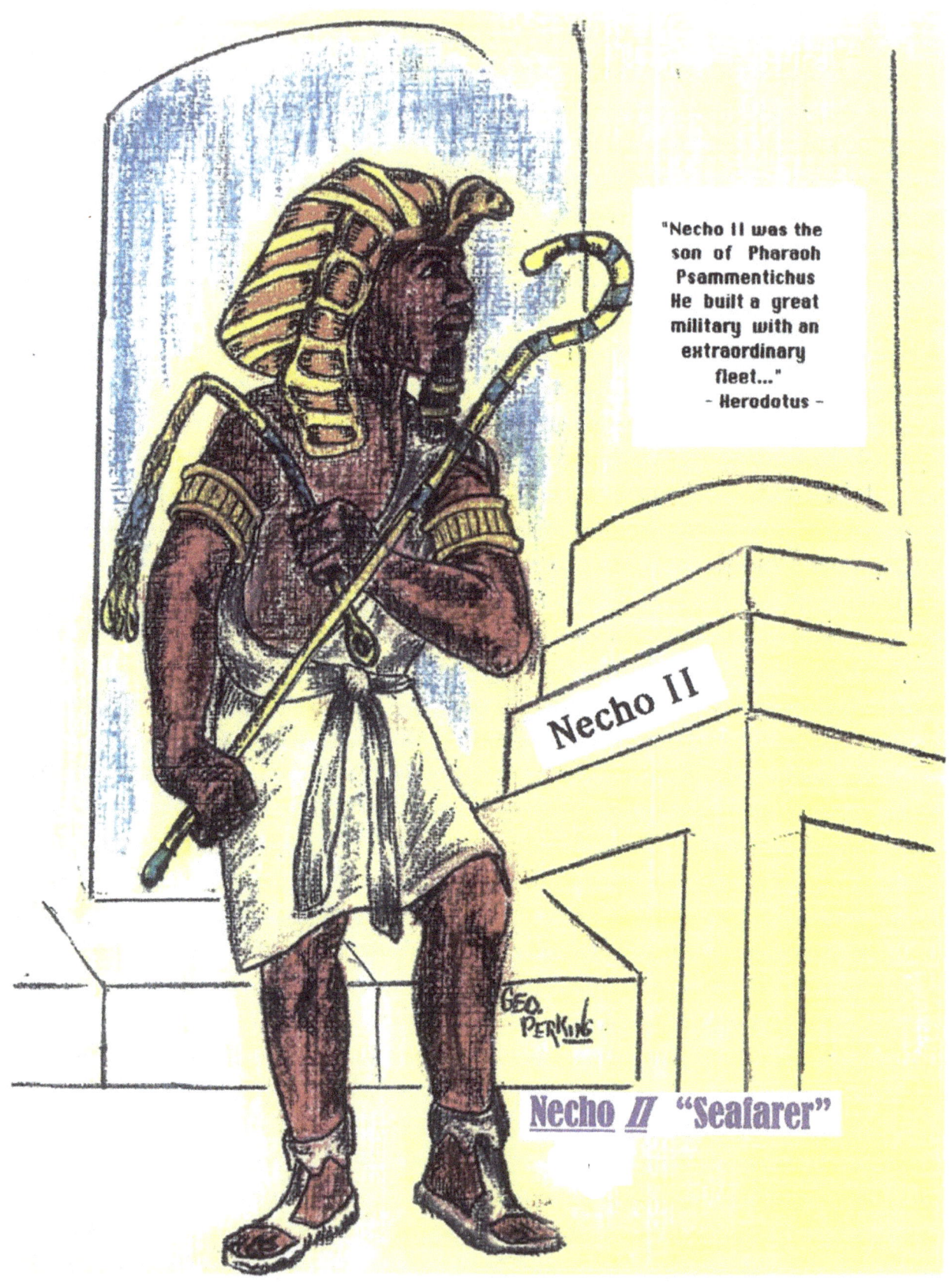

Yosef A. A. ben-Jochannan - No. 1: **ibid.**

John L. Johnson - **ibid.**

Editors - **Encyclopaedia Britannica,** Volume 8 (1972)
 Volume 13 (1972)
 Volume 21 (1972)

Necho II - c. 610 to 595 B.C.E. (Approximately 2,600 Years Ago)

The kings who were set up in Egypt after the fall of the Twenty-Fifth Cushitic (Ethiopian) Dynasty by the Assyrians were also black. It is just about certain that the seven kings of the Twenty-Sixth Dynasty were African Negroes. This includes Necho I, Psamtik I, Necho II, Psamtik II, Apries (the Biblical Hophra), Ahmose II (Amasis), and Psamtik III.

When we think of grandiose and ambitious plans, we should be sure to include the maritime programs of Necho II. Herodotus wrote that the Phoenician sailors hired and ordered by Necho II to sail around (circumnavigate) Africa (Alkebu-lan) actually did it! So what is the motive of the American schools for teaching students that Vasco da Gama, the Portuguese sailor, was the first sea captain to circumnavigate the African continent in 1497 C.E. (2,100 years after Necho II's time).

Necho II is also known for another grand scale, water-related project. The records of the ancient Egyptians show that another black Pharaoh, Senusret I (Senwosret I or Sesostris I of the 12TH Dynasty - c. 1970 to 1936 B.C.E.) dug a freshwater canal from the Nile Delta to a spot on the Red Sea near the present Port of Suez. Apparently, it was not properly maintained for sea traffic and fell into disuse. Its restoration was undertaken by Necho II about 600 B.C.E., but it was not completed until 500 B.C.E. when the Persian, Darius I took on the job. Nevertheless, this would have enabled Necho II's fleet to travel from the Red Sea and up the Nile into the Kemet (Mediterranean) Sea. About three thousand and eight hundred years after Senusret I, a permanent waterway from the Mediterranean Sea to the Red Sea for modern, seagoing vessels, was completed by the French diplomat and scientist, Ferdinand Marie Lesseps in 1869. This we know as the Suez Canal.

Carl Bronner

> Herodotus wrote that the Phoenician sailors hired by Necho II to sail around (circumnavigate) Africa actually did it!
> Encyclopaedia Britannica (1972)

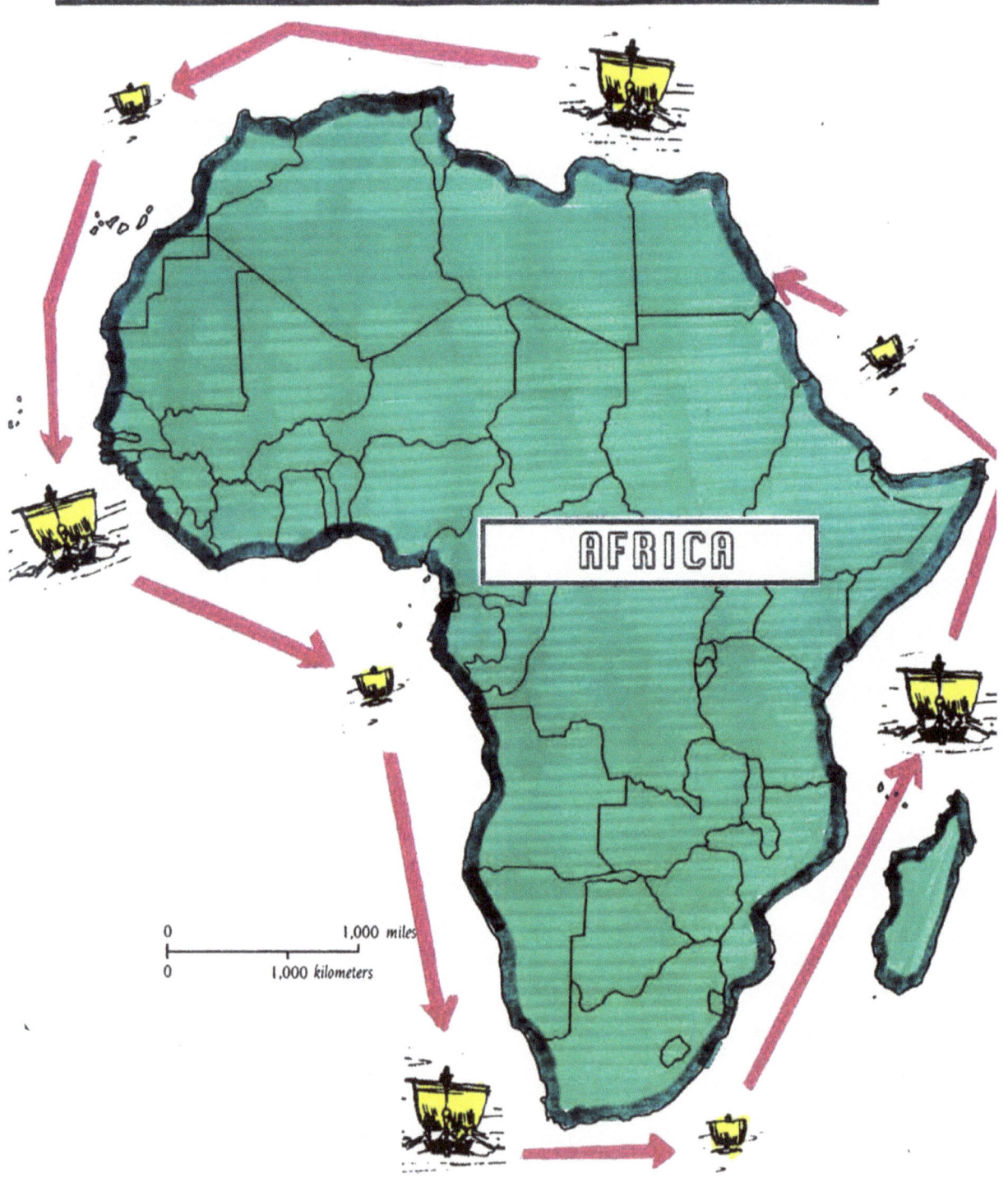

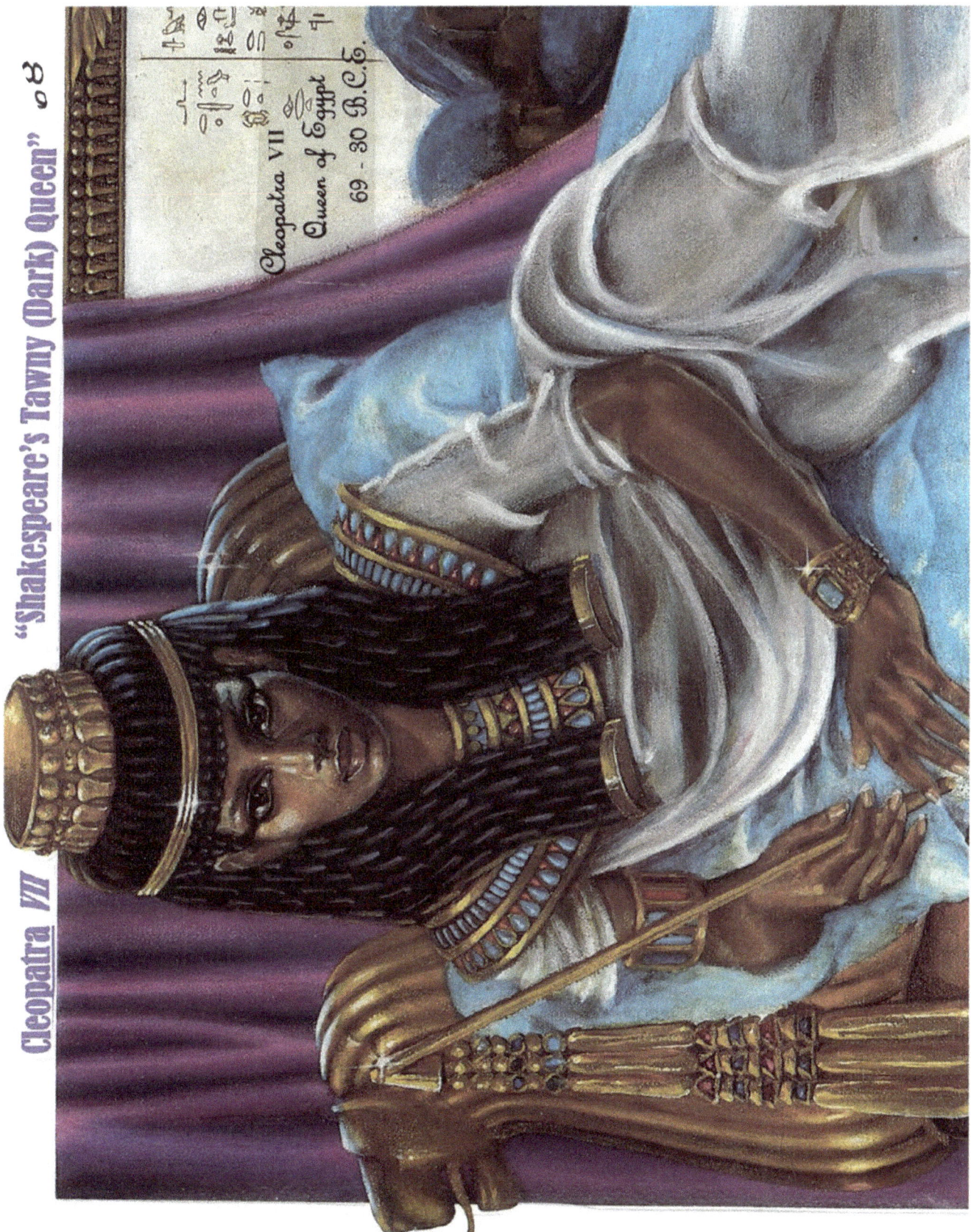

Cleopatra VII "Shakespeare's Tawny (Dark) Queen"

J. A. Rogers - **ibid.**

John Henrick Clarke - **Black Women in Antiquity** - Editor: Ivan Van Sertima

Yosef A. A. ben-Jochannan - No. 2: **ibid.**

Cleopatra VIII (Shakespeare's Tawny Queen) - 69 to 30 B.C.E.
(Approximately 2,050 Years Ago)

 The era of Pharaoh Necho II had been closed for nearly three hundred years when the first Europeans (caucasians) seized control of Egypt (Kemet). It came in the form of Alexander II ("The Great") of Macedonia with his cavalry led by the black Greek general, Clitus, a long time friend and the "King of Bactria."

> They "...sacked the archives of Egypt... They stole what they understood, and burned much of what they could not decipher." - ben-Jochannan

This period of alien, imitation Pharaohs was ushered in with the Greek General Soter, who proclaimed himself "Ptolemy I, Pharaoh of all Egypt." The Greeks were to enjoy their control over Egypt for just about two hundred and eighty-five years.

 About 50 B.C.E., Egypt became a protectorate of the Roman Empire as the Greek era was drawing to a close. It was at this time that the eighteen year-old, Cleopatra shared the throne with her brother, Ptolemy XIII. According to Dr. Clarke, she entered into a "...political and sexual relationship with Julius Caesar as a maneuver to save Egypt from the worst aspects of Roman domination," and with his military assistance was able to dispose of Ptolemy XIII and his supporters. To Caesar and Cleopatra, a son was born whom they named, Caesarion. When they joined him in Rome, Caesar left his wife to live with Cleopatra. But when Caesar was stabbed to death in the Senate House at Rome on March 15, 44 C.E. (the Ides of March), Cleopatra felt that her dreams and plans for Egypt had also died. But her hope was renewed after she had formed a strong amorous union with Mark Antony (Marcus Antonius). Rogers wrote that "this bond was strengthened by the birth of a son, Alexander Helios, and later by twins, a boy and a girl, Ptolemy and Cleopatra Silene."

Carl Bronner

J. A. Rogers - *ibid.*

John Henrik Clarke - *ibid.*

Cleopatra VIII -

> "Cleopatra was highly educated and very witty. She spoke Egyptian, Greek, Latin, Ethiopian, Hebrew, Arabic, and Syrian fluently, as well as several African dialects..."
> — Rogers

Cleopatra, says Rogers, was a "a...brown-skinned girl with crinkly hair and a voluptuous figure..."

> "Until the rise of the doctrine of white superiority Cleopatra was generally pictured as colored. ...As late as the Sixteenth Century Cleopatra was regarded as a Negro woman."
> — Rogers

Cleopatra's father, Ptolemy XII, was the illegitimate offspring of Ptolemy XI (Soter II), and his pictures show pronounced Negro traits. Pierre Louys wrote that her mother, the Princess Hadra was a Nubian woman. Even "the Bard of Avon," William Shakespeare in the classical play "Antony and Cleopatra" described her as being "tawny" which means yellowish-brown in color. In Act I, Scene 5 of this same play, Cleopatra orates that she was made black by the sun, Phoebus.

> "Contrary to popular belief, Cleopatra did not commit suicide over the loss of Mark Antony. Her great love was Egypt. She was a shrewd politician and an Egyptian nationalist. She committed suicide when she lost control of Egypt."
> — Clarke

Carl Brown

Martin Bernal - **ibid.**

Godfrey Higgins - **ibid.**

Afterthoughts and Footnotes

The final notes of this volume comes from a traveling scholar of the Nineteenth Century and another traveling scholar of the Twentieth Century. We will let their conclusions serve as afterthoughts.

First we hear the words of a writer who had a great deal to say about people of African descent in the 1830's. This was Godfrey Higgins who wrote:

> "Dr. Pritchard has most clearly proved, as I have stated...
> that the ancient Egyptians were Negroes. He observes
> that 'the Greek writers always mention the Egyptians
> as being black in their complexions.' In the Supplices
> (writings) of Aeschylus, when the Egyptian ship is de-
> scribed as approaching the land, and seen from an emi-
> nence (near) on the shore, it is said:
> The sailors too I marked,
> Conspicuous in white robes their sable limbs.'
> Osiris is the black divinity of Egypt. Osiris and his Bull
> were black; all the Gods and Goddesses of Greece were
> black; at least this was the case with Jupiter, Bacchus,
> Hercules, Apollo, and Ammon. The Goddesses Venus,
> Isis, Hecati, Diana, Juno, Metis, Ceres, Cybile are black."
> The three god-like, strong men of mythology "Cristna
> (Krishna), Hercules, and Samson were all black." In his
> genuine verses, Homer described Hercules thusly:
> 'Black he stood as night,
> His bow uncased, his arrow strung for flight.'

In speaking of the Greek Gods, Bernal has this to say:
> "The names of nearly all the gods came to Greece from
> Egypt. I know from the enquiries I have made that
> they came from abroad, and it seems most likely that
> it was from Egypt, for the names of all the gods have
> been known in Egypt from the beginning of time...

Carl Bronnei

Afterthoughts and Footnotes (Continuation)

You will recall our earlier quote from Herodotus about his visit to India. He concluded that the people of India were no different than those he had lived among in Egypt. Researchers throughout the centuries have been inclined to agree with Herodotus, including Godfrey Higgins who studied there in the Nineteenth Century:

> "In the most ancient temples scattered throughout Asia, where his worship is yet continued, Buddha of India is found black as jet, with the flat face, thick lips, and curly hair of the Negro. ...It has been observed, that the figures in all the old caves of India have the appearance of Negroes. This tends to prove not only the extreme antiquity of the caves, but also the original Negro character of the natives."

(See **African Presence in Early Asia** – Editoros: Ivan Van Sertima and Runoko Rashidi

Also see **Sex and Race**, Volume I by J. A. Rogers)

QUOTES FROM ORIGINAL THINKERS

1. Count C. F. Volney – **Ruins of Empires**, 1890
 Oeuvres, Vol. 2, 1883

 "A forgotten people, while others were uncivilized, discovered science and art. A race which is modernly rejected because of their woolly hair and dark skin, are the founders of the laws of nature, religious and civil systems which still control the universe..." (pp.16-17) (pp.65-68)

 Voyage to Syria and Egypt, 1787
 "...the first Egyptians were real Negroes of the same race as all the natives of Africa..."

2. J. P. Widney – **Race Life of the Aryans**, Vol. 2, 1987

 "The Babylonians and Egyptians seem to have been Negroes, who built eminent empires long before the Semites (Jews) Mongols or Aryans. Deep-down in the mud and mire of the beginnings..., rest the contribution of the Negroes to the superstsructure of modern civilization." (pp.238-39; p.241)

3. George Rawlinson – **Seven Great Monarchies**, Vol. 1, 19th Cent.

 "...the descendants of Ham acted as pioneers and led the world in various new fields of art, science and literature including alphabetic writings, astronomy, architecture, historical chronology, plastic art, sculpture, agriculture, navigation and textile industry." (pp.40-41)

 "The Babylonians were Ethiopians by blood, and the Chaldeans should be viewed as Negroes, not Semites or Aramaeans..." (pp.29-34)

 The Story of Egypt (1887)
 "Seti I had a strong 'complete' African face with thick lips and a depressed nose." (p.252)

Carl Bronner

4. Herodotus - **The Histories,** c.484-425 B.C.E.

 "...the Egyptians (were) burnt skinned, flat nosed, thick lipped, and woolly hair."

 "...the ancient inhabitants of Mesopotamia were Black. The Ethiopians, Persians and Babylonians were of the same family linguistically, ethnographically and historically."

5. **Encyclopaedia Britannica,** Vol. 8, 1959
 New Funk and Wagnalls Encyclopedia, Vol. XII

 "...the earliest Sumerians of Babylonia, to have been a non-Semitic Negritic people. The earliest sculptural remains found in Elam, which bordered Babylonia, presented indisputable evidence of an early Negro regional dominance." (p.118); (pp.1050-51; pp.4199-4200)

6. E. Reclus - **The Earth and its Inhabitants,** Vol. 1, 1893

 "Egypt was a great civilized power during the period in which Europe was being overrun by savage tribes. Arithmetic, architecture, geometry, astrology, all the arts, and nearly all of today's industries and sciences were known while the Greeks lived in caves. The pattern of our thinking originated in Africa..." (p.287)

7. Baird and Dillon - **The Family Bible,** 1884 Edition

 "...Arabia was first called 'Cush,' and was often translated 'Ethiopia'." (pp.7-11)

8. Lucian, Galen and Block - **Bulletins et Memoirs Society de Paris,** 1901
 Specimens of Ancient Sculpture Society of Dilettanti, Vol. 1

 "...all agreed that the Egyptians's large flat nose and puffy lips were proof of their Negro origin."

Carl Bronner

9. H. M. Stanley – *North American Review*, Vol. 170, 1900

> "...the ancient sculptures of Egypt's monuments, most mummies, the Sphinx, wooden and stone statues, bear a strong resemblance to the Afro-Asian... the Egyptians had woolly hair and dark-dusky skins." (p.656)

10. Manetho – *Manetho*, William G. Waddell, Translator, 1940

> "The Egyptian historian, Manetho, and also a priest under Ptolemy I, said that Ramesses I, was a black (Pharaoh) king, who was the son of Amenophis (Amenhotep) and the father of Seti I. Seti I was the father of Ramesses II."

11. William Whiston – *The Life and Works of Flavius Josephus*, 1957

> The great Jewish historian, Flavius Josephus, who was present during the time of Jesus (c. 30 B.C.E. to 5 C.E.) wrote that Moses had two Negro wives. Both were beautiful Ethiopian women, with the first being Tharbis, daughter of the Ethiopian king. While in exile, he married Zipporah, who was a daughter of a Midian priest called Jethro or Raquel in the Middle East. (pp.79-80)

12. M. Fishberg – *American Anthropologist*, Vol. 5, 1903
 The Jew, 1911

> "The ancient Hebrews possessed largely Negro features such as woolly hair, dark skins, thick lips that folded, large heads, and projecting jaws."
> (p.89)
> (p.117; pp.120-134; pp.146-149; p.174; p.178; p.181)

13. Tacitus, Roman Historian (55-120 C.E.) – "Tacitus," Book V, Chapt. 2

> "The Hebrews were people of Ethiopian origin."

14. Hamdani, Arabian Historian (10th Century C.E.) – "Manuscript"

> "...the Queen of Sheba's mother was an Ethiopian (Black) named Ekeye... the queen lived in Africa and Arabia (Kush), but mostly in Africa."

Carl Bronner

15. E. Pittard - *Les Races et L'histoire*, 1924

> "...the skulls of the Phoenicians were distinctly Negroid. Their noses were flat at the end, and their mouths were wide with thick lips... The museum in Carthage that held the tomb of the priestess of Tanit, bore Negro characteristics. The buried woman was of African origin."
> (p.188; pp.409-410)

16. John L. Johnson - *The Black Biblical Heritage*, 1975

> "The title Amon, first called 'Amen,' originated from the African continent (c. 1989 B.C.E.) about 1,350 years before the Colored Amon of Judah was born. The god Amon was the Negroes's chief deity of heaven and earth, streams and hills, and as a demiurgos, the creator of beings. Amon was anciently called Amen or Amen-Ra by the Ethiopians, Egyptians, Libyans, Arabians and other Negro stocks, whose worship would often motivate repetitious cheers "Amen, Amen," a name (word) now cherished by the Judaists and Christians." (p.173)

(Amen = Amon = Ammon = Amun = No-Amon = No)

> "...Arabia's earliest ancestors were people of the Negro race. Thus, study is proving that ancient and modern Arabia's Negro-mixture is indisputable." (p.187)

PRIMARY PROVIDER FOR ABOVE QUOTES FROM ONE THROUGH FIFTEEN:

John L. Johnson
The Black Biblical Heritage: Four Thousand Years of Black Biblical History, (1975 - 1991)
Nashville, Tn: Winston-Derek Publishers, Inc.

Carl Bronner

17. Chancellor Williams – *The Destruction of Black Civilization: Great Issues of a Race from 4500 B.C. to 2000 C.E.*, 1987

> "I knew even before leaving high school that (1) The Land of Blacks was not only the 'cradle of civilization' itself but that the Blacks were once the leading people on earth; (2) that Egypt once was not only all-black, but the very name 'Egypt' was derived from the Blacks; (3) and that the Blacks were the pioneers in the sciences, medicine, architecture, writing, and were the first builders in stone, etc." (p.18)

> "Egypt, Ethiopia's oldest daughter, was the north-eastern region of ancient Ethiopia..." (p.59)

> "Developments in Asia and Europe one and two thousand years after the 'golden age' of black civilization helped to obscure that civilization or paint it over as an entirely Euroasian achievement. Out task is to begin the removal of this false encrustation, hardened as it is by two thousand years of unchallenged growth." (p.66)

18. John G. Jackson – **Christianity Before Christ**, 1985

> "The Osiris-Horus cult can be traced back to the Ethiopian ancestors of the Egyptians. In the words of Harold P. Cooke (in his **Osiris: A Study in Myths, Mysteries and Religion**, 1931):
>
>> 'The worship and rites of Osiris may have passed into Egypt, I think from the neighboring state of Ethiopia... Herodotus says in his history, that following the Nile to the south, you will come to a great city, Meroe. The people have but two gods -- that is, Zeus and Dionysus or Bacchus... Now Zeus must be Amen or Amun. Dionysus is no doubt Osiris...'
>
> (Jackson: p.91)

> "Gods and heroes born of virgins were quite common in days of old, and the source of most, if not all of the virgin-born, dying and resurrecting gods seems to have

Carl Bronner

been Egypt. An English scholar, Jocelyn Rhys, has an interesting statement relating thereto: (Jocelyn Rhys - **Shaken Creeds: The Virgin Birth Doctrine**, 1922)

'Horus was said to be the parthenogenetic child of the Virgin Mother Isis. In the catacombs of Rome, black statues of this Egyptian divine Mother and infant still survive from the early Christian worship of the Virgin and Child to which they were converted. In these the Virgin Mary is represented as a black Negress and often, with the veiled in the true Isis fashion...'
(Jackson, p.189)

'As Isis was dark-skinned, (likewise Virgin Marys) became famous Black Virgins. Notre Dame in Paris was built on the remains of a temple of Isis; the original name of the city was <u>Para Isidos,</u> the Grove of Isis. There are Black Virgins near Marseilles, near Barcelona, at Czestochowa in Poland, and in numerous other cities in Europe. (Egerton Sykes, **Everyman's Dictionary of Non-Classical Mythology, p.249**)'
(Jackson, p110)

"In 1921 when Dr. Albert Churchward in his **The Origin and Evolution of the Human Race**, announced that Africa was the cradle of the human species and that mankind had emerged from the apes in the so-called Dark continent at least two million years ago, he was shouted down by his anthropological colleagues. Churchward also stated that the first true men were the Pygmies of Africa."
(p.173)
(See Kenneth F. Weaver and others in this Reference Guide, p.8)

Carl Bronner

"These ancient little men (Pygmies) were certainly not savages. In the words of Eugen Georg (in **The Adventure of Mankind**, 1931):

> 'There must once have been a tremendous Negro expansion, since the original masters of the lands between Iberia (Spain and Portugal) and the Cape of Good Hope (South Africa) and East India were primitive and probably dwarfed Black men...a primitive Negroid race of Pygmies once lived around the Mediterranean. Blacks were the first to plow the mud of the Nile; they were the dark-skinned, curly-haired Kushites. Blacks were the masters of Sumeria and Babylon before it became the country of the four tongues. And in India, the kingdom of the Dravidian monarchs, the Black and godless enemies, existed until the period of written history'."
>
> (p.175)

19. Robert Graves – **The Greek Myths**, Vol. 2, 1955

(King) "Priam had now persuaded his half-brother, Tithonus of Assyria, to send his son Memnon the Ethiopian to Troy...
...Tithonus emigrated to Assyria and founded Susa, Memnon, then only a child, had gone with him. Susa is now commonly known as the City of Memnon; and its inhabitants as Cissians, after Memnon's mother Cissia.
He (Memnon) was black as ebony, but the handsomest man alive, and like Achilles wore armour forged by Haphaestus."
(pp.313-314)

(See Amenemhet III in this Reference Guide, p.58)

Carl Bronner

28. Sir Godfrey Higgins, Esq. - Anacalypsis: An Attempt to Draw Aside the Veil of The Saitic Isis - (An Inquiry Into the Origin of Languages, Nations, and Religions), Vol. I, 1836

> "In the most ancient temples scattered throughout Asia, where his worship is yet continued, he (the religious Buddha of India) is found black as jet, with the flat face, thick lips, and curly hair of the Negro." (p.52)

> "...Memnon who was said to have been sent to the seige of Troy, and to have been slain by Achilles; and who was also said, by the ancient authors, to be an Ethiopian or a Black. (p.55)
> ...Virgil (70-19 B.C.E.) (author of the Eclogues, the Georgics and the Aeneid, was the greatest Roman poet - Encycl. Britannica, Vol. 23, 1972) makes Memnon black, as does also Pindar (c.518-438 B.C.E.) (The greatest of the Greek choral lyrist... - Encycl. Britannica, Vol. 17, 1972) (p.56)

> "Osiris and his Bull were black; all the Gods and Goddesses of Greece were black: at least this was the case with Jupiter, Bacchus, Hercules, Apollo, Ammon. The Goddesses Venus, Isis, Hecati, Diana, Juno, Metis, Ceres, Cybile, are black...
> There is scarcely an old church in Italy where some remains of the worship of the BLACK VIRGIN and the BLACK CHILD are not met with. Very often the black figures have given way to white ones, and in these cases the black one, as being held sacred, were put into retired places in the churches, but not destroyed, but are yet to be found there." (p.138)

> "The truth is, that the worship of the virgin and child, which we find in all Romish countries, was nothing more than a remnant of the worship of Isis (Auset) and the god Horus (Heru)." (p.316)

> "The Rev. Dr. Claudius Buchanan ...published Travels in India, in which he states, that he found no less sixty-five settlements of BLACK Jews..." (p.398)

Carl Bronner

Yosef A. A. ben-Jochannan - No. 1: ibid.

Runoko Rashidi - **African Presence in Early Asia** - Editors: Ivan Van Sertima
and Runoko Rashidi

Wayne B. Chandler - **African Presence in Early Asia**

James E. Brunson - **African Presence in Early Asia**

Beyond The Kingdoms of Kemet and Nubia in Ancient Ethiopia

While we have focused our attention on Egypt and its ancestors, we do not mean to suggest that this was the only place in the ancient world where history was being made by Africans. We made it a focal point because the Greeks, Romans, and other European nations learned so much, claimed many African ideas and resources, and then began to cover-up the identities of their creators and inventors.

Before recorded history (that is 30,000 to 40,000 years ago), when far-eastern Asians (people later mis-named by Christopher Columbus) were undergoing the great migrations into the Americas, the people of southeast Africa (in and around present day, Zimbabwe) were excavating iron ore from their mines and carving sculptures of the human figure. Both the mining and the sculpture offer distinct evidence of an advanced culture. But one piece of Zimbabwean sculpture—estimated to be about 32,000 years old—has been named, oddly enough, "The Venus of Dusseldorf" by Europeans. This European and American practice of incorrectly titling artifacts from foreign cultures causes them to lose their true identity and value. Just as we pointed out that the Greeks changed the names of everything they found in Africa, we still find Europeans labeling such items as Thutmose III's obelisks as "Cleopatra's Needle." Cleopatra had absolutely nothing to do with the obelisks except perhaps to honor them.

Dr. Rashidi states that the black people who were the founders of the Indus (or Sind) Valley civilizations in India had straight to wavy hair texture with distinct Africoid features. Wayne Chandler estimates that Africans settled in the Indus Valley perhaps as long as nine thousand years ago. These are the same people that Herotodus called Ethiopians. And James Brunson introduces us to the first Chinese emperor, Fu-Hsi (2953 - 2838 B.C.E.) who was a woolly-haired Negro.

Carl Bronner

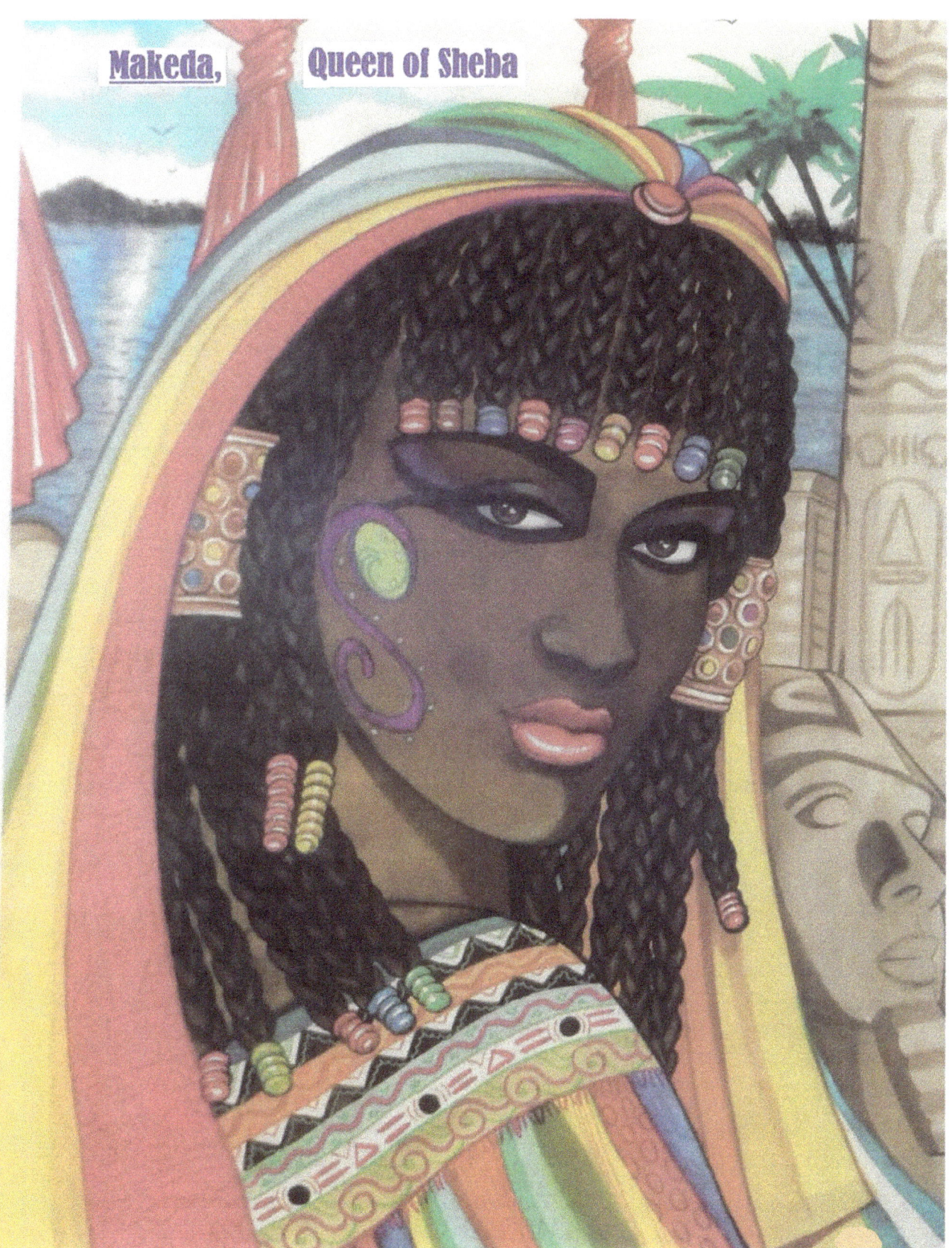

Larry Williams & Charles S. Finch - "The Great Queens of Ethiopia," **Black Women In Antiquity,** 1984, Ivan Van Sertima, Editor

J. A. Rogers - **ibid.**
John L. Johnson - **ibid.**
King James Version of the **Holy Bible**

Makeda - "The Queen of Sheba" - c. 960-930 B.C.E. (Close to 3,000 Years Ago)

Makeda, the Queen of Sheba, lived in Africa and Kush (Arabia). She was an Ethiopian by blood, land, and culture, and according to biblical historians, she was an outstanding "descendant of Ham's great-grandson, Cush." In some writings she is known as the "Queen Belkis."

From his deathbed, her father appointed Makeda to succeed him. "Tradition has it that the land area she governed was quite extensive and while it is not always possible to separate legend from fact, the various lands ascribed to her empire included (some) parts of Upper Egypt (i.e., southern Egypt), Ethiopia, Arabia (Kush), Syria, Armenia, India and the whole region between the Mediterranean and the Erythraean Seas." Her capital was located at Axum on the southwestern shore of the Red Sea. It must have been the legend of this seemingly endless empire that led Flavius Josephus, the ancient Jewish historian, to label Makeda as "the Queen of Egypt and Ethiopia."

Makeda "...engaged in extensive trade. Her astuteness as a commercial trader is observed by the boldness of her trade relations in the markets of Damascus and Gaza. The trade network she organized was both by land and sea and was effectively manned by vigilant Ethiopian merchants. It was these skills along with her beauty which captivated the heart and soul of King Solomon. Her life represented firmly the way in which the matriarch co-existed in Africa side by side with the patriarchy."

This Kentake (Candace) Queen and King Solomon formed a matrimonial union from which their descendants ruled old Ethiopia and Abyssinia (modern Ethiopia).

Several mentions are made of Makeda in the "Song of Solomon" of the **Holy Bible,** where she describes herself as "...black but comely." Elsewhere Jesus refers to her as the "Queen of the South."

Carl Bronner

Long before Christianity was instituted in Europe, the Kentake (Candace) Queen brought it to Ethiopia by sending her high treasurer, the eunuch, to Jerusalem to seek information concerning the new religion of the recently crucified Christ.

John L. Johnson

(Artist: Yvonne Lawson)

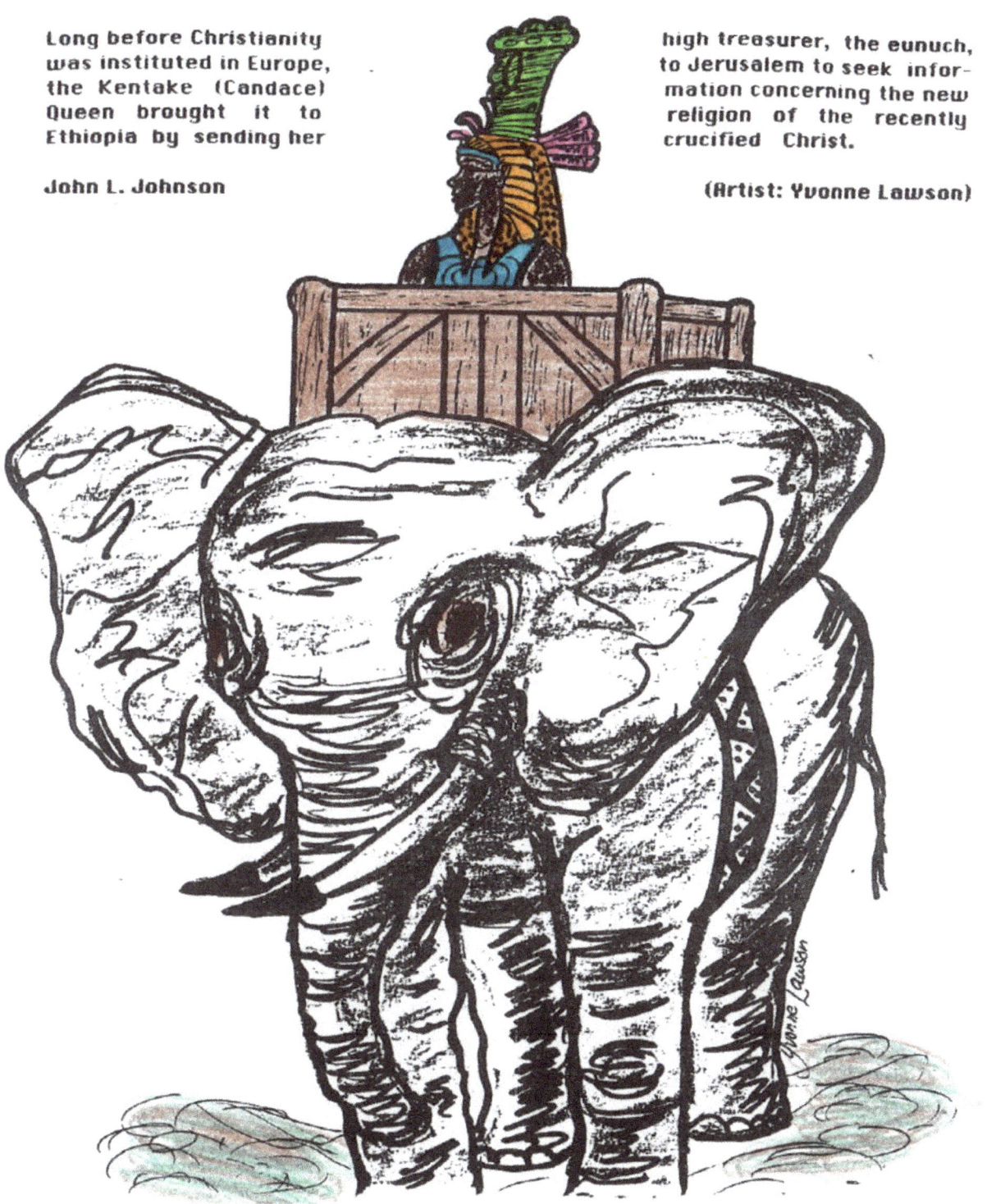

Charles S. Finch III, M.D. - **Black Women in Antiquity** - Editor: Ivan Van Sertima

Asa G. Hilliard III - No. 1: ibid.

Kentake (Queen Mother) - c. 332 B.C.E. (Approximately 2,325 Years Ago)

Although Egypt had fallen into the hands of Asian and European conquerors, kingdoms south of it still managed to maintain their power and independence. Guided by the strong leadership of her many kings and queens, Cush (Ethiopia) was one of those kingdoms which maintained control until 350 C.E. (A.D.). The time and event coincide with the adoption of Christianity in Europe. Before and after the time of Alexander "the Great" (332 B.C.E.), Cush's royal dynasties included four or five queens who were independent rulers; that is, these were solitary monarchs without companion kings. These were the "Kentakes" (Kantakes) or "Queen-Mothers" who often led their armies into battle. Modern historians refer to these queens as "the Candaces."

Alexander "the Great" reportedly had a brief encounter with one of the Kentake queens. It seems that Alexander was not totally satisfied with his military conquest of Egypt, and went forward with plans to subdue Cush as well. But when his army came face to-face with the army of the Kentake (Candace) Queen, with a cavalry mounted on the backs of elephants and a impressive number of infantrymen, Alexander halted his army at the first cataract and headed back to Alexandria.

The power of the Ethiopian monarchs was never challenged again by either the Greeks or the Romans, whom as you know, followed the Greeks as provincial rulers of Egypt. Because many writers of ancient history arbitrarily decided to omit and deny black participation in all of these empires, Cush, Egypt, Greece, and Rome, most people are unaware that even the Greek and Roman armies, in Europe, Africa, and the Middle East, utilized the services of many black Africans. Some of these were of high rank, such as the one mentioned earlier, General Clitus who was Alexander's ("the Great') cavalry leader. And in the Roman era, there were Septimus Severus, Caracalla, Maurice of Aganaum and others who will be discussed in volume two of **Black Africans**.

Carl Bronner

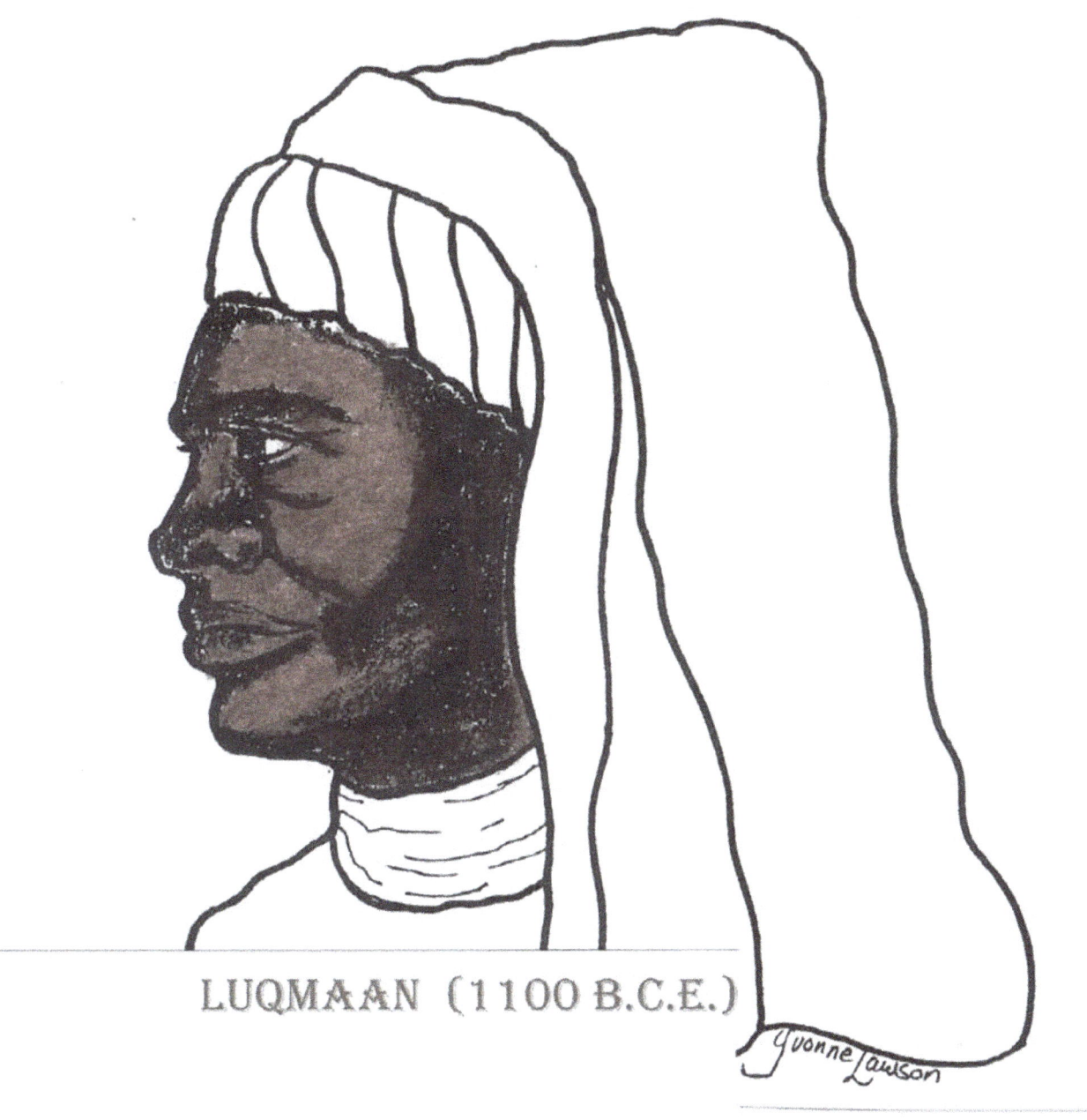

LUQMAAN (1100 B.C.E.)

"We enjoined the human being to honor his parents. His mother bore him, and the load got heavier and heavier. It takes two years (of intensive care) until weaning. You shall be appreciative of Me, and your parents. To Me is the ultimate destiny." *Quran: The Final Testament*, Sura 31
"Walk humbly and lower your voice – the ugliest voice is the donkey's voice."
Quran..., Sura 3; See "Lokman", J. A. Rogers's *World's Great Men of Color*

Luqmaan (Lokman)

J. A. Rogers - **ibid.**

Jamal Koram the Storyman - **Aesop: Tales of Aethiop the African**

The Great Fablists

Lokman (Luqman or Luqmaan) – c. 1100 B.C.E. (3,100 Years Ago)

Aesop – 560 B.C.E. (2,550 Years Ago)

A most celebrated sage (profoundly wise man) lived in southern Arabia when that land was still known to the Asian and African world as Cush (Ethiopia) This was the legendary fablist, Luqman.

The Arabs say that Luqman was a coal-black Ethiopian with woolly hair who lived about 1100 B.C.E. Luqman is often confused with Aesop, who was also a black African. About 500 years after Luqman, it appears that Aesop, the other famous fablist, used some of Luqman's fables. Luqman has often been quoted by the Arabs. Even the founder of Islam, the great Prophet Muhammad quoted him as an authority on religious and moral matters, and named the Thirty First chapter of the Quran after him.

The second and most loved fablist of the western world is Aesop who lived in the Sixth Century B.C.E. His name Esop is another form of "Ethiop" which means Ethiopian. J. A. Rogers plainly states that millions of people have benefitted from their experience with "Aesop's Fables."

We have learned valuable lessons from his fables. In "The Boy Who Cried Wolf," we learned that it is not wise for one to call for assistance when one does not need it. In "The Terrapin and the Hare," we learned that the prize is not always meant for the swiftest. In "The Lion and the Fox," we learned how the mistakes of others can be beneficial lessons for us all, and in "Umoja (Unity), we clearly see that a family's strength is in togetherness. More families of the 1990's should tune into the message of Aesop's "Umoja."

J. A. Rogers - **ibid.**

John L. Johnson - **ibid.**

To the east of northeast Africa --in the southwestern region of Asia now called the Middle East--, to the south and west of Egypt, Nubia, and Ethiopia there lived other Africans of great fame. For example, at about 1100 to 945 B.C.E., when the last Rameses and the Tanite kings were ruling Egypt, the Region in Asia east of the Red Sea called Cush (now Arabia) was home to the famous wise man, Lokman (Luqman or Luqmaan). Both Cushitic lands (Ethiopia and Arabia) made up the realm of Makeda, the Queen of Sheba.

During the period 570 to 525 B.C.E., when Pharaohs Apries (Hophra) and Amasis (Ahmose II) ruled in Egypt, the fame of another Lokman-like sage known as Aesop was spreading in Phrygia (Turkey) and Greece. To the west of Egypt, less than a thousand miles away lay Carthage (Tunisia) where "the Father of Military Strategy," General Hannibal ruled from the year 221 until 183 B.C.E.

And still before the time of Cleopatra VIII, the world famous Latin Stylist, Terence --whose real name was Publius Terentius Afer--was born in Africa. He resided in Rome sometime between the years 190 and 159 B.C.E. where he was forced to live the life of a slave.

Carl Brown

"THE ETHIOP"
Native of Phrygia

"If you don't know who you are, you will try to be some of everybody"

"...Terrapin and the Hare"
"...the prize is not always meant for the swiftest"

AESOP

"Before you hunt for the truth, be prepared to meet it."

"Today is tomorrow yesterday; Live for today, plan for tomorrow, remember yesterday."

Publius Terentius

"Homo sum humani nihil a me alienum puto." Publius Terentius Afer
(translation)-"I am a man and nothing human is alien to me."
The above drawing of an African Mesahhar would most correctly approach
the true dusky appearance of the Latin Stylist, Terence.
(From the Afro-Vision Collection)

J. A. Rogers - ibid.

Terence "The Greatest Latin Stylist" – c. 190 to 159 B.C.E.
(Approximately 2,175 Years Ago)

"The greatest of the Latin Stylists was Publius Terentius Afer," whose name meant, Terence, the African. Suetonius, the Roman writer of Terence's biography reported that he was born in Africa about 190 B.C.E. and lived to be about thirty-one or thirty-two years old. He further wrote that Terence was dusky (black) in color. Other Roman and Greek historians had described Hannibal and his "dusky" legions in the same manner. The record reveals that he was a Roman slave in Africa who was brought to Rome. There he was purchased by Terentius Lucanus who upon recognizing his great aptitude for learning set him free. Lucanus furthered honored him by naming him after himself, Terentius. Oddly enough, this African, Terence was said to be a close friend of Scipio Africanus, the general who saved Rome from Hannibal.

Terence wrote six comedies which today still serve as models of Latin composition. The titles of the comedies are as follows:
1) "Andria"
2) "The Mother-in-Law"
3) "The Self-Avenger"
4) "The Eunuch"
5) "Phormio"
6) "The Brothers"

"Terence is immortal, not alone for the purity of his language and the flawlessness of his verse. He is also regarded as one of the greatest humanists of all time. There is one line of his which, if all else had been lost, would have been sufficient to assure his immortality, a line that will remain the criterion of the truly cultured individual as long as as breadth of knowledge is valued. It is:
 'Homo sum humani nihil a me alienum puto'
 (I am a man and nothing human is alien to me.)"
 - J. A. Rogers

Carl Bronner

Part Two

Includes

"Great Kings of Africa" Series

by
The Budweiser Artists
(Anheuser-Busch, St. Louis, MO)

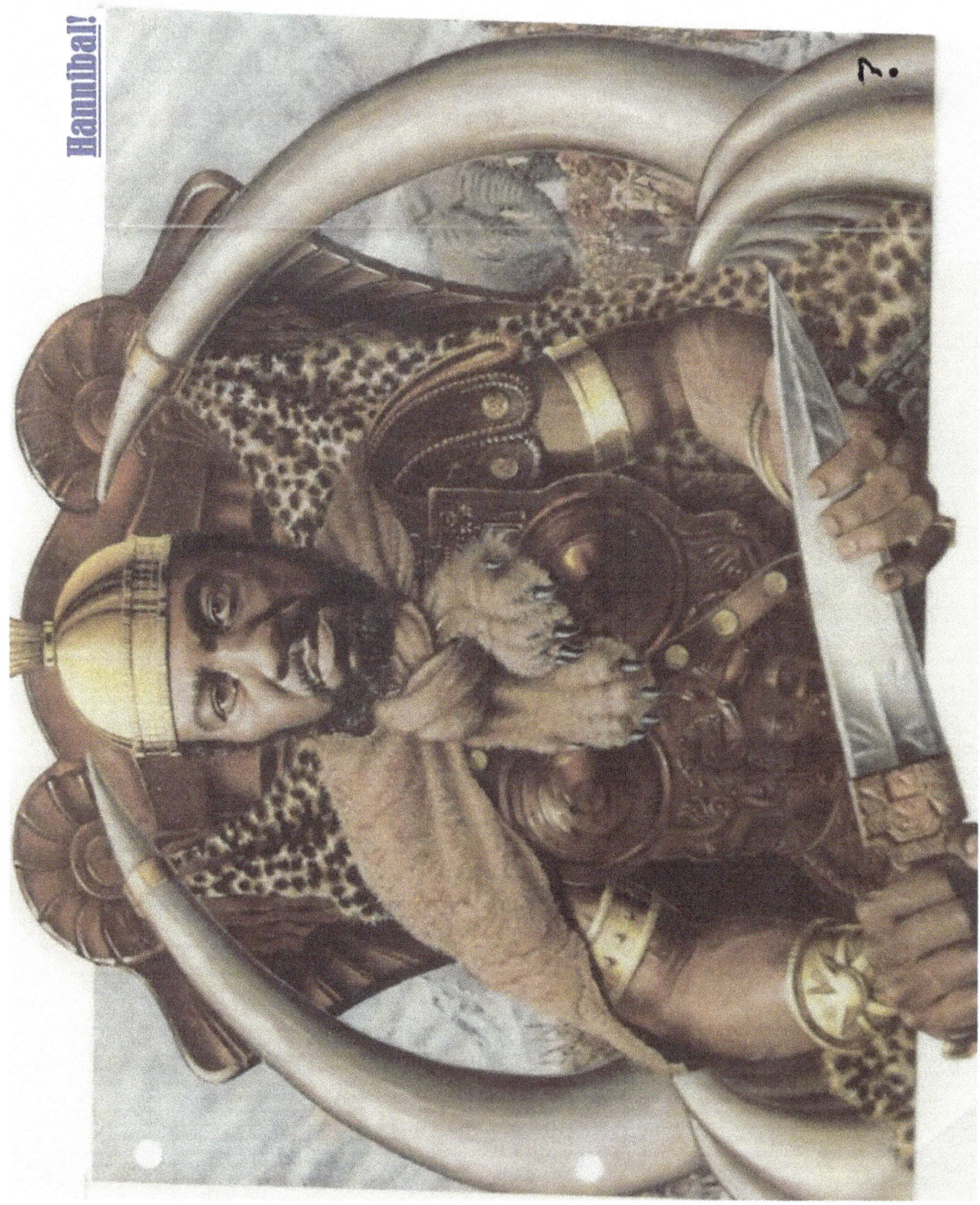

J. A. Rogers - **ibid.**

Hannibal "Father of Military Strategy" – c. 247 to 183 B.C.E.
(Approximately 2,200 Years Ago)

The Greek reign in Egypt came to an end with the Roman conquests during the final fifty years of the old B. C. Era. That is before the A. D. Era which is now the Common Era (C.E.) for many of the world's peoples.

However, by the year 216 B.C.E., the most formidable enemy of the Roman Empire was an African general (Carthaginian, to be exact) named Hannibal. So bold was Hannibal that he ordered his army to invade the Roman Empire by way of the Maritime Alps (i.e., the French and Italian Alpine Mountains). His army consisted of a cavalry whose complement included elephants and horses, and a fierce infantry.

He re-wrote the book on military strategy when he took on the armies of the Roman empire and for fifteen years defeated them. Having learned a great deal about military strategy from his father, Hamilcar Barca, "the Lightning," Hannibal became supreme military commander of the Carthaginian army on the Iberian peninsula (Spain and Portugal today). When the second Punic War with Rome began Hannibal was at the Pyrenees mountains (border between Spain and France) with 80,000 infantry, 12,000 cavalry and 40 elephants. Once beyond the Pyrenees he moved into Gaul eliminating all of his enemies and captured a Roman stronghold at Massillia (now Marseilles, France).

Hannibal then set out to accomplish what the Romans considered to be the impossible. In assuming this daring feat, he marched his entire army, including elephants across the snow-capped peaks of the Swiss Alps into Italy. On this fifteen day trek, the weather conditions had a devastating effect on his army's soldiers and animals. Fifty-six thousand men were lost. But this did not keep him from carrying out a number of brilliant victories over much larger Roman armies in Italy.

In the year 218 B.C.E., General Scipio engaged his Roman army of 80,000 in battle against the forces of Hannibal which now totalled approximately 26,000. After forcing Scipio's army to attack en masse (in a bunch), Hannibal set "his armored elephants upon them, trampling them and throwing them into complete disorder." The elephant attack was followed by his

Hannibal – Ruler of Carthage (247-183 B.C.)

Regarded as one of the greatest generals of all time, Hannibal and his overpowering African armies conquered major portions of Spain and Italy and came close to defeating the mighty Roman Empire.

Born in the North African country of Carthage, Hannibal became general of the army at age twenty-five. His audacious moves — such as marching his army with African war elephants through the treacherous Alps to surprise and conquer Northern Italy — and his tactical genius, as illustrated by the Battle of Cannae, where his seemingly trapped army cleverly surrounded and destroyed a much larger Roman force, won him recognition which has spanned more than 2000 years. His tactics have been studied and successfully imitated by Generals as recently as World War II.

The genius of Hannibal extended beyond the battlefield, however. After the Punic Wars, his leadership and administrative abilities brought Carthage great prosperity and prestige.

Hannibal, Ruler of Carthage, N. Africa

J. A. Rogers - **ibid.**

Hannibal - (From Carthage in Numidia)

African swordsmen who cut the rest down without mercy, including Scipio himself. Scipio was snatched from the hands of death by his son and heir, Scipio Africanus, "the Elder." About two decades after this battle, this Roman earned the title "Africanus" by scoring a number of military victories against African armies such as Hannibal's. But keep in mind, that at this time they were no match for Hannibal, and it would be nearly two decades before the tide of war turned in the Romans' favor.

Between the years 218 B.C.E. and 216 B.C.E., major battles lost by the Romans included, Ticino, Trebia, Lake Trasimeno, and the Battle of Cannae where the most brilliant of Hannibal's plans fell into place. In this battle, the Romans, under the command of generals, Varro and Emilius, charged at what they thought to be the main center of Hannibal's army. Instead they found themselves surrounded and as a result "were slaughtered like sheep."

Much of Hannibal's brilliance stemmed from his ability to use the natural elements to his advantage. For example, he routed one Roman army by tying flaming torches of sticks and twigs to the horns of a thousand head of cattle. At Trebia, he forced the Romans to become bogged down in a marsh (swamp). And at Cannae, he tricked the Romans into hurling themselves at the imposter army. After the Battle of Cannae, Hannibal controlled all of Italy except for the city of Rome itself.

Now the entire Roman Empire was preoccupied with the threat that Hannibal presented. The Greek historian, Polybius put it this way:
> "...all that happened at Rome, as well as at Carthage, depended on a single man: I speak of Hannibal!"

And another writer said:
> "...Hannibal baffles Rome by the originality and greatness of his plan. He annihilates her army in battle after battle, showing throughout all, supreme excellence, resource, skill, daring, the heroic spirit, the faculty of command in the very highest degree, caution, sound judgment, extraordinary craft, etc."

Hannibal's battle tactics, especially those used in the Battle of Cannae, have been taught (and perhaps still is) in Twentieth Century military academies.

Carl Bronner

Hannibal of Carthage

Images of himself and his prize war elephant are depicted on the two faces of the Hannibal coins. J. A. Rogers

He routed one Roman army by tying flaming torches of sticks and twigs to the horns of a thousand head of cattle.

(Artist: Yvonne Lawson)

26

Tenkamenin, King of Ghana, 1037-1075 A.D.

The country of Ghana reached the height of its greatness during the reign of Tenkamenin. Through his careful management of the gold trade across the Sahara desert into West Africa, Tenkamenin's empire flourished.

But his greatest strength was not in economics, but in government.

Each day Tenkamenin would ride out on horseback and listen to the problems and concerns of his people. He insisted that no one be denied an audience and that they be allowed to remain in his presence until satisfied that justice had been done.

His principles of democratic monarchy and religious tolerance make Tenkamenin's reign one of the great models of African rule.

3

Mansa Kankan Mussa – King of Mali (1312-1337)

A flamboyant leader and world figure, Mansa Mussa distinguished himself as a man who did everything on a grand scale. An accomplished businessman, he managed vast resources to benefit his entire kingdom. He was also a scholar, and imported noteworthy artists to heighten the cultural awareness of his people.

In 1324 he led his people on the Hadj, a holy pilgrimage from Timbuktu to Mecca. His caravan consisted of 72,000 people whom he led safely across the Sahara Desert and back, a total distance of 6,496 miles. So spectacular was this event, that Mansa Mussa gained the respect of scholars and traders throughout Europe, and won international prestige for Mali as one of the world's largest and wealthiest empires.

HIGGIN BOND

10

Sunni Ali Ber – King of Songhay (1464-1492)

When Sunni Ali Ber came to power, Songhay was a small kingdom in the western Sudan. But during his twenty-eight-year reign, it grew into the largest, most powerful empire in West Africa.

Sunni Ali ruled from horseback, leading his country while leading his army. He built a remarkable army – not farmers hastily pressed into service, but full-time, professional soldiers, including a horse and camel cavalry with men in armor.

With this ferocious force, the warrior king won battle after battle. He routed marauding nomads, seized trade routes, took villages, and expanded, ever expanded, his domain. He captured Timbuktu, bringing into the Songhay empire a major center of commerce, culture, and Moslem scholarship. He conquered the city of Jenne, invincible for centuries, with a relentless seven-year siege.

Sunni Ali was both feared by his enemies and revered by his people, who called him Ali the Great. His greatness is still legendary among the Songhay people today.

L+D DILLON

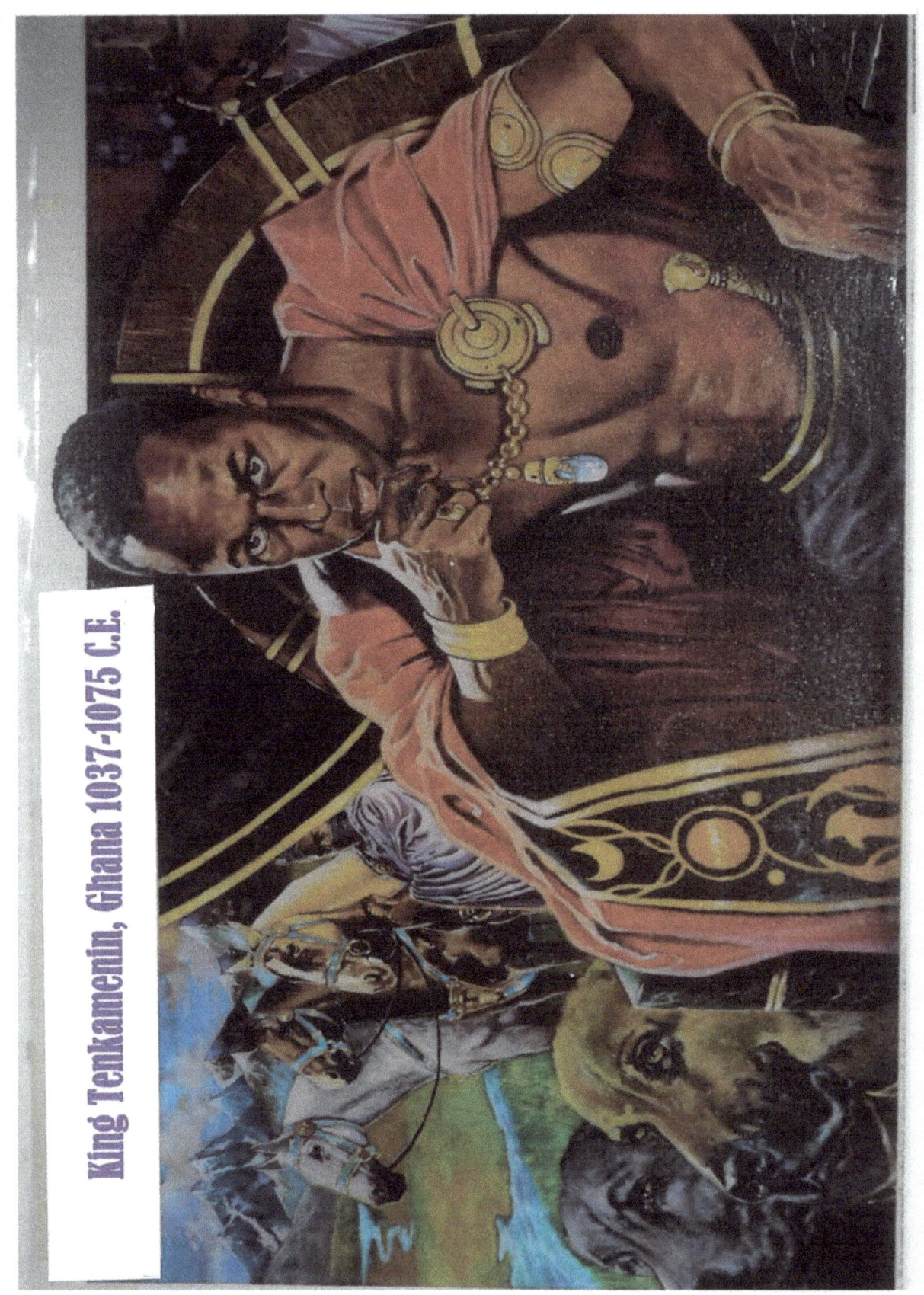
King Tenkamenin, Ghana 1037-1075 C.E.

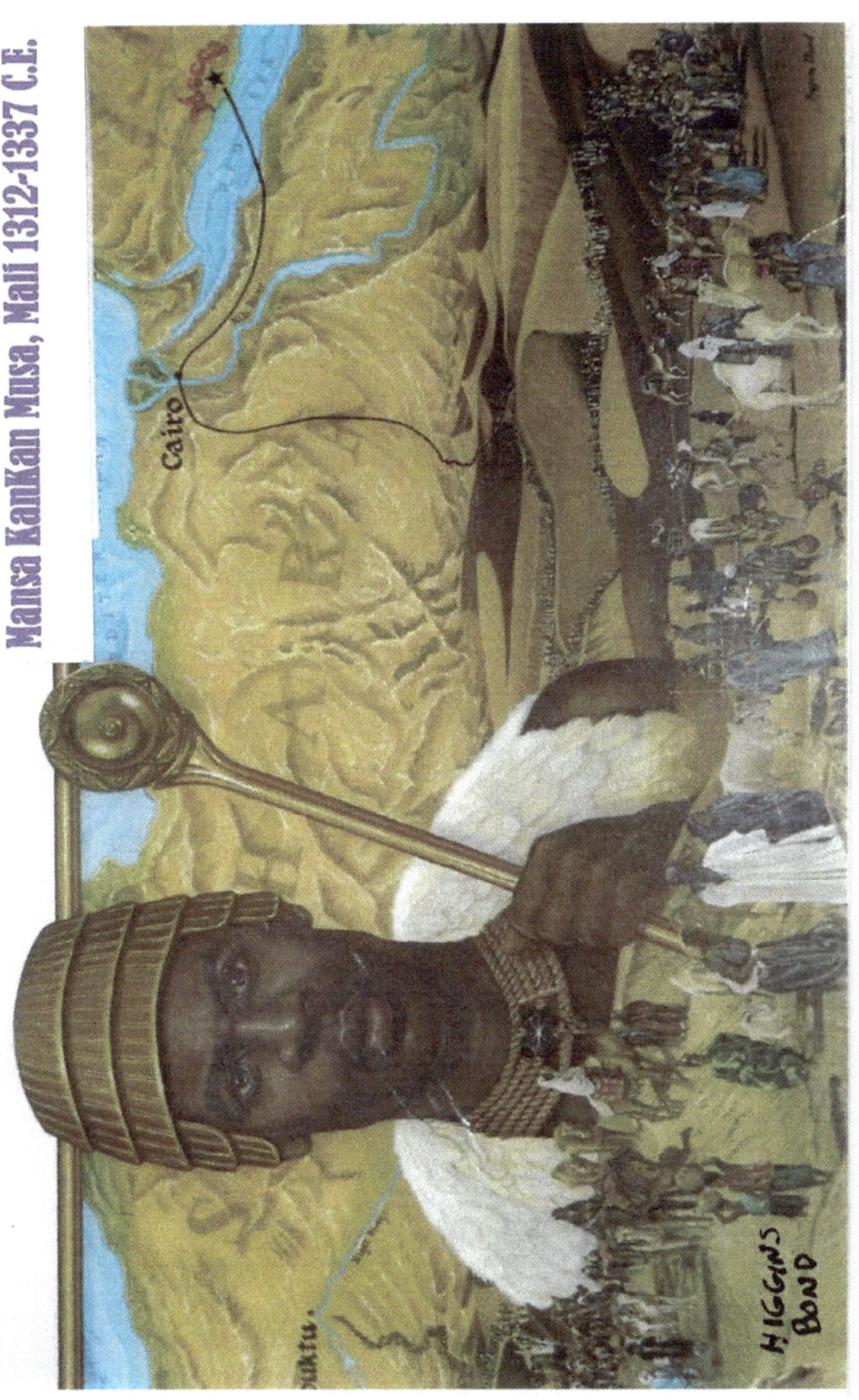
Mansa KanKan Musa, Mali 1312-1337 C.E.

Sunni Ali Ber, Songhay 1464-1492

2

Askia Muhammed Touré – King of Songhay (1493-1529)

Askia "The Great" was a fair and deeply religious man who at times fought established tradition to rule in the best interests of his people.

A devout Muslim, he ruled and administered Songhay strictly according to Islamic Law. He divided his country into provinces, each with a professional administrator as governor, and ruled each fairly and uniformly through a staff of distinguished legal experts and judges. He also adjusted the taxes to reduce the burden on the commoners.

Askia Muhammed Touré united the entire central region of the Western Soudan, and established a governmental machine that is still revered today for its detail and efficiency.

DILLON

1

Affonso I – King of the Kongo (1506-1540)

Affonso I was a visionary, a man who saw his country not as a group of separate cultures, but as a unified Christian nation fully equipped with advanced knowledge and technology.

Affonso I was the first ruler to modernize Black Africa on a grand scale. Because he saw progress as a healthy mix of physical and spiritual development, Affonso encouraged his people to learn Christianity and made it possible for them to practice new skills in masonry, carpentry, and agriculture. He also streamlined Kongo politics, and established one of the most modern school systems in Black Africa.

A proud man, Affonso later became the first black ruler to resist the slave trade.

CARL OWENS

21

Queen Amina Of Zaria

The elder daughter of Bakwa Turunku, who founded the Zazzau Kingdom in 1536, Queen Amina came to power between 1588 and 1589 A.D. Unlike her younger sister, Zariya (from whom the city of Zaria derives its name), Amina is generally remembered for her fierce military exploits.

Many wars she fought, and all she won. And through her conquests, she expanded the area under her reign southward to the great River Niger — including Idah and Nupeland — and up the Kano on the north.

A brilliant military strategist, Amina erected great walled camps during her various campaigns, and is generally credited with the building of the famous Zaria wall. She is today remembered — by some fondly, by others less so — as "Amina, Yar Bakwa ta san rana", meaning "Amina, daughter of Nikatau, a woman as capable as a man."

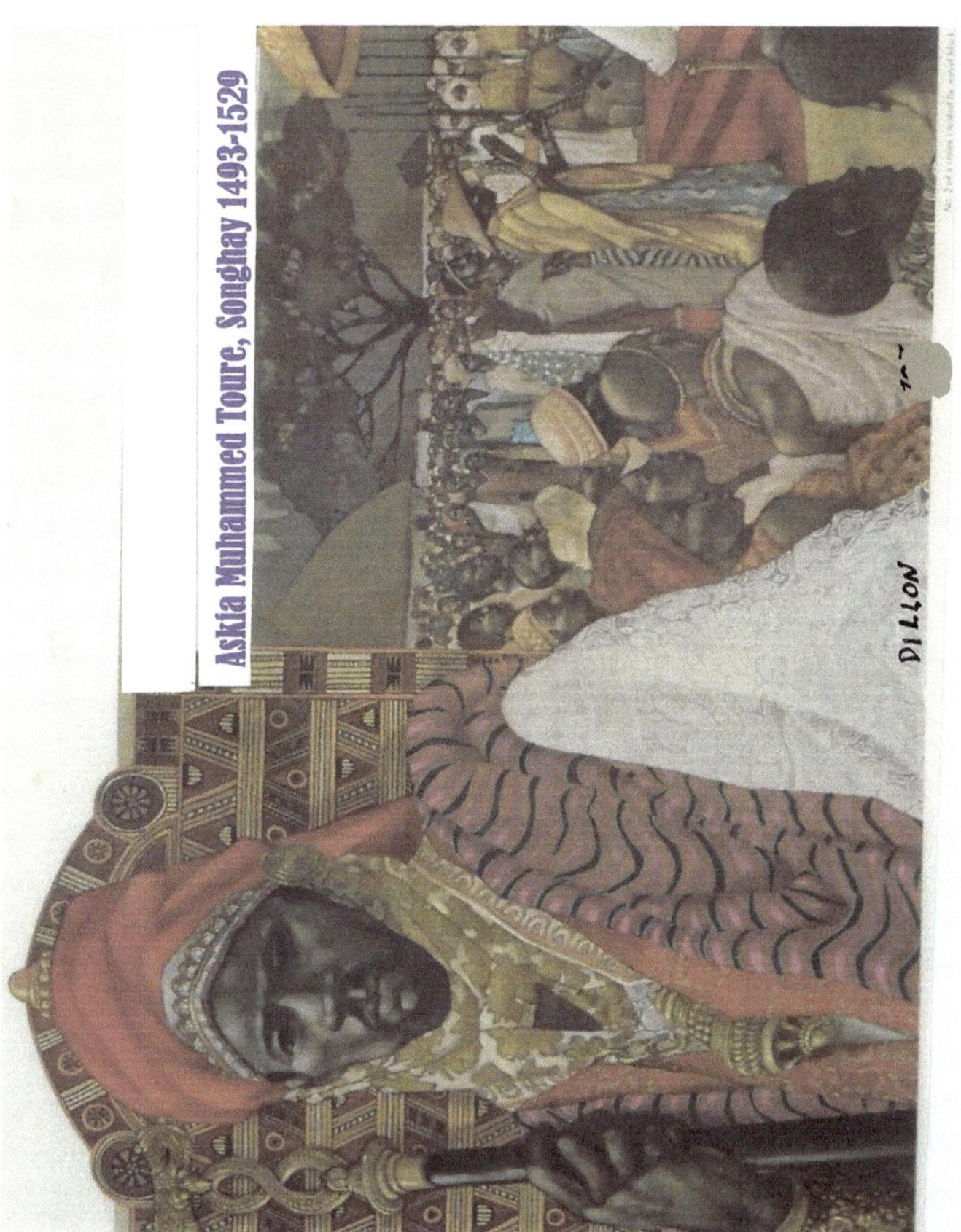

Askia Muhammed Toure, Songhay 1493-1529

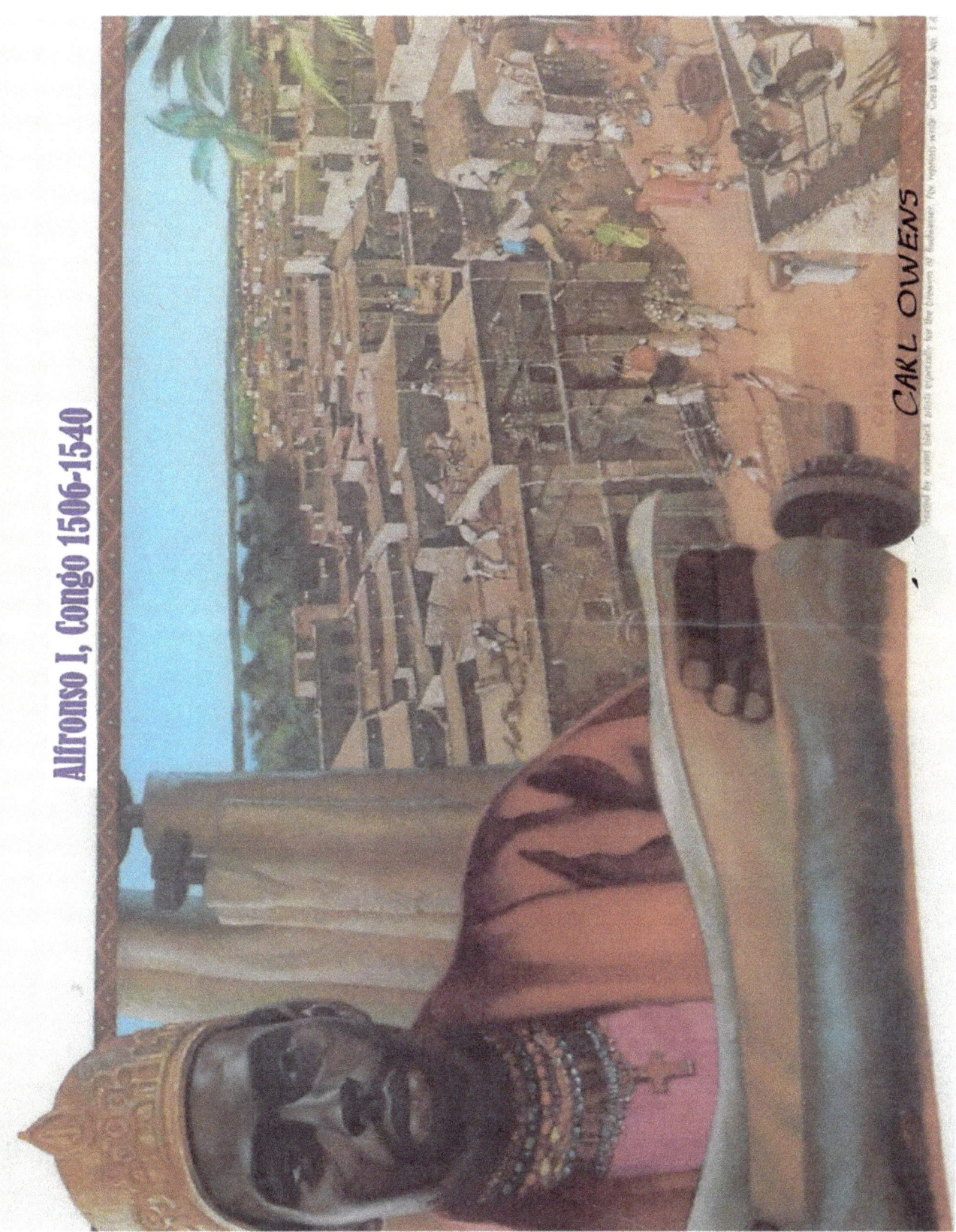

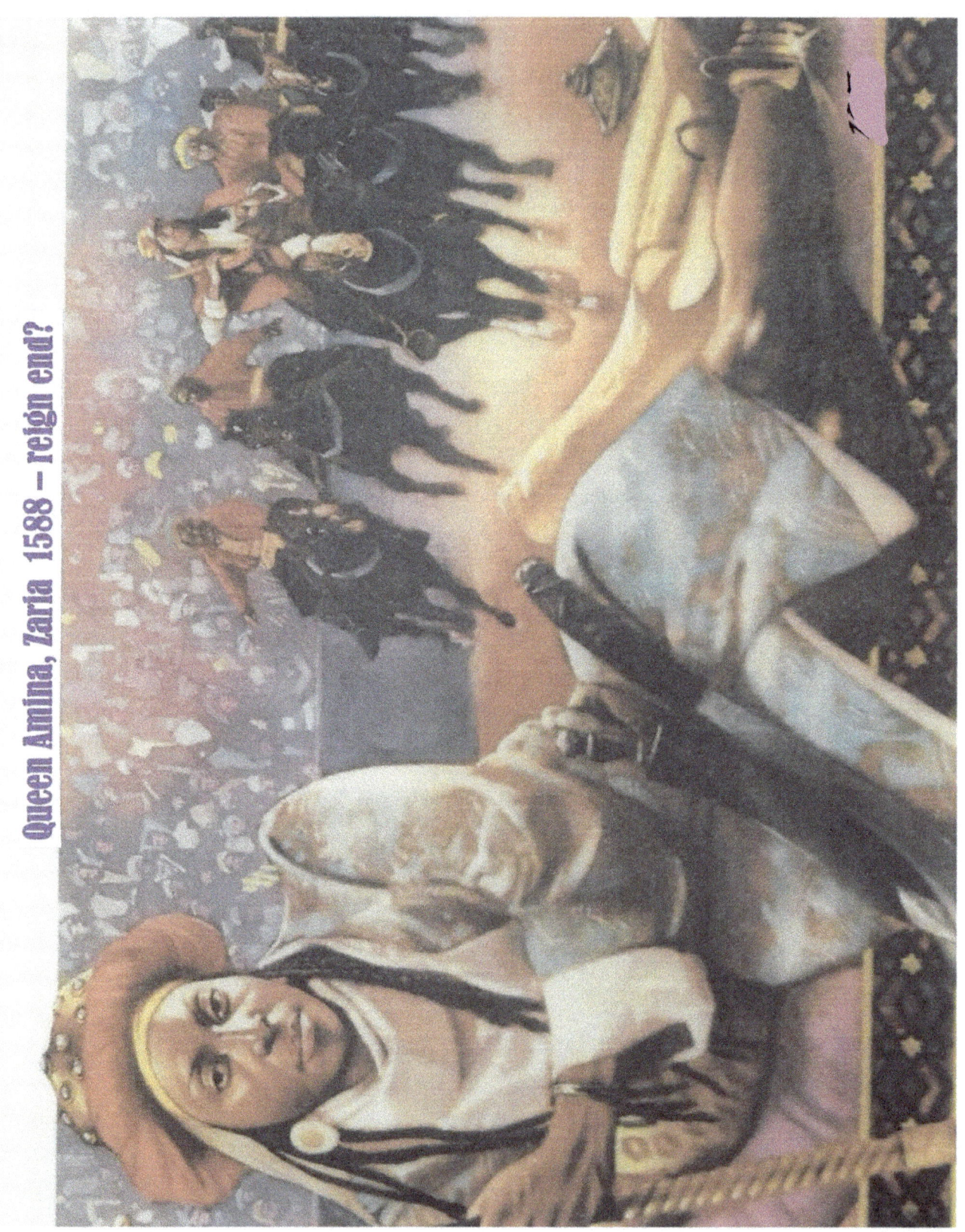

Queen Amina, Zaria 1588 – reign end?

17

Nzingha – Amazon Queen of Matamba, West Africa (1582-1663)

Many women ranked among the great rulers of Africa including this Angolan queen who was an astute diplomat. When the Portuguese attacked the army of her brother's kingdom, Nzingha was sent to negotiate the peace. She did so with astonishing skill and political tact, despite the fact that her brother had her only child killed.

Additionally, Nzingha excelled as a military leader. To arrest the swelling influx of slave-hunting Portuguese, she formed an army and waged war for nearly thirty years. These battles saw a unique moment in colonial history as Nzingha allied her nation with the Dutch. This marked the first African-European alliance against a European oppressor.

Nzingha continued to wield considerable influence among her subjects despite being forced into exile. Because of her quest for freedom and relentless drive to bring peace to her people, Nzingha remains a glimmering symbol of inspiration.

DOROTHY CARTER

12

Idris Alooma – Sultan of Bornu (1580-1617)

The histories of Kanem and Bornu are so intertwined that the two central Sudan states can be considered one great civilization which endured for a thousand years.

Yet for two centuries before Idris Alooma became Mai (sultan) of Bornu, Kanem was a separate land whose people had been driven out by their nomadic cousins, the Bulala. It took one of Africa's most extraordinary rulers to reunite the two kingdoms.

Idris Alooma was a devout Moslem. His brick mosque was the first of its kind. He replaced tribal law with Moslem law. And early in his reign, he made a pilgrimage to Mecca. But the trip had as much military as religious significance, for he returned with Turkish firearms.

Now Mai Idris commanded an incredibly strong army – not only musketeers, but a cavalry that looked surprisingly like European knights in armor. They marched swiftly and attacked suddenly, crushing hostile tribes in annual campaigns. Finally Idris conquered the Bulala, establishing dominion over the Kanem-Bornu empire and a peace lasting half a century.

CHARLES LILLY

14

Shamba Bolongongo – African King of Peace (1600-1620)

Hailed as one of the greatest monarchs of the Congo, King Shamba had no greater desire than to preserve the peace.

Subjects from Bushongo often travelled to distant villages wearing their wood-bladed knife of state, which was recognized and respected by other nations as their sole means of weaponry. Shamba's love for peace is reflected in a common quote of his: "Kill neither man, woman nor child. Are they not the children of Chembe (God), and have they not the right to live?"

Shamba was also noted for designing a complex and extremely democratic form of government featuring a system of checks and balances. The government was divided into sectors including military, judicial, and administrative branches and represented all Bushongo people. It even included a special council for fathers of twins.

Also, Shamba promoted the arts and crafts to such an extent that many were developed to their highest level during his reign.

ROY E. LaGRONE

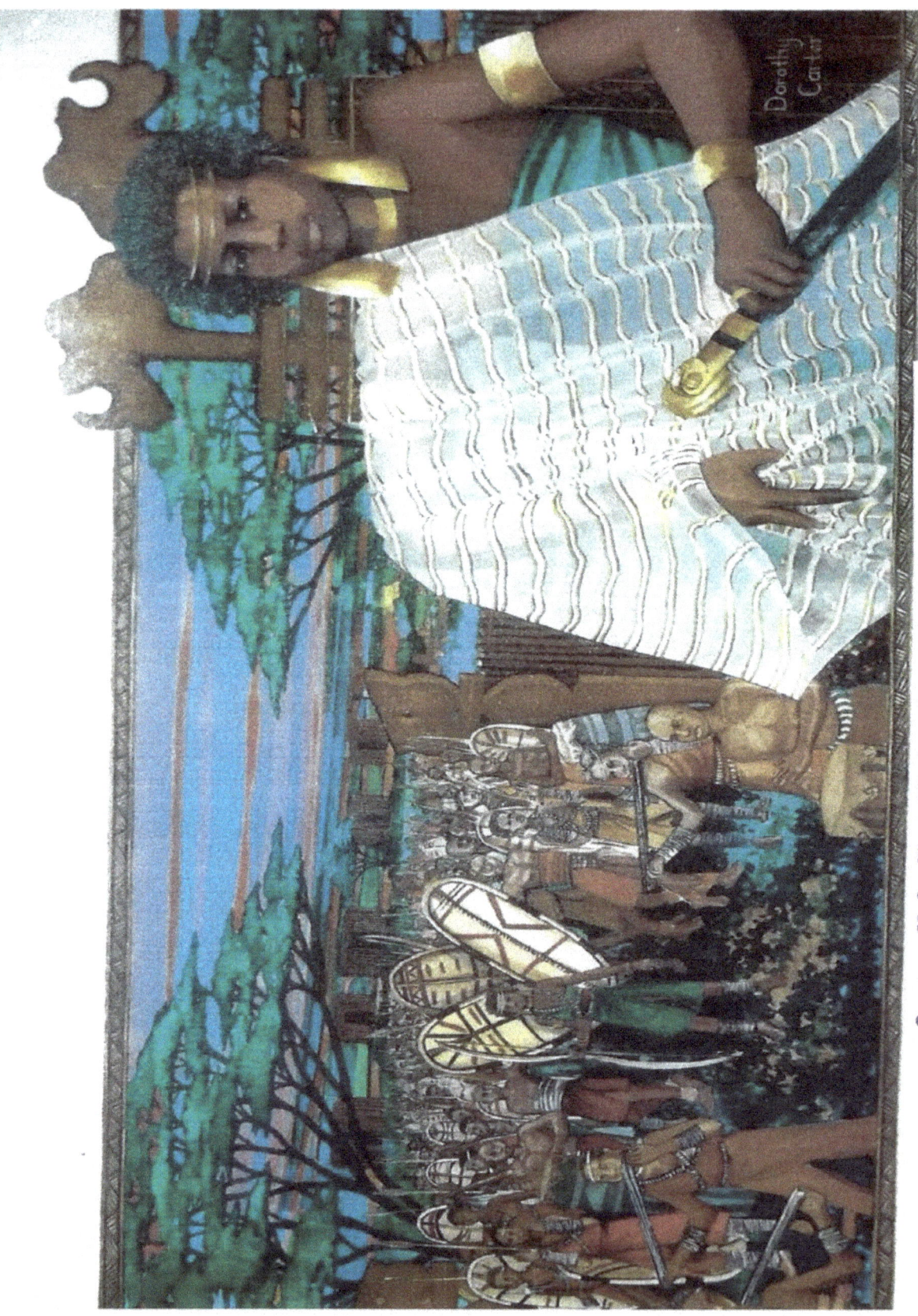

Queen Nzingha, Matamba, W. Africa 1582-1663 DOROTHY CARTER

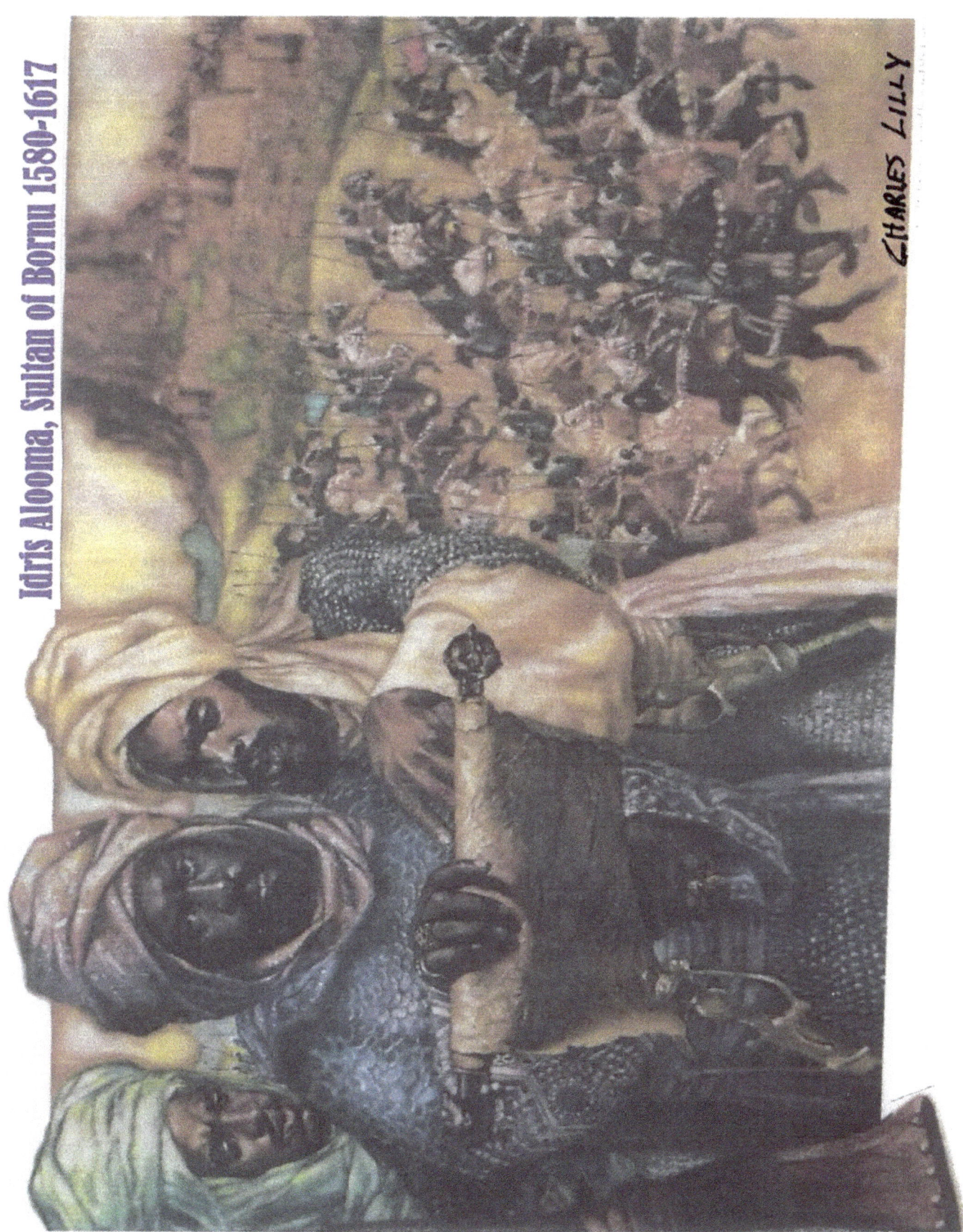
Idris Alooma, Sultan of Bornu 1580-1617

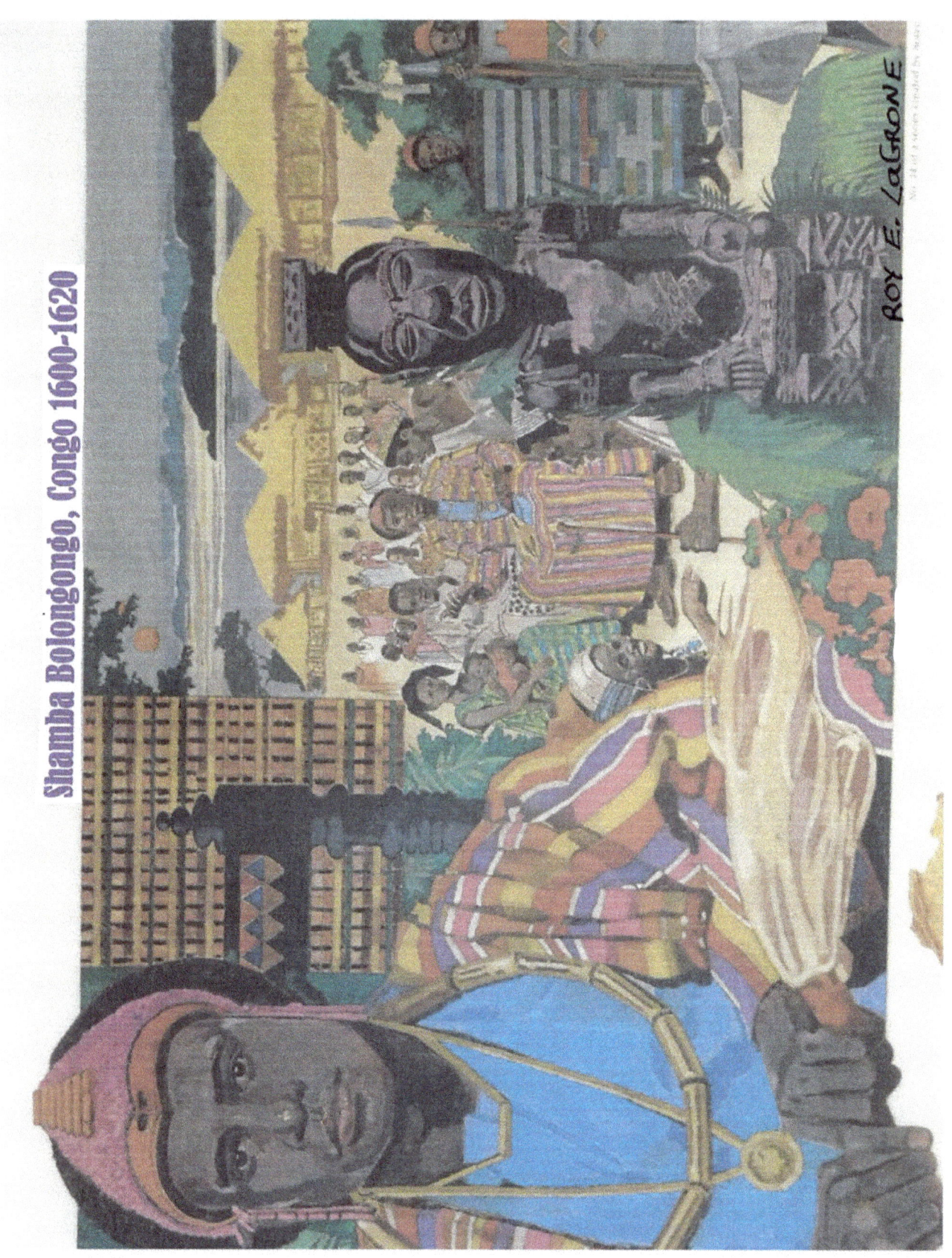

Shamba Bolongongo, Congo 1600-1620

#9

Osei Tutu – King of Asante (1680-1717)

Osei Tutu was the founder and first king of the Asante nation, a great West African forest kingdom in what is now Ghana. He was able to convince a half dozen suspicious chiefs to join their states under his leadership.

According to legend, this occurred when the Golden Stool descended from heaven and came to rest on Osei Tutu's knees, signifying his choice by the gods. The Golden Stool became a sacred symbol of the nation's soul, which was especially appropriate since gold was the prime source of Asante wealth.

Under Osei Tutu, the loose knit coalition was unified not only by this common throne, but also by a common capital city (Kumase), a common festival celebrating the yam harvest, and a common enemy – the Denkyeras, powerful rivals and an ever-present threat to Asante survival. By defeating them in a four-year campaign, the Asantes gained access to the rich coastal trade.

During Osei Tutu's reign, the geographic area of Asante tripled in size. The kingdom became a significant power that, with his military and political prowess as an example, would endure for two centuries.

#25 ALFRED J SMITH

Nandi: Queen of Zululand, 1778-1826 A.D.

The story of Nandi is a story of courage and steadfast devotion.

The year was 1786. The King of Zululand was overjoyed. His wife, Nandi, had given birth to a son, his first son, whom they named Chaka. But the King's other wives, jealous and bitter, pressured him to banish Nandi and the young boy, Chaka.

Steadfast and proud, Nandi raised her son in exile and made sure he received the kind of training and guidance a royal heir should have.

For her many sacrifices, Nandi was finally rewarded. Her son Chaka returned to become the greatest of all Zulu Kings.

To this day, the Zulu people use her name, "Nandi," to refer to a woman of high esteem.

#4

Shaka – King of the Zulus (1818-1828)

A strong leader and military innovator, Shaka is noted for revolutionizing 19th century Bantu warfare.

He was first to group regiments by age, and to train his men to use standardized weapons and special tactics. He developed the "assegai," a short stabbing spear, and marched his regiments in tight formation, using large shields to fend off the enemies' throwing spears. Over the years, Shaka's troops earned such a reputation that many enemies would flee at the sight of them.

With cunning and confidence as his tools, Shaka built a small Zulu tribe into a powerful nation of more than one million people, and united all tribes in South Africa against Colonial rule.

PAUL COLLINS

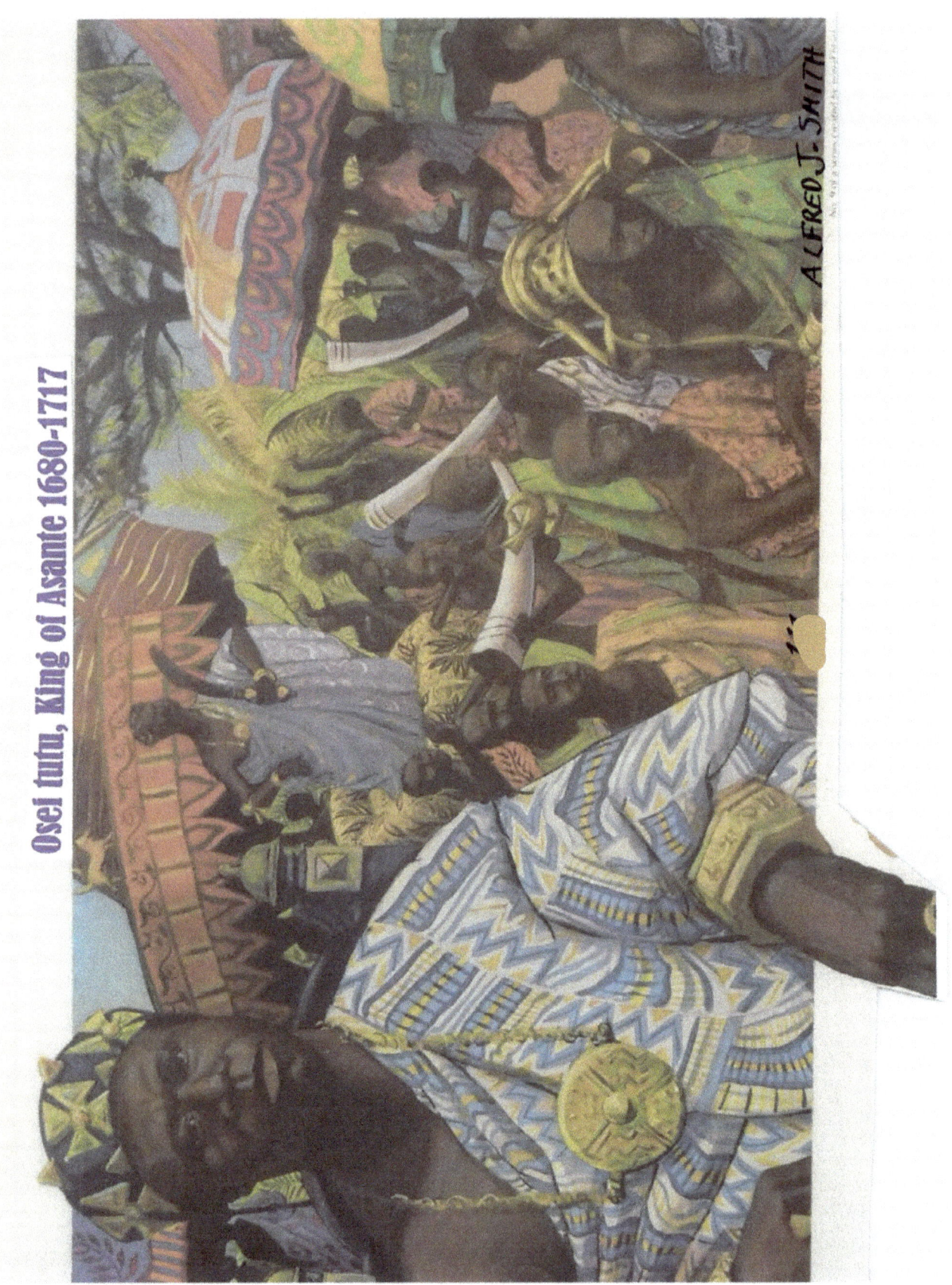

Osei tutu, King of Asante 1680-1717

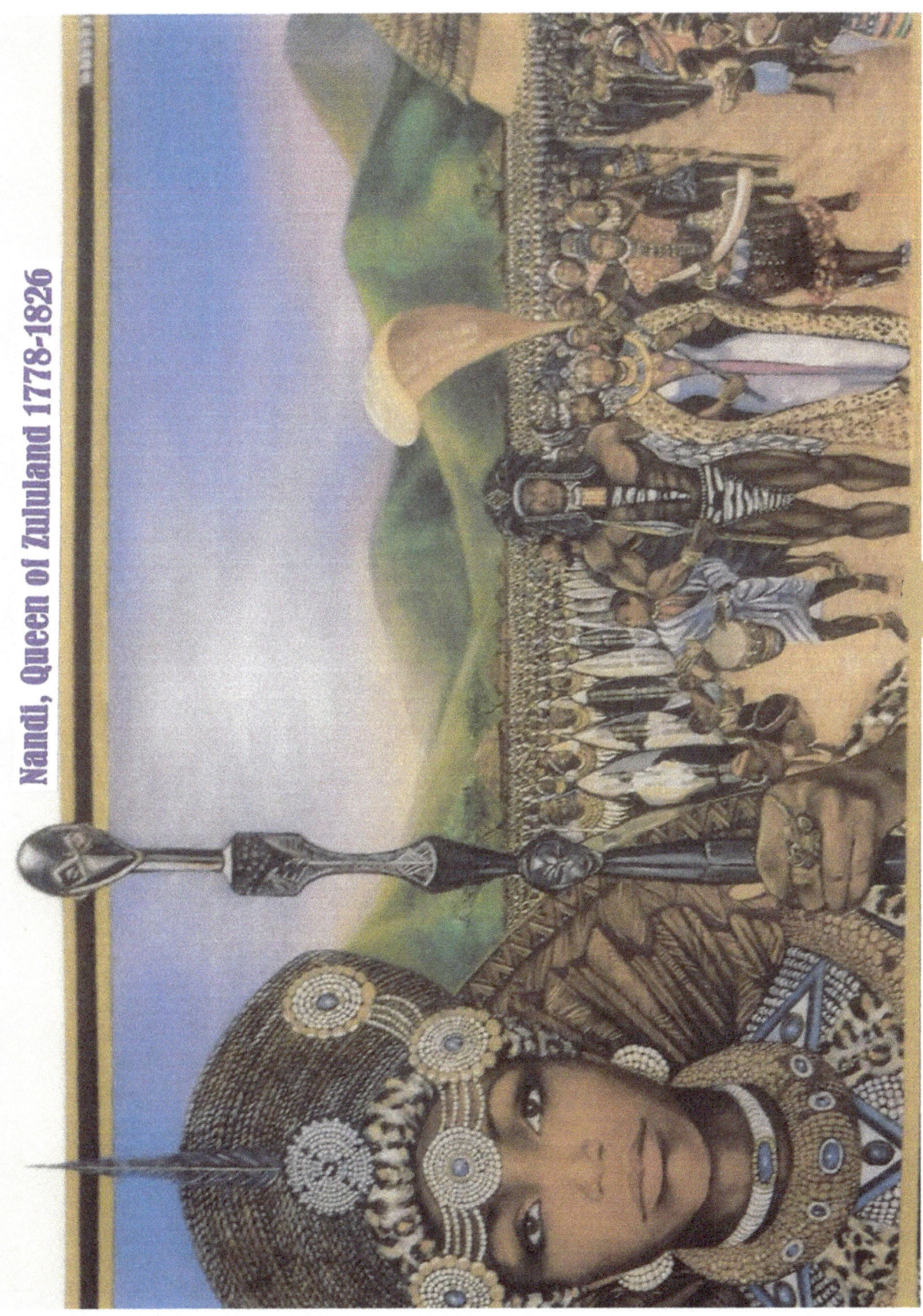

Nandi, Queen of Zululand 1778-1826

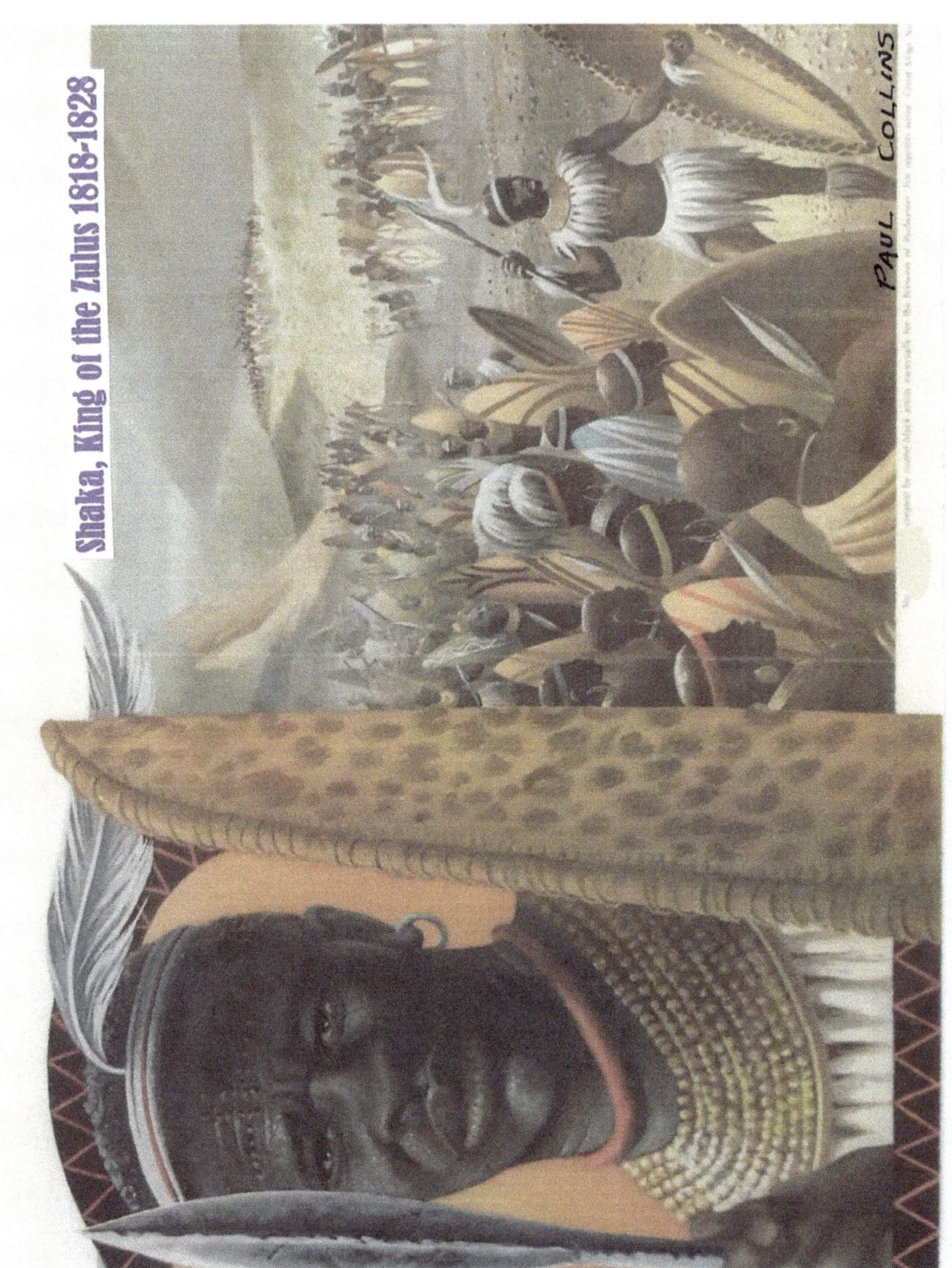

Shaka, King of the Zulus 1818-1828

11

Moshoeshoe – King of Basutoland (1815-1868)

For half a century, the Basotho people were ruled by the founder of their nation, a wise and just king who was as brilliant in diplomacy as he was in battle.

To create Basutoland, Moshoeshoe united many diverse groups, uprooted by war, into a stable society where law and order prevailed and the people could raise their crops and cattle in peace. He knew that peace made prosperity possible, and he often avoided conflict through skillful negotiations.

Even so, the Basotho had to fight for their survival. First came plundering Africans, later European colonialists – the British and particularly the Boers, who took more and more land from the Basothos.

Moshoeshoe solidified Basotho defenses at Thaba Bosiu, their impregnable mountain capital. From this stronghold he engineered a number of major victories over superior forces.

But eventually the relentless Boers were about to annihilate the Basothos and take their remaining land. Moshoeshoe persuaded the British to intervene and make Basutoland a protectorate in 1868. It was yet another of his diplomatic coups, one that not only helped assure his nation of its survival but also helped assure Moshoeshoe of a permanent place in African history.

JERRY PINKNEY

13

Khama – The Good King of Bechuanaland (1819-1923)

So peace loving was Khama, that on several occasions he surrendered control of his kingdom to his father, Sekhomi, who despised Khama's conversion to Christianity. The Bamangwato tribe displayed strong affection and support for Khama, however. Once, when Khama departed for a self-imposed exile, most of the tribe gathered their belongings to follow.

Khama distinguished his reign with the desire and ability to extract technological innovations from Europeans while resisting their attempts to colonize his country.

Bechuanaland advancements under Khama included the building of schools, scientific cattle breeding, and the introduction of a mounted police corps which practically eliminated all forms of crime.

Respect for Khama was exemplified during a visit with Queen Victoria of England to protest English settlement in Bechuanaland in 1875. The English honored Khama and confirmed his appeal for continued freedom for Bechuanaland.

CARL OWENS

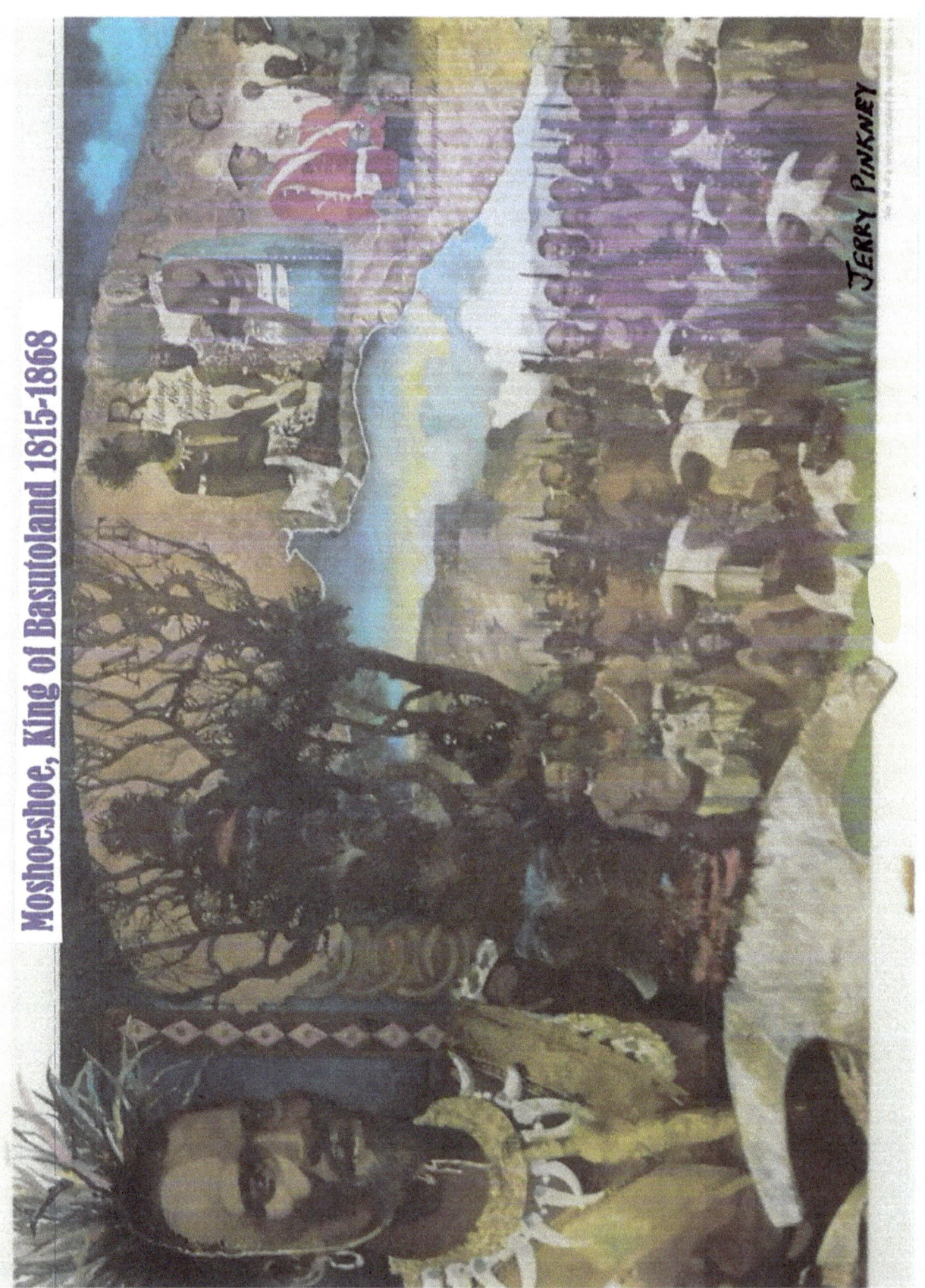
Moshoeshoe, King of Basutoland 1815-1868

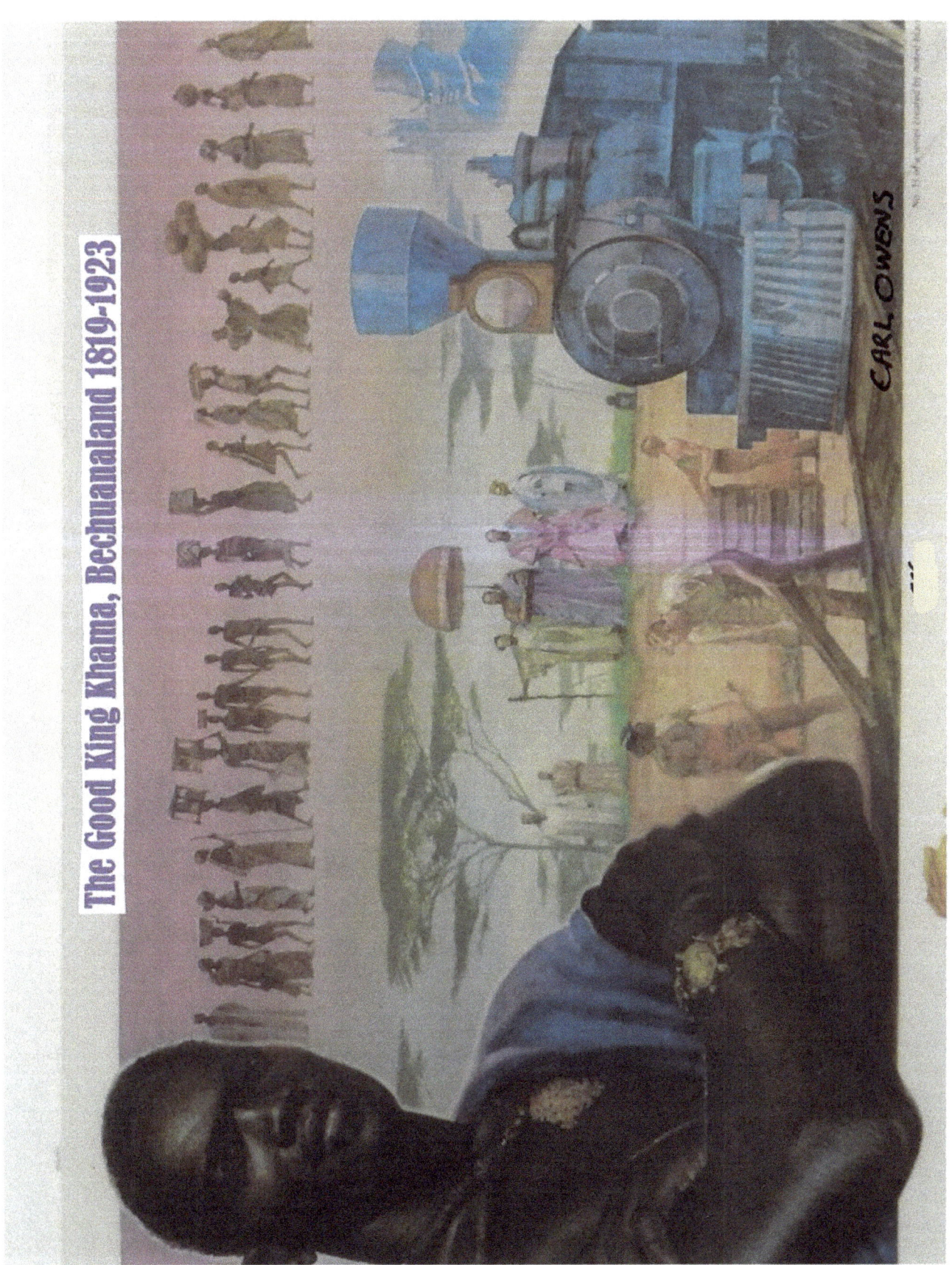

The Good King Khama, Bechuanaland 1819-1923

15

Samory Toure – "The Black Napoleon of the Sudan" (1830-1900)

The ascendance of Samory Toure began when his native Bissandugu was attacked and his mother taken captive. After a persuasive appeal, Samory was allowed to take her place.

He later escaped and joined the army of King Bitike Souane of Torona. Following a quick rise through the ranks of Bitike's army, Samory returned to Bissandugu where he was soon installed as king.

Defying French expansionism in Africa, Samory launched a conquest to unify West Africa into a single state. He annexed the lands bordering Bissandugu and continued until his kingdom spanned 100,000 square miles, making him the most powerful native ruler in West Africa. In each city, Samory built a Mosque – a testimonial of his devotion to Islam.

During the eighteen-year conflict with France, Samory continually frustrated the Europeans with his military strategy and tactics. This astute military prowess prompted some of France's greatest commanders to entitle the African monarch, "the Black Napoleon of the Sudan."

EZRA

16

Behanzin Hossu Bowelle – "The King Shark" (1841-1906)

The people of Dahomey often referred to their monarch, Behanzin, as the "King Shark," a Dahomeyan surname which symbolized strength and wisdom.

Behanzin was the most powerful ruler in West Africa during the closing years of the nineteenth century and was strongly determined to prevent European intervention into his country as he had seen occur in kingdoms surrounding Dahomey. The king readily welcomed European visitors but took precautionary measures to prevent their spread of influence among his subjects.

Behanzin maintained a strong army to defend his nation's sovereignty. Its warriors kept physically fit through special gymnastics developed in Dahomey. But perhaps the most formidable aspect of Behanzin's army was the division of five thousand female warriors who were noted for their zeal in battle.

A fond lover of the humanities, Behanzin is credited with the creation of some of the finest song and poetry ever produced in Dahomey.

THOMAS BLACKSHEAR II

5

Menelek II – King of Kings of Abyssinia (1844-1913)

Proclaimed to be a descendant of the legendary Queen of Sheba and King Solomon, Menelek was the overshadowing figure of his time in Africa. He converted a group of independent kingdoms into the strong, stable empire known as the United States of Abyssinia (Ethiopia).

His feat of pulling together several kingdoms which often fiercely opposed each other earned him a place as one of the great statesmen of African history. His further accomplishments in dealing on the international scene with the world powers, coupled with his stunning victory over Italy in the 1896 Battle of Adwa, an attempt to invade his country, placed him among the great leaders of world history and maintained his country's independence until 1935.

His profound pride of independence helped stabilize his people and made his country one of only two nations in Africa (the other is Liberia) to successfully resist colonization by the European powers.

DON MILLER

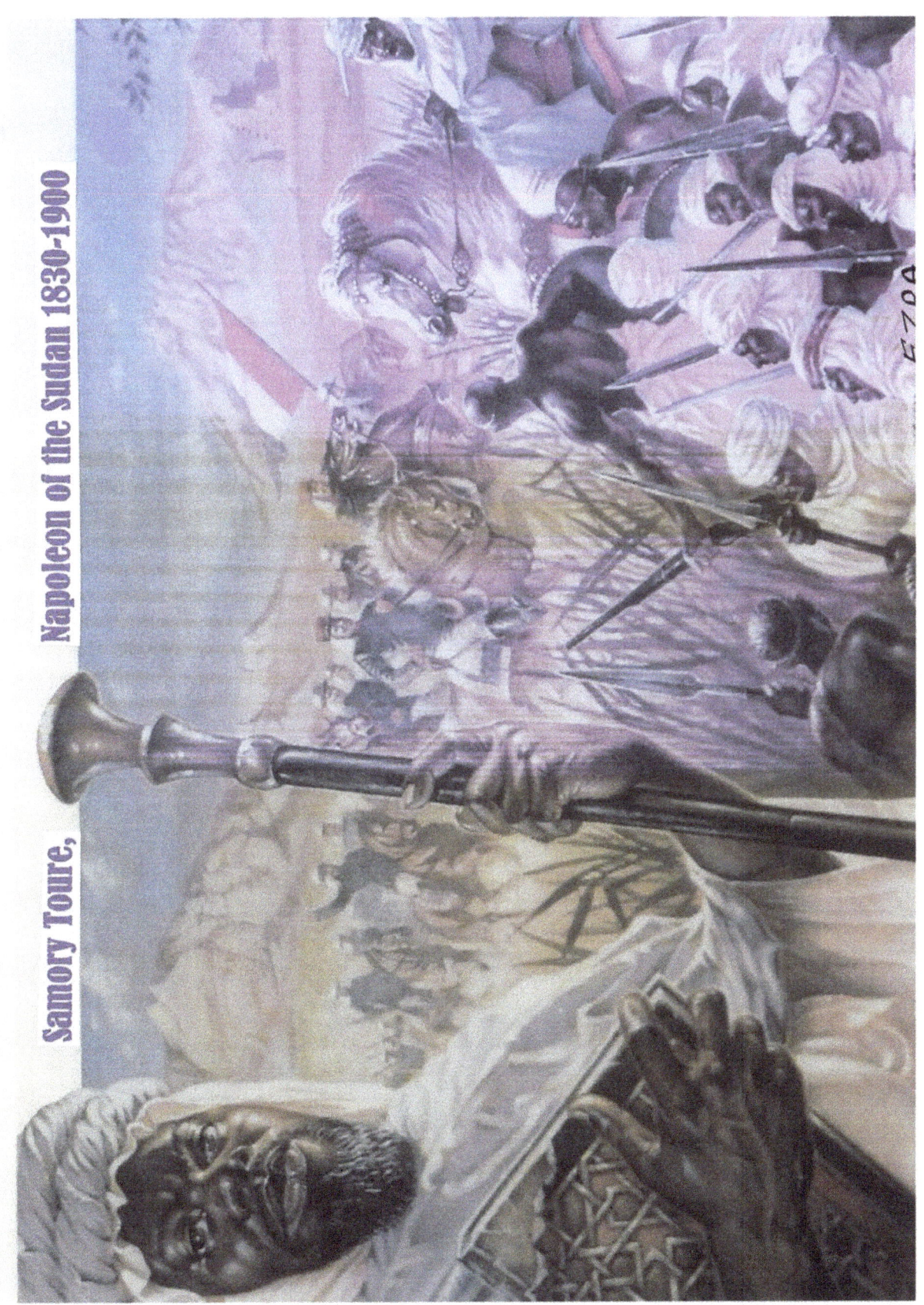

Samory Toure, Napoleon of the Sudan 1830-1900

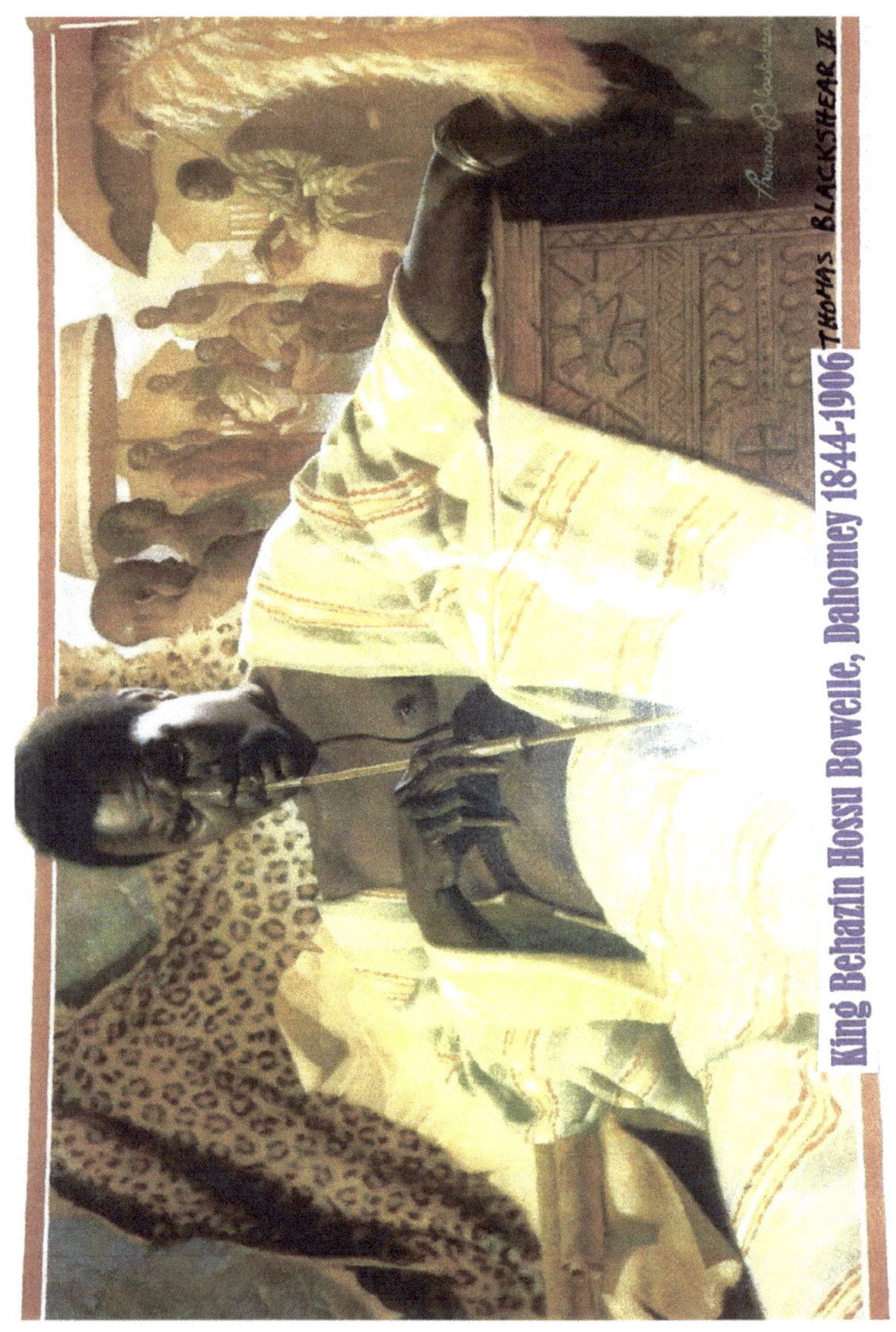
King Behazin Hossu Bowelle, Dahomey 1844-1906 — Thomas Blackshear II

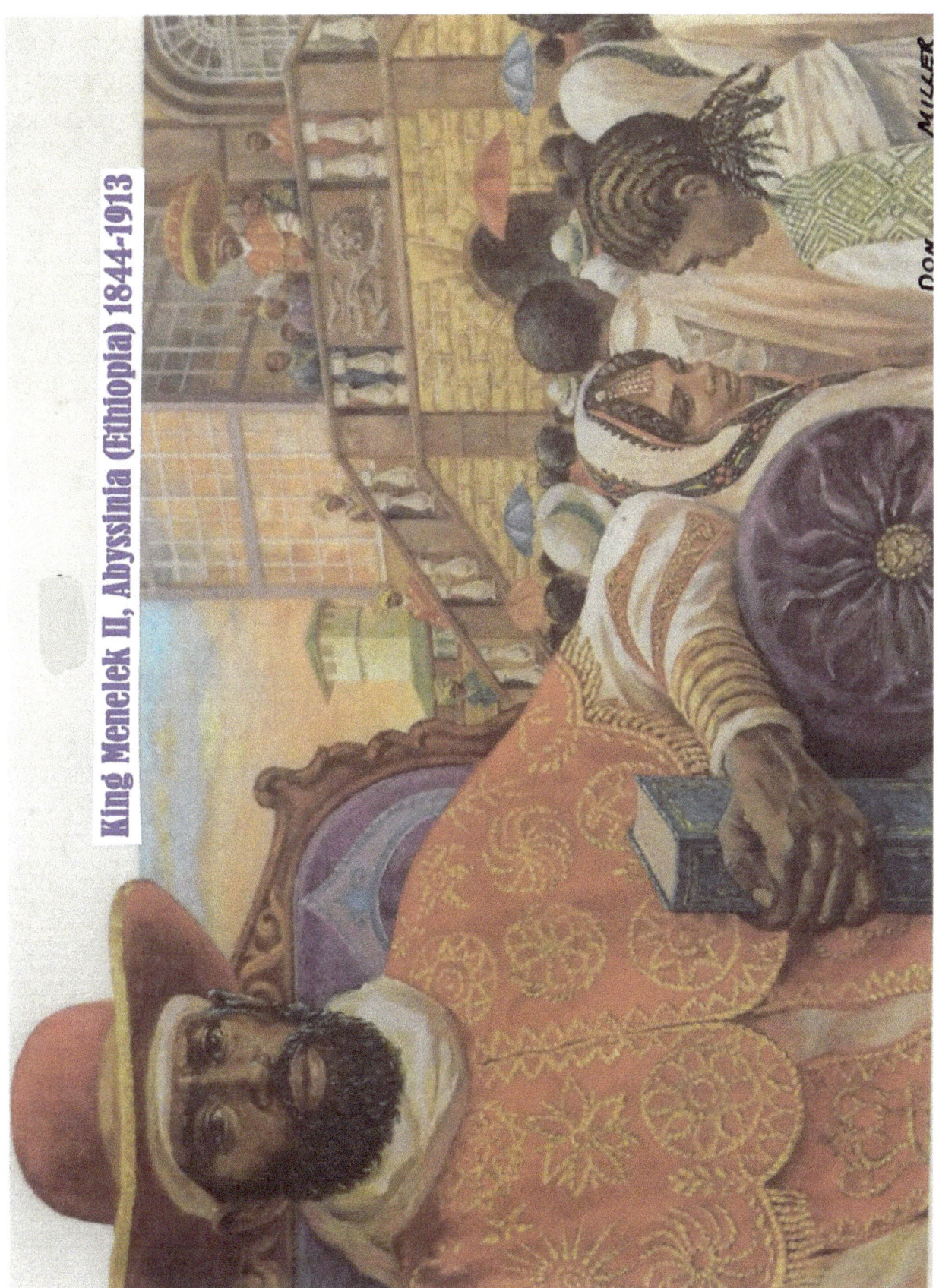

King Menelek II, Abyssinia (Ethiopia) 1844-1913

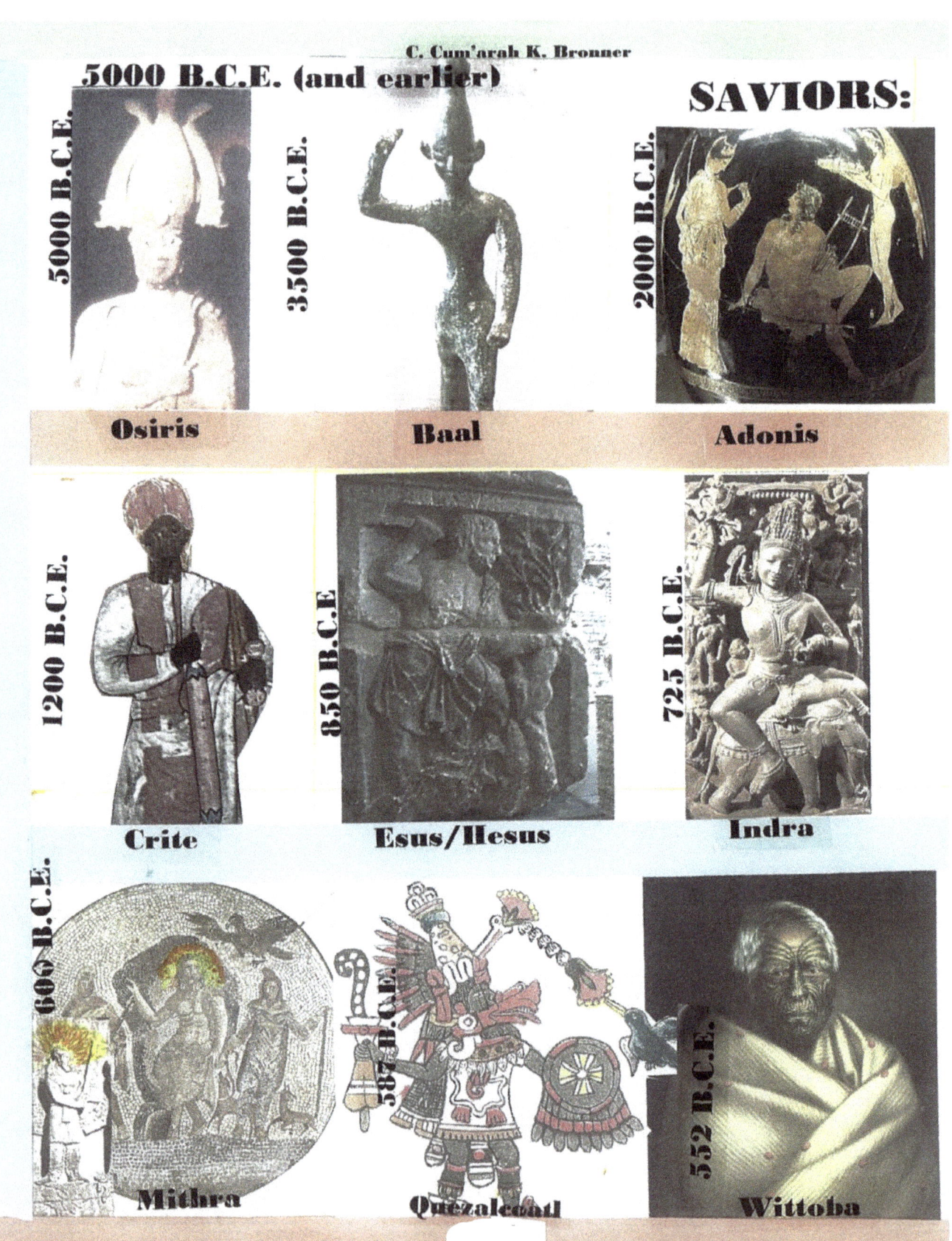

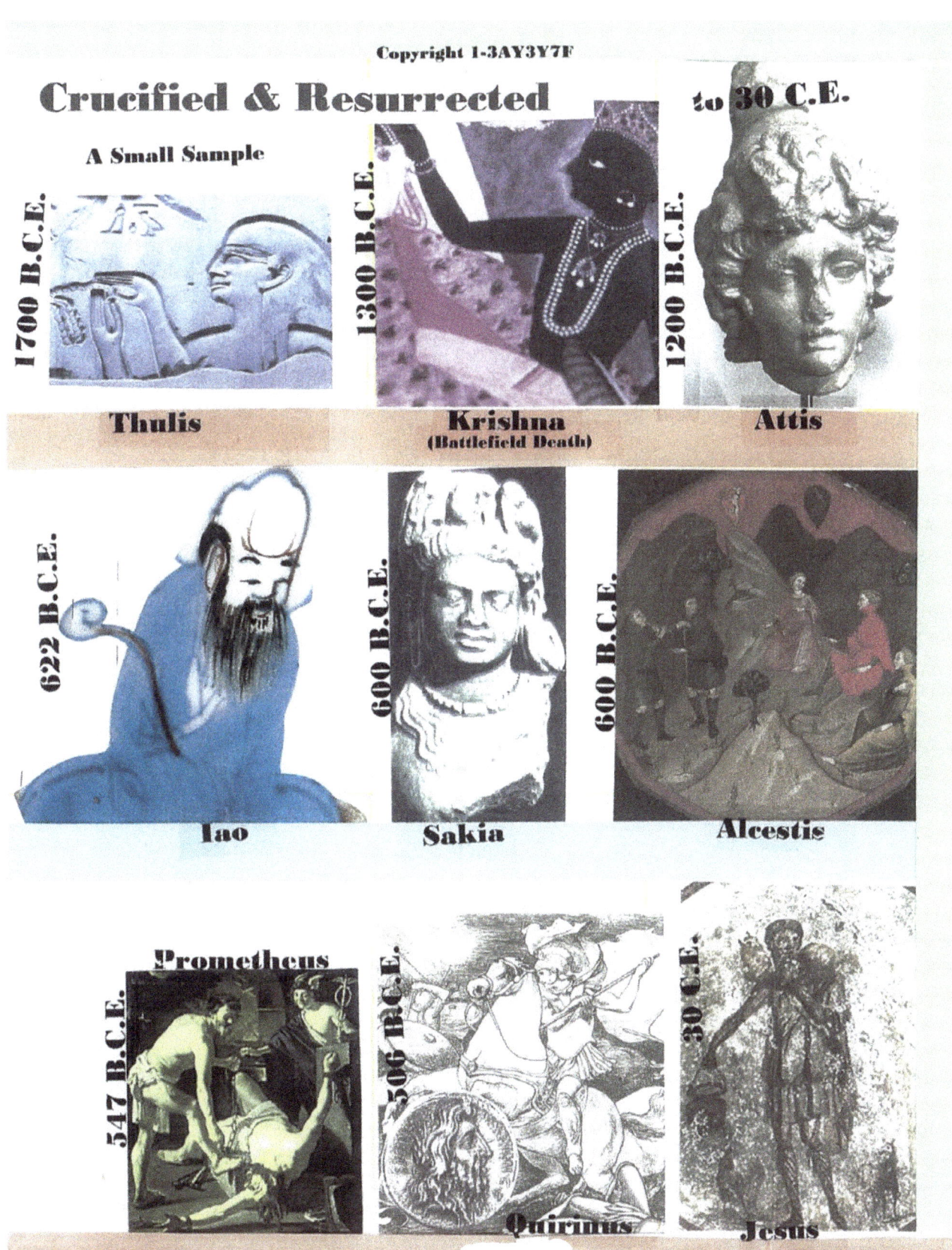

DIFFERENT DEMIGODS WITH DIFFERENT FATES – DEATHS: 4 NATURAL & 3 TRAGIC

Imhotep

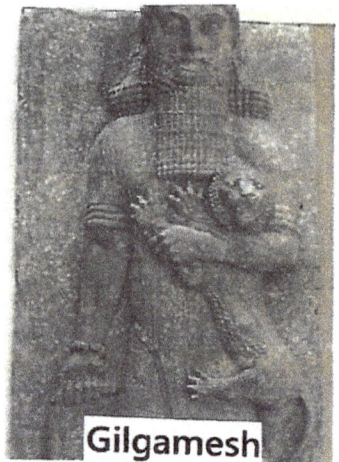

Gilgamesh

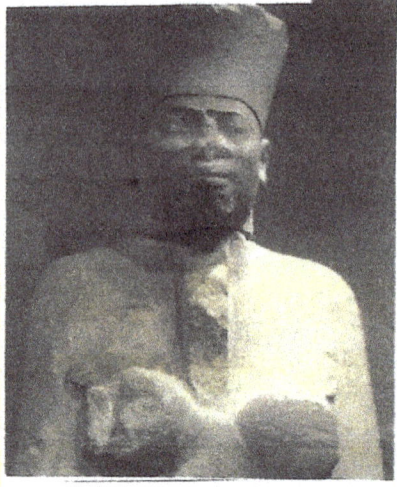

Mentuhotep II

Deified by people

Demigods's Longevity:
Imhotep
2,500+ Years B.C.E.
Mentuhotep II
1,000+ Years B.C.E.
Sugawara no Michizane
1,000 Years – Current C.E.
Natural Deaths for Top 3
<><><><><><><><><>
Gilgamesh
2,400+ Years B.C.E.
Hercules
1,000+ Years B.C.E.
Biblical: Samson B.C.E.

Hercules aflame

Hercule's ascension

Perseus

Sugawara no Michizane

Theseus

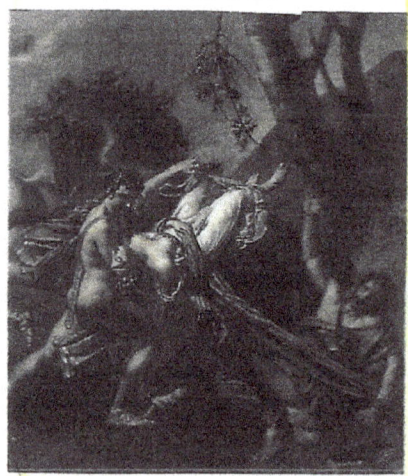

132

EASY ACCESS BIBLIOGRAPHY

Ben-Jochannan, Yosef A. A. - <u>Africa: Mother of Western Civilization</u> (1971)
<u>Black Man of the Nile and His Family</u> (1989)
<u>African Origins of the Major Western Religons</u> (1970)
<u>Africa (Alkebu-lan) in History, A Chronology:
1,750,000 B.C.E. to 1966 C.E. (7 Volumes)</u> (1966)
New York: Alkebu-lan Books Associates
<u>We The Black Jews</u> - Spain: N.P., 1949

Bernal, Martin - <u>Black Athena - The Afroasiatic Roots of Classical Civilization, Volume I:
The Fabrication of Ancient Greece 1785 - 1985</u>
New Brunswick, N. J.: Rutgers University Press, 1987
<u>Ancient or Aryan: A Competition Between Models on the Origins of
Ancient Greece</u> - SCETV "For The People" Host: Listervelt Middleton

Budge, E. A. Wallis - <u>The Egyptian Book of the Dead (The Book of The Great Awakening)</u>
London: British Museum, Longmans and Co., 1895

Diop, Cheikh Anta - <u>Great African Thinkers, Vol. I</u> Editor, Ivan Van Sertima
New Brunswick, N. J.: Transaction Books, 1986
<u>The African Origin of Civilization: Myth or Reality</u> - Westport, Ct.:
Lawrence Hill and Co., 1974
<u>The Cultural Unity of Black Africa</u> - Paris (1955) - Chicago: Third World
Press, 1978

Finch III, Charles S. - <u>Echoes of The Old Darkland: Themes From the African Eden</u>
Decatur, Ga.: Khenti, Inc. 1991
<u>Ancient Kemet and Its Gift to Modern Religions</u> - SCETV "For The
People" Host: Listervelt Middleton

Freud, Sigmund - <u>Moses and Monotheism</u> - New York: Vintage Books, 1939

Herodotus - The Histories, Translator: Aubrey DeSelincourt - Middlesex, Eng.: Penguin
Books, Ltd., 1954

Higgins, Godfrey - <u>Anacalypsis...An Inquiry Into the Origin of Languages, Nations, and
Religions, Vols. I and II,</u> London: Longman, 1836

Hilliard III, Asa G. - <u>Free Your Mind: Return to the Source of African Origins</u> - SCETV "For
The People" Host: Listervelt Middleton

Houston, Drusilla Dunjee - <u>Wonderful Ethiopians of the Ancient Cushite Empire</u>
Baltimore: Black Classic Press, 1985 (1926)

Jackson, John G. - <u>Ethiopia and the Origin of Civilization</u>
<u>Introduction to African Civilization</u>
<u>Man, God, and Civilization</u>
<u>Christianity Before Christ</u>
Secaucus, N. J.: Citadel Press

James, George G. M. - <u>Stolen Legacy</u> - San Francisco: Julian Richardson Associates,
Publishers, 1985 (1954)

Johnson, John L. - <u>The Black Biblical Heritage</u> - St. Louis: The Black Biblical Heritage
Publishing Company, 1975

Koram, Jamal - <u>Aesop: Tales of Aethiop The African, Vol. I</u> - Silver Spring, Md.:
Flying Lion Press, 1989

Massey, Gerald - <u>Ancient Egypt: Light of the World, Vols. I and II</u> - Mokelumne
Hill, Ca., 1907

McCray, Walter Arthur - <u>The Black Presence in The Bible (Black and African Identity)</u>
<u>The Black Presence in The Bible (Table of Nations)</u>
Chicago: Black Light Fellowship, 1990

Carl Brown

EASY ACCESS BIBLIOGRAPHY

Rashidi, Runoko - *African Presence in Early Asia* - New Brunswick, N.J.: Transaction Publishers, 1985
Rogers, Joel A. - *World's Great Men of Color*, Vol. I - 1946-1947
　　Nature Knows No Color-Line - 1952
　　Sex and Race, Vol. I - 1940-1944
　　New York J. A. Rogers Publications
　　　Macmillan Publishing Company
Tierney, John and Others - "The Search For Adam and Eve" *Newsweek*, January 11, 1988
UNIPUB/UNESCO - *General History of Africa: Methodology and African Prehistory*, Vol. I
　　General History of Africa: Ancient Civilizations of Africa, Vol. II
Van Sertima, Ivan - *Egypt Revisited* - 1989
　　Black Women in Antiquity - 1984
　　Great African Thinkers - 1986
　　African Presence in Early Asia - 1985
　　African Presence in Early Europe - 1985
　　New Brunswick, N.J.: Transaction Publishers
　　African Presence in Ancient America: They Came Before Columbus
　　New York: Random House, 1976
Weaver, Kenneth F. and Others - "Stones, Bones, and Early Man: The Search For Our Ancestors," *National Geographic*, November 1985
Williams, Bruce - "The Lost Pharaohs of Nubia" *Egypt Revisited* - Ivan Van Sertima, Ed.
　　"Forebears of Menes in Nubia: Myth or Reality," *JNES*, Vol. 46, January 1987
Williams, Chancellor - *The Destruction of Black Civilization: Great Issues of a Race from 4500 B.C. to 2000 A.D.* - Chicago: Third World Press, 1987

SUPPLEMENTAL BIBLIOGRAPHY

Asante, Molefi Kete - *Afrocentricity* - Trenton, N.J.: Africa World Press, Inc., 1988
　　The Afrocentric Idea - Philadelphia: Temple University Press, 1987
Begg, Ean - *The Cult of the Black Virgin* - London: Arkana Penguin Book Group, 1985
Davidson, Basil - *The African Past: Chronicles from Antiquity to Modern Times* - New York: Grossett and Dunlap, 1964
El-Amin, Mustafa - *Freemasonry: Ancient Egypt and the Islamic Destiny* - Newark, N.J.: El-Amin Productions, 1988
Graves, Kersey - *The World's Sixteen Crucified Saviors: Christianity Before Christ* - New York: The Truth Seeker Company, 1875
Green, Richard L. - *A Salute to Historic African Kings and Queens*, Vol. VI - Chicago: Empak Enterprises, Inc., 1986
King James Version - *The Holy Bible* - Great Britain: Cambridge University Printing House
Mazrui, Ali A. - *The Africans: A Triple Heritage* - Boston: Little, Brown and Company, 1986
Ouspensky, Leonid and Vladimir Lossky - *The Meaning of Icons* - Crestwood, New York: St. Vladimir's Seminary Press, 1952
Palmer, R. R., and Joel Colton - *A History of the Modern World* - New York: McGraw Hill, 1950
Ra Un Nefer Amin - *Metu Neter: The Great Oracle of Tehuti and the Egyptian System of Spiritual Cultivation* - Bronx, N.Y.: Khamit Corporation, 1990
Vercoutter, Jean and Others - *The Image of the Black in Western Art* - Vol. I: *From the Pharaohs to the Roman Empire* - Cambridge, Ma.: Harvard Univ. Press, 1976

Carl Brown

FROM HISTORIANS, YOSEF A. A. BEN-JOCHANNAN, J. A. ROGERS, AND THE TRANSACTION PUBLISHERS' AUTHORS:

ADDITIONAL REFERENCES

Abbott, J. - <u>History of Hannibal</u> - 1876
Abbott, Jacob - <u>Cleopatra</u> - New York: John D. Morris and Company, 1904
Breasted, James Henry - <u>Ancient Records of Egypt</u>, Vols. I, II, III, IV, and V - Chicago: University of Chicago Press, 1906-1907
 <u>A History of Egypt from the Earliest Times to the Persian Conquest</u>, New York: Scribner, 1937
Budge, E. A. Wallis - <u>A History of Ethiopia, Nubia and Abyssinia</u>, Vols. I and II - London: Methuen and Company, 1928
 <u>Osiris and the Egyptian Resurrection</u>, Vols. I and II - London: P. L. Warner, 1911
 <u>The Queen of Sheba and Her Only Son, Menyelek</u> - London: 1923
Burckhard, John L. - <u>Travels in Nubia</u> - London: J. Murray, 1819
Diodorus Siculus (Sicilian) - <u>Universal History</u>, Books III and XVII (In Egypt 60-57 B.C.E.)
Frazer, James G. - <u>The Golden Bough: A Study in Magic and Religion</u>, Vols. 1 through 13 - London: Macmillan, 1911-1936
Frobenius, Leo - <u>The Voice of Africa</u>, Vols. I and II - London: Hutchinson and Company, 1913
Gardiner, Sir Alan - <u>Egypt of the Pharaohs</u> - New York: Oxford University Press, 1966
Gonzales, Ambrose Elliott - <u>With Aesop Along the Black Border</u> - Columbia, S.C.: The State Company, 1924
Hurry, Jamieson B. - <u>Imhotep, the Vizier and Physician of King Zoser and Afterwards the Egyptian God of Medicine</u> - London: Oxford University Press, 1926
Josephus, Flavius - <u>The Complete Works of Flavius-Josephus</u> - Chicago: Thompson and Thomas, 1900
Kenrick, John - <u>Ancient Egypt Under the Pharaohs</u>, Vols. I and II - London: B. Fellowes, 1850
Leakey, Louis S. - <u>Adam's Ancestors</u> - London: Methuen, 1953
 <u>The Stone Age Races of Kenya</u> - London: Oxford University Press, 1935
Leo Africanus, Joannes - <u>The History and Description of Africa</u>, Vols. I and II - London: Hakluyt Society, 1896
Lepsius, Richard - <u>Discoveries in Egypt, Ethiopia, and the Peninsula of Sinai</u> - London: R. Bentley, 1852
Livy (Titus Livius) - <u>Roman Historian 59 B.C.E. - 17 C.E.</u> - Books XXI to XXIV
Manetho - <u>Manetho</u> - Translated by William W. Waddell - London: W. Heinemann, 1940
Murray, Margaret A. - <u>The Splendor That Was Egypt</u> - New York: Hawthorn Books, Inc., 1963
Ormonde, Czenzi - <u>Solomon and the Queen of Sheba</u> - New York: Farrar, Straus and Young, 1954
Osei, G. K. - <u>The Forgotten Great Africans</u> - 3000 B.C. to 1959 A.D. - London: G. K. Osei, 1965
Petrie, William M. - <u>A History of Egypt</u>, Vols I through VI - London: Methuen, 1898-1924
Petrie, Sir Flinders - <u>The Making of Egypt</u> - London: Sheldon Press, 1939
Plutarch (c. 46-120 C.E.) - <u>Lives of Illustrious Greeks and Romans</u>, For General Clitus See "Alexander the Great"
Polybius (c. 205-125 B.C.E.) - <u>The Histories</u> - Trans. W. R. Paton - London: W. Heinemann, 1922-1927
Rawlinson, George - <u>The Five Great Monarchies of the Ancient Eastern World</u>, Vols. I through IV London: J. Murray, 1862-1867
 <u>Origin of Nations</u> - New York: Charles Scribners' Sons, 1912
 <u>Ancient Egypt</u>, Vol. II - 1880

Carl Bruton

ADDITIONAL REFERENCES

Snowden, Frank M. - <u>Blacks in Antiquity: Ethiopians in Greco-Roman Experience.</u>
 Cambridge, Ma.: Belknap Press of Harvard University Press, 1970
Soames, Jane - <u>The Coast of the Barbary</u> - London: J. Cape, 1938
Suetonius (Gaius Suetonius Tranquillis) Roman Historian - c. 100 C. E. - <u>De viris Illustribus</u>
Terentius, Afer Publius - <u>Terence's Comedies</u> - London: D. Midwinter, 1741
Volney, Constantin F. - <u>The Ruins: Or, A Survey of the Revolutions of Empires</u> - London:
 Printed for J. Johnson, 1791
 <u>Voyage en Syrie et en Egypte</u>, Vols. I and II - Paris: 1787

History of Superstition, Mythology and Religion

Bibliography

Adam's Ancestors by Louis S. Leakey

"Adherents of All Religions by Six Continental Areas(1), Mid-2003" The World Almanac And Book of Facts: 2005, p. 731**

African American Humanism: An Anthology** by Norm R. Allen, Jr., Ed.

The African Origins of the Major Western Religions** by Yosef A. A. ben-Jochannan

The Africans Who Wrote the Bible: Ancient Secrets African and Christianity Have Never Told** by Nana Banchie Darkwah, Ph. D.

A History of God: The 4,000-Year Quest of Judaism, Christianity and Islam ** by Karen Armstrong

The Ankh: African Origin of Electromagnetism ** by Nur Ankh Amen

The Best of Robert Ingersoll ("the great agnostic") by Roger E. Greeley, Ed.

The Bible Myth: The African Origins of the Jewish People ** by Gary Greenberg

Biblical Nonsense by Dr. Jason Long

The Black Biblical Heritage: 4000 Years of Black Biblical History ** by John L. Johnson

The Black Muslims in America ** by C. Eric Lincoln

The Black Presence in the Bible & the Table of Nations…Vol. I, and Discovering the Black African Identity of Biblical Persons and Nations, Vol. II by Rev. Walter Arthur McCray

The Book Your Church Doesn't Want You to Read by T. C. Leedom

Breaking the Chains of Psychological Slavery ** By Dr. Na'im Akbar

Buddhist Scriptures ** by Translator Edward Conze & Editor Betty Radice

Can We Be Good Without God? By Dr. Robert Buckman, M.D.

The Case for Humanism by Lewis Vaugh & Austin Dacey

Christianity Before Christ ** by John G. Jackson

Complete Works of Lao Tzu: Tao Teh Ching & Hua Hu Ching **by Hua-Ching Ni, Trans.

The Cosmos ** by Carl Sagan

History of Superstition, Mythology and Religion 2

The Cult of the Black Virgin ** by Ean Begg

"Deism," Encyclopaedia Britannica, 1972, Vol. 7, pp. 181-183 ** (*notes below)

The Demon-Haunted World ** by Dr. Carl Sagan

The Dragons of Eden: Speculations on the Evolution of Human Intelligence ** by Dr. Carl Sagan

Does God Exist? by J. P. Moreland & Kai Nielson

Echoes of the Old Darkland: Themes From the African Eden**Charles S. Finch III, M.D.

The Egyptian Book of the Dead ** by E. A. Wallis Budge

Egypt During the Golden Age, Part 1 ** by Legrand H. Glegg

Egypt: The World of the Pharaohs by Regine Schulz & M. Seidel

The End of Faith: Religion, Terror, and the Future of Reason ** by Sam Harris

Freedom From God: Restoring the Sense of Wonder by Harry Wilson

Freedom of Choice Affirmed by Dr. Corliss Lamont

Freedom: Quotes and Passages from the World's Greatest Thinkers **by Leonard Roy Frank

Freemasonry: Ancient Egypt and the Islamic Destiny **by Mustafa El-Amin

Freethinkers: A History of American Secularism by Susan Jacoby

Freethought Across the Centuries by Dr. Gerald Larue

From Babylon to Timbuktu: A History of Ancient Black Races Including the Black Hebrews
 by Rudolph R. Windsor

The Fundamentals of Extremism: The Christian Right in America by Ed. Kimberly Blaker, Herb
 Silverman, Edward M. Buckner, et. al

God Delusion by Richard Dawkins

God Fraud ** by Rev. J. R. Reid, D. D.

Greatest Show On Earth: The Evidence For Evolution by Richard Dawkins

The Greek Myths, Volumes I & II, ** by Robert Graves

The Happy Heretic by Judith Hayes

History of Superstition, Mythology and Religion 3

Holy Bible: King James Version ** by Gen. Ed., The Rev. Cain Hope Felder, Ph. D.

Humanism As the Next Step by Mary & Lloyd Morain

Let the Ancestors Speak: Removing the Veil of Mysticism from Metu Netcher ** by Ankh Mi Ra

Losing Faith in Faith: From Preacher to Atheist by Dan Barker

Man, God and Civilization **by John G. Jackson

Metu Neter: The Great Oracle of Tehuti & the Egyptian System of Spiritual Cultivation, Vol. I
 by Ra Un Nefer Amen

The Militant Agnostic by E. Haldeman-Julius

The Mind of the Bible Believer by Edmund D. Cohen

Moses and Monotheism ** by Sigmund Freud

The Moses Mystery by Gary Greenberg

Myths & Legends: World's Most Enduring Myths & Legends Explored and Explained ** by Neil Philip

The Necessity of Atheism and Other Essays by Percy Bysshe Shelley

101 Myths of the Bible: How Ancient Scribes Invented Biblical History **by Gary Greenberg

The Power of Myth ** by Joseph Campbell with Bill Moyers

Quotations That Support Separation of State & Church by Edward Buckner & Michael Buckner, Eds.

Quran: The Final Testament ** by Rashad Khalifa, Ph. D.

Sleeping with Extra-Terrestrials: The Rise of Irrationalism and Perils of Piety by Wendy Kaminer

The Teachings of Ptahhotep: The Oldest Book in the World ** by Asa G. Hilliard III, Larry Williams and
 Nia Damali

Time Traveling with Science and the Saints ** by George A. Erickson

The Unabridged Devil's Dictionary ** by Ambrose Bierce, & Ed. S. T. Joshi et. al.

An Uppity Old Athiest Woman's Dictionary by Carol Faulkenberry

The Ways of an Athiest by Bernard Katz

When God was a Woman ** by Merlin Stone

History of Superstition, Mythology and Religion

Why I Am Not A Christian by Bertrand Russell

Why I Am Not A Muslim by Ibn Warraq

Woe to the Women: The Bible Tells Me So By Annie Laurie Gaylor

Women Without Superstition: No Gods, No Masters by Anna Laurie Gaylor, Ed.

The World's Religions ** by Huston Smith

The World's Sixteen Crucified Saviors: Christianity Before Christ ** by Kersey Graves

The X-Rated Bible-Updated "Born Again" Edition ** by Ben Edward Ackerley

2000 Years of Disbelief: Famous People with the Courage to Doubt **Jas. A. Haught

Ye Will Say I Am No Christian: T.Jefferson & J. Adams Correspon... Bruce Braden

Video Series - VHS & DVD

The History Channel Video Catalog:

 "Banned From the Bible: 159 Great Rejected Books"

 "The Crusaders"

 "Invention of Satan and Hell - Hell: The Devil's Domain"

 "Who Wrote the New Testament?"

Public Broadcasting System (PBS) Home Video Series

 "Heritage: Civilization and the Jews" by Abba Eban

 "The Power of Myth" ** by Joseph Campbell with Bill Moyers

 "For The People: Free Your Mind" Listervelt Middleton (PBS-SC - South Carolina)

WPFW 89.3 FM Program: "We Ourselves"

 "Spiritual Sanity in the 21st Century for an Insane World" by Ambrose I. Lane, Sr.

<><><><><><><><><><><><><><><><><><><><><><><><><><><><><><><><><><><>

Deists among the founding fathers: By the end of the 18th century, "deism" --wrote some historians-- had become a dominant religious attitude among upper-class Americans, with the first four presidents adhering

to their convictions, as is amply evidenced in their correspondence: "The ten commandments and the sermon on the mount contain my religion," (that's it!) John Adams wrote to Thomas Jefferson in 1816.

Deism: *Encyclopaedia Britannica 1972*

Deism started with a lot of the Western World's most prominent citizens in Europe. To the American list of "founding fathers," add James Madison, Benjamin Franklin, Thomas Paine, Ethan Allen, Gouverneur Morris, John Quincy Adams, Abraham Lincoln, Frederick Augustus Douglass and many other 19th and and 20th century freethinkers. Who invented the word "deism"? It's structure is very similar to deity, deify, deist, deistic, deistical and. It could be interpreted that the founding fathers were themselves dieties or worshippers, when in fact, "deism" refers to a totally absent deity (god) lost somewhere in our infinite universe.,

"While Thomas Jefferson was in the White House, he began the project of cutting his Bible apart and pasting into a notebook the pieces that, to him, made sense. In this way he hoped to discover the 'real' Jesus. He wrote of this exercise:

> 'Among the sayings and discourses imputed to him (Jesus) by his biographers, I find many passages of fine imagination, correct morality, and of the most lovely benevolence; and others again of so much ignorance, so much absurdity, so much untruth, charlatanism (false claims of powers and/or skills), and imposture (impostor), as to pronounce it impossible that such contradictions should have proceeded from the same being. I separate therefore the gold from the dross (worthless); restore to him the former and leave the latter to the stupidity of some and, roguery of others of his disciples's.

U. U. World Magazine, Vol. XVIII, No. 1, Jan/Feb. 2004

www.ingramcontent.com/pod-product-compliance
Lightning Source LLC
Chambersburg PA
CBHW041920180526
45172CB00013B/1341